W9-BYG-889

Revolution
in Clay

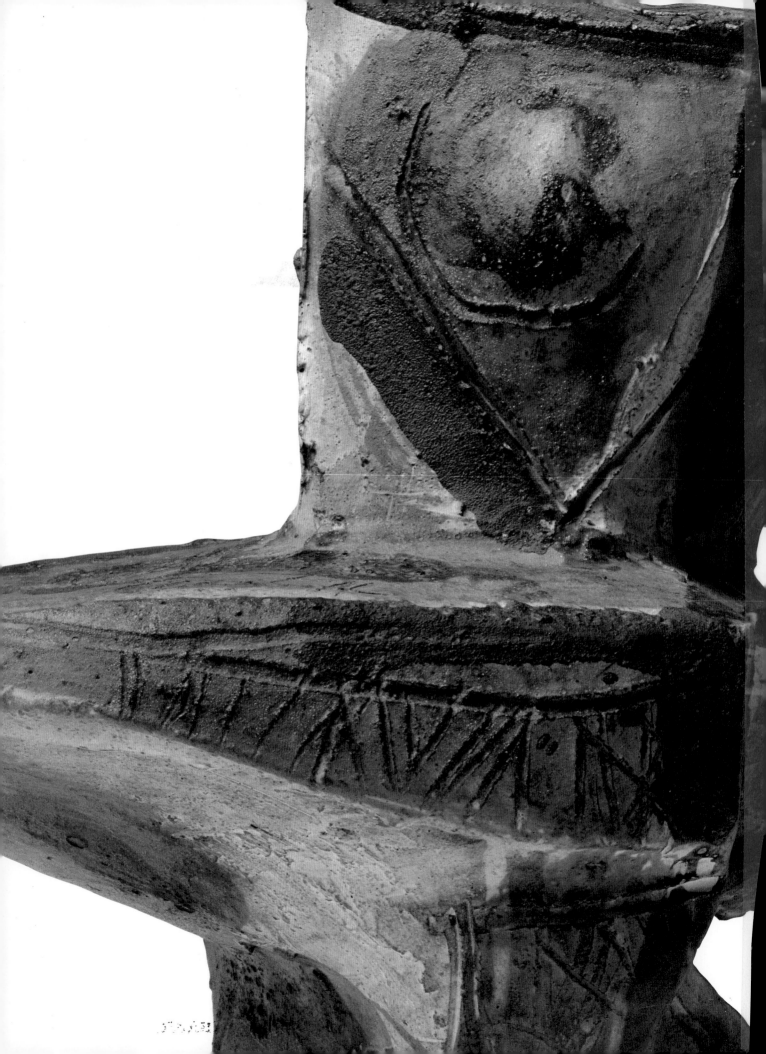

Revolution in Clay

THE MARER COLLECTION OF CONTEMPORARY CERAMICS

Exhibition organized by

MARY DAVIS MACNAUGHTON

Essays by

Kay Koeninger

Mary Davis MacNaughton

Martha Drexler Lynn

Ruth Chandler Williamson Gallery

Scripps College

in association with

University of Washington Press

Seattle and London

REVOLUTION IN CLAY:
THE MARER COLLECTION OF
CONTEMPORARY CERAMICS

TOUR ITINERARY

October 22–December 4, 1994
RUTH CHANDLER WILLIAMSON GALLERY
SCRIPPS COLLEGE
Claremont, California

January 8–February 26, 1995
RINGLING SCHOOL OF ART AND DESIGN
Sarasota, Florida

March 25–May 21, 1995
SUNRISE MUSEUMS
Charleston, West Virginia

June 11–July 30, 1995
KALAMAZOO INSTITUTE OF ART
Kalamazoo, Michigan 49007

August 27–October 15, 1995
CANTON ART INSTITUTE
Canton, Ohio

November 12–January 7, 1996
LAGUNA GLORIA ART MUSEUM
Austin, Texas

January 28–March 17, 1996
EDWIN A. ULRICH MUSEUM OF ART
WICHITA STATE UNIVERSITY
Wichita, Kansas

April 14–June 2, 1996
MUSEUM OF ARTS AND SCIENCES
Macon, Georgia

September 15–November 3, 1996
FINE ARTS MUSEUM OF THE SOUTH
Mobile, Alabama

ISBN: 0-295-97405-2

LC number 94-61295

Cover: Jun Kaneko: *Plate,* 1971. Cat. 53

Printed in Hong Kong

CONTENTS

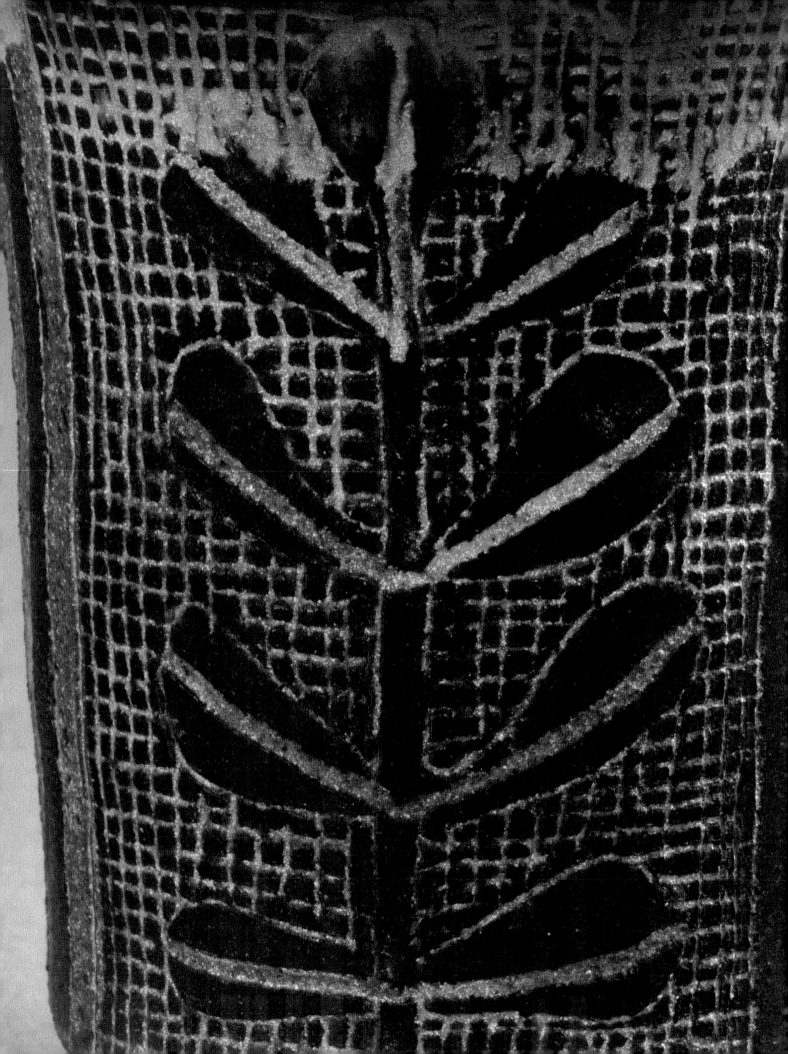

PRESIDENT'S FOREWORD

Ellen Browning Scripps, the founder of Scripps College, believed that the goal of education is to develop "the ability to think clearly and independently and the ability to live confidently, courageously and hopefully." Throughout her own career as a publisher, entrepreneur and philanthropist, she demonstrated those qualities of mind and spirit. Late in life, she created a college dedicated to teaching women to develop their own talents and abilities. Following her philosophy, Scripps's first President, Dr. Ernest L. Jaqua, and the trustees recognized the importance of the visual arts in fostering independent and creative thinking and fulfilling lives. Studio art, taught in the context of the liberal arts, has long been a key element of the Scripps curriculum.

In 1932, the founder of the art department, Morgan Padelford, was succeeded by Millard Sheets, who, during the next twenty years, brought leading artists—ceramists William Manker and Richard Petterson, sculptor Albert Stewart, designer Jean Ames, painters Henry Lee McFee and Phil Dike, and weaver Marion Stewart—to teach art at Scripps. That Sheets's first appointment was in ceramics indicates the important place ceramics has always held in the constellation of arts at Scripps. Manker's and Petterson's successor, Paul Soldner—who retired in 1991, after a thirty-six year teaching career—expanded the clay program so that it became internationally recognized as one of the finest of its kind in the country. Soldner also brought increased attention to the Ceramics Annual Exhibition, which he made national in scope and contemporary in emphasis. Now in its fifty-first year, the Annual is distinguished as the oldest continuous ceramic annual in the United States.

Paul Soldner's leadership in ceramics and his friendship with the Marers played a key role in attracting the extraordinary Marer Collection of Contemporary Ceramics to Scripps. This renowned collection, which is highly regarded by artists and scholars alike, is used to enhance the

teaching of ceramics at Scripps. Each year ceramics classes at Scripps and Pomona Colleges, as well as many visiting school groups and researchers, study aspects of this vast collection of more than 900 works. In addition, each year many pieces from the Marer Collection are requested for loans to exhibitions throughout the country. Portions of the collection have also been shown at Scripps during the past ten years, but the last time the collection was seen in depth was in 1984 in the exhibition "Earth and Fire." The current exhibition and fully illustrated catalogue celebrate the recent gift of the Marer Collection to Scripps and its first showing in the new Ruth Chandler Williamson Gallery. Through the generosity of Fred and Estelle Marer, students at Scripps, as well as the public, will learn about the history of clay art in our time for years to come. We thank them for this rare and special gift.

NANCY Y. BEKAVAC
President
Scripps College

8

PREFACE

THE OCCASION FOR THIS EXHIBITION AND CATALOGUE, *Revolution in Clay: The Marer Collection of Contemporary Ceramics,* is the remarkable gift of the Marer Collection of Contemporary Ceramics to Scripps College. This donation is extraordinary in many ways. On the one hand, the scope of the collection is both immense and international: it includes nearly 900 works by American, British, Chinese, Korean, and Japanese artists. On the other hand, the collection's core is focused on West Coast ceramics, especially the work of "the Otis group" who, in the mid 1950s, challenged ceramists' tradition-bound attitudes. The work of several artists in this group are represented in great depth. For example, there are fifty-one pieces by Peter Voulkos, forty-seven by Michael Frimkess (some of which are collaborative works made with his wife, Magdalena), twenty-three by John Mason, twenty-two by Jerry Rothman, sixteen by Paul Soldner, and twenty-nine by Henry Takemoto. No other collection offers such an intensely focused look at the turning point in the history of contemporary ceramics when these artists and their colleagues broke the boundaries of functional ceramics to claim a freedom of expression long enjoyed by painters and sculptors. The works from this period were not acquired years after the fact, but at the time they were made, and by a collector who knew the artists personally. Consequently, these pieces offer unparalleled documentation and special insight into the creative development of that period.

Another extraordinary fact is that this collection was assembled not by an industrialist of vast wealth, but by a man of modest means. As a mathematics professor at Los Angeles City College, Fred Marer never had substantial resources, but he nevertheless assembled a huge and impressive collection. What he lacked in funds he made up for in engagement with artists. Because his budget was limited, he most often bought works directly from the artists. There is evidence of his discerning eye in the large number of emerging artists he identified who later became major talents.

By his own account, Fred Marer began collecting in the early 1950s,

Fred Marer, c. 1956

when he acquired a piece by one of the leading ceramists in Southern California, Laura Andreson. This purchase peaked his interest in clay and encouraged him to look further. Curiosity led him to a faculty exhibition at the Los Angeles County Art Institute (later Otis Art Institute), where he saw the work of a talented young artist, Peter Voulkos. Marer began visiting the studio where Voulkos and a dynamic group of young artists were producing new and unfamiliar works that challenged traditional notions of ceramics. Marer queried them about their art and, in the process, became their friend and patron. He served an important role for these artists because he purchased their works early in their careers when many of them needed support the most. Marer has assisted not only the Otis group but also many later artists who were struggling at the beginning of their careers.

Eventually, Marer's collection grew so large that it took over his small house and garage on Kenmore Street in Los Angeles. As Suzanne Muchnic, *Los Angeles Times* critic, wrote, "His wife, Mary, who died about 15 years ago, had only a closet and a kitchen to call her own. Meanwhile, the collection assumed mythic proportions as potters traded stories about threading through aisles between the ceramics when they visited Marer." Marer claims that he never had an acquisition plan: "I bought things because I liked them." He also acknowledges that he has been more interested in artists than in periods or styles. As he explains, "When I acquire, I don't look for types of work, but the work I like. I respond to each work individually." Although many of the young artists he collected became famous, fame was never a requirement for him. Indeed, his collection contains many works by lesser-known and anonymous artists, whose works he bought because they appealed to him.

Marer doesn't point to any compelling motivation to collect ceramics, but he does admit that, "When I was a child, I used to go to the library to get books before they were put on the shelves. I got works from [the Otis group] from their studio, often before they were exhibited." Indeed, several artists remember Marer buying their pieces as soon as they came out of the kiln. During the last thirty years, Marer has expanded his collection greatly, but he still primarily acquires works directly from artists. When Marer travelled to Europe and the Far East in the 1970s and 1980s, he most often met artists through other artists whose works he had collected. Following the death in 1977 of his first wife, Mary, in 1978 Marer travelled to Japan, where Jun Kaneko introduced him to Japanese artists. In the early 1980s Marer made several trips to Europe with his second wife, Estelle, who has enthusiastically supported his collecting. In England Michael Cardew helped them meet artists, and in Italy Betty Woodman was their guide.

It was through Paul Soldner that the Marers developed a connection with Scripps. Soldner, who came to Scripps after graduating from Otis, built the Scripps ceramic program into a major center for the study of clay and organized the annual ceramic exhibition for thirty-three years, until he retired in 1991. Although Soldner is self-effacing about his role in helping to bring the Marer Collection to Scripps, his leadership was clearly one of the reasons Marer decided to make this generous gift to the college.

With the assistance of Soldner and Douglas Humble, an artist who has also been Marer's long-time curator, sections of the collection have come to Scripps through long-term loans and donations. In 1993, the Marers gave the core of the collection, which focuses on the Otis group, to Scripps.

This exhibition and its accompanying catalogue highlight only a portion of the works in this immense collection. Our goal in assembling them has been to examine the ways in which ceramics have been transformed during the last fifty years by certain artists who have seen expanded expressive possibilities for art in clay. The operative word here is art, for many of the works in this exhibition, while well crafted, are not delimited by the notion of "craft," a term that has been used by some critics to make clay into a minor medium. For the artists in this exhibition, and for Fred Marer who collected their works, clay is simply another medium, one that should be seen on equal footing with other artistic disciplines.

In order to survey the last half century of ceramics, as seen through the Marer Collection, the project has been divided into three sections: "The Studio Pottery Tradition, 1940–1970"; "Innovation in Clay: The Otis Era, 1954–1960"; and "Contemporary Ceramics in the Marer Collection, 1960–1990." In the first section, Kay Koeninger looks at the ways in which artists working within the craft tradition asserted the unity of designer and maker and opened their art to influences from other cultures. In the second section, Mary Davis MacNaughton examines the brief but important period during the mid 1950s when Peter Voulkos and his students at the Otis Art Institute cross-fertilized ideas in contemporary art with eastern philosophy to break down the barriers between craft and art to create new sculptural expressions in clay. Finally, in the third section, Martha Drexler Lynn explores the many stylistic avenues that this new freedom opened to artists from the 1960s to the 1990s.

As large as it is, however, the Marer Collection does not give a comprehensive view of all the historic changes in ceramic art of the last fifty years. For example, the collection does not emphasize the Funk movement that became popular in the 1960s and 1970s. Although a few of the works of Robert Arneson, one of Funk's leading practitioners, are in the collection, they are early expressionist pieces, not the later Pop-inspired works for which he is better known. Yet no other private collection can offer as detailed a look at the art of Jun Kaneko, who is represented by fifty-one pieces spanning his career. Clearly, the Marer Collection reflects the personal and idiosyncratic view of its collector. Yet, the collection is remarkably wide-ranging and contains works of many different sensibilities and cultures. Fred Marer's embrace of such a variety of artistic expressions, which his collection so amply documents, helps us expand our own ideas of what art in clay can be. It is this expansive vision that we celebrate.

MARY DAVIS MACNAUGHTON
Director
Ruth Chandler Williamson Gallery

ACKNOWLEDGMENTS

Oﾠrganizing this exhibition has been a pleasurable project because we have had the assistance and goodwill of many people at every stage of our work. We are indebted first of all to Fred and Estelle Marer for the gift of their collection of contemporary ceramics, which richly chronicles a half-century of art in clay. We are extremely grateful to the Marers not only for their generous gift of art but also for their generous gift of time. I thank them for patiently answering my questions, as well as the queries from other writers in the catalogue. The exhibition and catalogue would not have been possible without the encouragement of President Nancy Y. Bekavac, who has supported this endeavor from the beginning. The members of our board of trustees, who are interested in exhibitions that focus on Scripps College's permanent collections, also deserve our thanks. We are especially grateful to one trustee, Victoria Andrew Williamson, and the members of the gallery advisory committee, for their counsel. Financial support, which has enabled us to produce the exhibition and catalogue, comes from Scripps College through the bequest of Jean Ames, the Fine Arts Foundation of Scripps College, and the National Endowment for the Arts, a federal agency.

In the initial phase of this project, Marjorie Harth, Director of the Galleries of the Claremont Colleges, helped structure the exhibition and write grant materials. Under her leadership, in 1984 the Galleries staff organized an earlier exhibition of the Marer Collection entitled "Earth and Fire." Marjorie Harth and Kay Koeninger, former Curator of Collections, also secured grants for special storage for the Marer Collection, and the resulting structures have protected the collection during three significant earthquakes. I am also grateful to Douglas Humble, the Marers' curator, who has facilitated our efforts in many ways. The exhibition was guided in its early stages by the advice of Steve Comba, Registrar, and Gary Keith, Manager for the Galleries of the Claremont Colleges, who have worked closely with the collection and know its

many facets. I appreciate their efforts as well as those of Kirk Delman, Registrar for the Ruth Chandler Williamson Gallery, who has coordinated photography of the work and has supervised the many details of insurance and shipping. The design of the exhibition has also been in his talented hands. I value his creative solutions to difficult problems and his calm professionalism. I am also grateful to Paula Molter, who took charge of the huge task of typing catalogue copy and who efficiently and cheerfully kept the project on track.

We would like to acknowledge the letters of support for this project written by Karen Tsujimoto, Patrick Ela, Michael McTwigan, and Gerry Williams. The exhibition's two-year tour has been expertly organized by David Smith, President of Smith Kramer Fine Arts Services. We are also grateful to Audrey Powell and Michael Otto of Smith Kramer for arranging the complexities of safely crating and shipping the works. We appreciate the participation of all the museums on the tour.

Special thanks go to the writers in the catalogue. Kay Koeninger, former Curator of Collections and now Director, Denison University Gallery, Granville, Ohio, is thoroughly familiar with the Marer Collection through cataloguing its vast holdings. She has organized earlier exhibitions from the Marer Collection, including *Earth and Fire* in 1984. Thus, she was a natural choice to write the essay on the first section of the exhibition on the studio pottery tradition. Martha Drexler Lynn, Associate Curator of Decorative Arts at the Los Angeles County Museum of Art, who has organized many exhibitions of contemporary ceramics, brings an extensive knowledge of this field to her writing. I appreciate her engaging essay as well as her valuable advice and thought-provoking questions at various stages of this project. For access to oral histories, which I drew on for my own essay on the Otis era in clay, I am indebted to Paul Karlstrom, West Coast Regional Director, and Barbara Bishop, Research Center Manager, at the Archives of American Art, Smithsonian Institution. For making other oral histories available to me, I would also like to thank Dale E. Trevelen, Director of the Oral History Program, University Research Library at University of California, Los Angeles. For help in obtaining photographs, thanks go to Rudy Autio, Sam Jornlin, Marilyn Levine, Anne Scott Plummer, Rob Sidner, Henry Takemoto, David Van Gilder, and Betty Woodman. A special acknowledgment is due David Van Gilder for help in dating Beatrice Wood's work. Ann Scott Messana, Director of Alumni Relations at Otis School of Art and Design, patiently answered many of my questions regarding the records of classes taught at Otis. Most important, I convey my gratitude to the artists who shared their ideas and memories with me: Carol Radcliffe Fisher, Janice Roosevelt Gerard, Martha Longenecker, John Mason, Mac McClain, Ken Price, Jerry Rothman, Paul Soldner, Henry Takemoto, and Peter Voulkos. This project would not have been possible without the special help of Paul Soldner, who gave generously of his time and supplied me with many photographs and slides from the Otis era.

The catalogue was realized through the assistance of several of my students, who have contributed countless hours of work. Thanks go to Ella Howard, Jennifer Iaconetti, and Cynthia Lewis for their thorough

research on individual artists and their insightful wall texts in the exhibition. The daunting task of assembling a checklist of more than 900 objects was completed by Ella Howard, Sarah Jenny, Cynthia Lewis, Paula Molter, and Wendy Petty. Cynthia also wrote the useful glossary and met the heavy demands of deadlines with grace under pressure. Crucial assistance also came from Juliette Heinze and Rachel Latta, who compiled the extensive bibliography.

The catalogue for the exhibition has been entrusted to the talented staff of Perpetua Press, Los Angeles. For the extraordinary design of the catalogue, I convey my gratitude to Dana Levy, and for the sensitive editing of text, I give my heartfelt thanks to Tish O'Connor. She has provided not only scrupulous attention to detail, but also valuable criticism of content in the texts. In the face of time pressures, she and Dana carefully guided the book through the complexities of its production.

Organizing the publicity for the exhibition has been the responsibility of Andrea Jarrell, Director of Public Relations and Communications, who has, with her customary professionalism and enthusiasm, helped bring the project to the public's attention. To her, and to Linda Davis Taylor, Vice President of Development, I owe special thanks for coordinating related exhibition events. Finally, I thank my husband, Sperry, and my children, Amanda and Matthew, for their love and support.

MARY DAVIS MACNAUGHTON
Director
Ruth Chandler Williamson Gallery

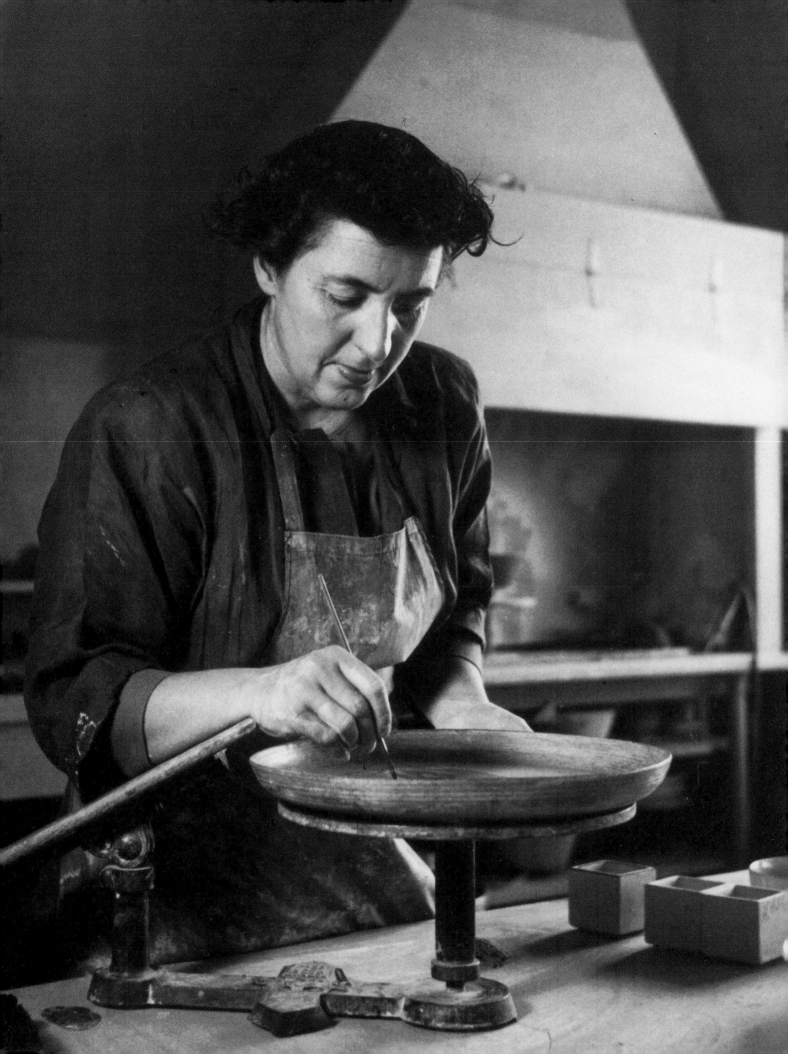

The Studio Pottery Tradition, 1940–1970

Kay Koeninger

THE MARER COLLECTION has been justly celebrated for its documentation of ceramics produced at the Otis Art Institute in Los Angeles when Peter Voulkos headed its ceramics department, 1954–1957. Ceramics historians often refer to this period as the beginning of the first true school of American ceramics. Garth Clark attributes this new beginning to discovering the "American" qualities in American art: "The 1950s was the decade of liberation. The American potter finally cut loose the shackles that had bound him for so long to the manners and values of European art and design."[1] American art criticism has often been characterized by the search for such qualities in its native art.[2] This criteria has been over-applied to art in the United States in the 1950s, especially abstract expressionism, and, by extension, the ceramics of the Otis school.

The achievement of the Otis school was crucial to developing American ceramics; however, the Marer Collection places these works within an international context (including both Asia and Europe) as well as within the earlier tradition of studio ceramics in California. From this perspective, the Otis school can be seen as a more complex example of artistic innovation, rather than as completely ahistorical and revolutionary. This view is well documented by ceramics not related to the Otis school in the Marer Collection. The first pot purchased by Fred Marer was not produced at Otis; it was a striped bowl by Laura Andreson (cat. 2), a leading California studio potter.[3] Although his soft-spoken manner belies his vast knowledge, Fred Marer is a collector who knows the history of American ceramics. In his introduction to the 1984 exhibition catalogue of his collection, he revealed that he viewed the Otis school within an established tradition:

> Some have the impression that Voulkos and company came upon immaculate clay when they descended upon Los Angeles in 1954. In fact, Laura Andreson had been at UCLA as early as 1933, Glen Lukens had

Laura Andreson decorating a plate.
Photograph by Imogene Cunningham.

been in Los Angeles since 1939, Marguerite Wildenhain was active at California College of Arts and Crafts in 1940 and had established Pond Farm in 1942, the Heinos had come to USC in 1952, Tony Prieto was working at Mills....So the clay had undergone some tilling when Voulkos arrived at his basement quarters at Otis.[4]

This "tilling," illustrated by works from the Marer Collection, is the subject of this essay.

Studio ceramics in California begin in the rich regional variant of the Arts and Crafts movement which flourished throughout the state during the period 1870–1920 and encompassed all areas of design, including pottery.[5] The terms "studio ceramics" and "studio pottery" are drawn directly from the arts and crafts tradition, used to differentiate these ceramics from the inferior, mass-manufactured, and poorly designed ceramics that were produced after the mechanization of the Industrial Revolution in the nineteenth century. They also affirm the importance of individual style and the status of pottery as a legitimate artistic expression. The Arts and Crafts movement in the United States had its roots in the ideas of English writers William Morris, John Ruskin, and others, who reacted to the decline of design and craftsmanship brought on by the Industrial Revolution as well as to the culturally limiting division between the fine and the applied (or decorative) arts. Many so-called art potteries, which emphasized the importance of orignal design, fine craftsmanship, and the unity of maker and designer, even though some of them relied upon techniques of mass production, were established in California. These potteries initiated the important studio ceramics tradition in California, a phenomenon supported in part by such factors as a mild climate and the diversity and availability of different clays, as well as a prosperous and knowledgeable middle class who purchased their output.[6] Some of these potteries included Roblin Art Pottery, San Francisco (1898–1906); Stockton Art Pottery, Stockton (1896–1900); Rhead Pottery, Santa Barbara (1913–1917); and California Faience, Berkeley (1924–c. 1930). They made a wide variety of both cast and thrown ceramics that were often individually decorated. Other firms, such as the several companies (1909–1932) directed by Ernest A. Batchelder in Pasadena and later in Los Angeles, concentrated on ceramics for architectural purposes.[7]

Many art potteries in California closed because of changes in taste in the 1920s and the harsh economic climate in the 1930s. The ideals of Arts and Crafts pottery were, however, kept alive in schools such as the California College of Arts and Crafts in Oakland, originally founded in 1907 as the California School of Arts and Crafts in Berkeley by the designer-educator Frederick H. Meyer. Meyer was active in the Guild of Arts and Crafts of Northern California, a regional organization spawned by the Arts and Crafts movement. Although pottery was later taught in universities, it was usually at an introductory level without instruction at the wheel.[8] The first university programs in ceramics in California were initiated by Glen Lukens at Fullerton Junior College in the late 1920s, which he later continued at the University of Southern California; by William

Manker at Scripps College in 1934; and by Olive Newcomb at UCLA in the early 1930s.[9] In the 1940s studio ceramics expanded in the state, and talented potters from other parts of the United States, as well as foreign artists, moved to California in the wake of World War II. Many works in the Marer Collection document this unfolding.

Laura Andreson, born 1902 in San Bernardino, was educated at UCLA (where she first studied ceramics) and Columbia. She began teaching ceramics classes at UCLA in 1936 (she had been teaching at UCLA since 1933, in a wide range of other media). These classes were known for the instruction Andreson offered in glaze technology and experimentation. She originally worked in low-fire earthenware, as in her slip-cast *Teapot*, 1944 (cat. 1), with matte glaze over dark engobes. Her work was slip-cast or formed by coil or slab construction until she learned to throw with Los Angeles potter Gertrud Natzler in 1944. After 1948 she concentrated on high-fire stoneware and often experimented with matte glazes.[10]

Her matte-glazed stoneware *Bowl*, 1954 (cat. 2), was the first ceramic that Fred Marer purchased. It was bought in 1954–5 through Pauline Blank, Andreson's longtime companion and business partner, who, like Fred, was on the faculty at Los Angeles City College. According to Marer, Blank acted as the artist's agent and often sold Andreson's work to the LACC faculty during this period.[11] The bowl is an important example of her work from this time, the glaze producing "surfaces like glazed and polished stones."[12] The simple forms of both this bowl and the earlier teapot indicate Andreson's interest in Scandinavian design. The use of narrow, vertical stripes to enhance the bowl's shape demonstrates her knowlege of Japanese ceramics, specifically of Tamba stoneware, a Japanese folk pottery known for its simple shapes and similarly placed, painted vertical stripes.[13] After 1957 Andreson concentrated on producing porcelain, the most delicate and translucent ceramic form. These porcelains were enhanced by her formulations of crystalline, ash-reduction, and lustre glazes.[14] Marer did not collect these porcelains because Andreson's reputation had grown to the extent that he could not afford her later works.[15]

Vivika (born 1909) and Otto Heino (born 1915) moved to Los Angeles in 1952 from New Hampshire, where Vivika was Otto's teacher at the League of New Hampshire Arts and Crafts and where they ran their own pottery. The League of New Hampshire Arts and Crafts, started in 1931, was the first state-supported craft program in the United States, offering both sales outlets and instruction (in 1968 it was renamed the League of New Hampshire Craftsmen). In Los Angeles, the Heinos established a studio on Hoover Street, and Vivika began teaching at USC under Glen Lukens, her old teacher. After studying with Lukens, Vivika Heino had earned an M.A. in ceramics at Alfred University (the site of the oldest university ceramics program in the United States, founded in 1900) in 1944. Otto Heino had become interested in studio pottery when, while he was stationed in England during World War II, he visited Bernard Leach's pottery, as well as small studio potteries in France and England.[16] He returned to the United States and studied ceramics under

the GI bill at the League of New Hampshire Arts and Crafts. World War II had a profound effect on American art education in the 1950s, because of the double influences of foreign travel and the GI bill; Otto Heino is one of many artists molded by this particular history.

In the organization of their artistic life, the Heinos' inspiration was the one- to two-person, small-scale cooperative European pottery. Their pottery was their main source of income, even though both were teaching at USC from 1952 to 1953 and at the Chouinard Art Institute from 1955 to 1963. As teachers, the Heinos used the apprenticeship model and emphasized the need for their students to exhibit and to sell their work. Even though their teaching method was more formal than Peter Voulkos's at Otis, there was constant interchange between them, with students visiting the other's classes.[17] When their studio was overtaken by urban renewal, the Heinos moved back to the East Coast, where Vivika taught at the Rhode Island School of Design from 1963 to 1965, and both Heinos operated a studio in Hopkinton, New Hampshire, from 1965 to 1973. Returning to Southern California in 1973, they purchased their friend and fellow ceramist Beatrice Wood's home and studio in Ojai, an artists' colony, and continue to work there today.

Their pottery, as exemplified in *Lidded Container*, a stoneware pot, c. 1960 (cat. 7), is expertly thrown and classic in shape. Decoration is applied to accentuate, rather than to compete with, the shape of the vessel.[18] Throughout their career, the Heinos have produced ceramics in a variety of shapes and surface decoration, including architectural elements. All are closely tied to utilitarian forms and are marked by simplicity and understatement.[19]

Antonio Prieto (1912–1967) was born in Spain and moved with his family to Chico, California, in 1916. In 1940 he studied at the California School of Fine Arts in San Francisco and later attended Alfred University on the GI bill. He began teaching in 1946 at the California College of Arts and Crafts. In 1950 he accepted a teaching appointment at Mills College, Oakland, where he remained until his death. He was a friend of such leading ceramic figures as Bernard Leach, Shoji Hamada, and Kanjiro Kawai, and he often traveled to Spain. In his ceramics, he represents the internationalism of contemporary art in the twentieth century; many of the designs on his ceramics are clearly derived from European avant-garde art.[20]

Originally a painter, Prieto was more influenced by twentieth-century European abstract painting, specifically the surrealists, Joan Miró and Max Ernst, than by an Asian pottery aesthetic.[21] The shape of his small-mouthed stoneware *Bottle*, 1959–60 (cat. 13), is secondary to the sgrafitto design, which is further emphasized by the contrast between the incised surface decoration and the thickness of the glaze.

Marguerite Wildenhain (1896–1985) also emigrated to California from Europe. Unlike Prieto, she was representative of the utilitarian European craft tradition, specifically as espoused by the Bauhaus, which rejected the division between the arts and crafts that so troubled William Morris. Born in France, she studied ceramics at the Weimar Bauhaus under master potter Max Krehan and sculptor Gerhard Marcks from 1919 to 1926.[22]

After her studies at the Bauhaus, Wildenhain became head of the ceramics department of the Muncipal School for Arts and Crafts in Halle, Germany, and designed porcelain for the Royal Berlin porcelain factory. Hounded by the Nazis because she was Jewish, she lived in the Netherlands from 1933 to 1940, emigrating to Oakland in 1940. In 1942, she established her pottery at Pond Farm, Guerneville, California, and influenced generations of students who attended her summer workshops. Her teaching style was quite formal, based upon the master-apprentice relationship of the Bauhaus; her students were expected to work long hours at mastering the basics, including the wheel.[23] She also lectured and gave workshops throughout the United States, where she espoused ceramics not only as means of artistic expression but as a way of life: "For the artist-potter is like the priest: he has dedicated his life to something that is greater than he—to beauty, expression, art."[24]

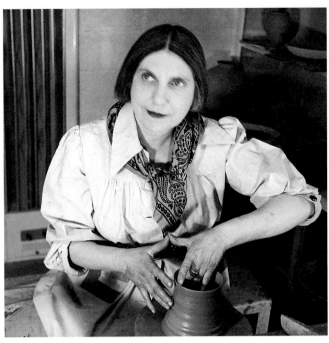

Beatrice Wood in her studio in Ojai, California, 1951. Photograph by Jack Case

Utilitarianism is central to Wildenhain's aesthetic. Her emphasis on form rather than color, evident in *Bowl*, 1954, was an attitude she learned from her teacher Gerhard Marcks. Both of these aspects are directly related to her Bauhaus training, as well as her interest in native ceramics of North and South America, which she studied and collected.[25] A rich variety is present in her work because she uses a wide range of forms and surface treatments. Her stoneware *Vase*, 1954 (cat. 16), balances a green glaze with crosshatching. Its leaf designs are typical, as botanical drawings are often found in her pottery.[26] Wildenhain's interpretation of natural color and motif characterizes her work. In the words of Richard Petterson, who succeeded William Manker as head of the ceramics program at Scripps College in 1947,

> ...everything she did was an object lesson in the integration of pottery with Nature: her clay bodies infused with her glazes to become one; her colors, textures and decorations were object lessons in the beauties to be found also in Nature, delights to eye and hand alike.[27]

Beatrice Wood (born 1893) was associated, through her friendship with Marcel Duchamp, with avant-garde art in New York and Los Angeles and became one of the first avant-garde figures in ceramics.[28] Born into a wealthy San Francisco family who moved to France when she was a child, Wood performed with the Comédie Française in Paris before World War I. She was then associated with the French Repertory Theater in New York after she returned to the United States in 1914. Wood's interest in ceramics began in 1933 when she purchased six lustreware plates in a Dutch antique shop. She studied in Los Angeles with Glen Lukens at USC and with Gertrud and Otto Natzler. Later, she studied with the Heinos in Los Angeles.[29] She was a member of the artistic circle around Walter and Louise Arensberg, wealthy collectors of art by Duchamp and other avant-garde figures, who lived in Hollywood from 1921 to 1954.[30]

Her earthenware vase of 1955 (cat. 17) documents her post-1950 experimentation with lustre glazes. It is clearly a vessel shape, but the

spontaneous, vague, and dreamlike drawing on its sides emphasizes the artist's personal expression rather than any functionalism. The costumed figure that adorns this vase recalls Wood's stage experience.[31] This theatrical element is intensified by the lustre glaze with its reflected distortion of light and color. Working as a conceptual artist, Wood often takes elements from everyday life and places them in a new and unexpected context. In the example of this vase, she has taken lustre glaze, which is more often associated with amateur china painting, and transformed it through her nontraditional application.[32]

The above works in the Marer Collection reflect the influence of European art, both avant-garde painting and utilitarian craftsmanship, on ceramics in California. Other ceramics that Fred Marer collected reveal his interests in English and Japanese pottery. Marer traveled to Japan in 1977 and visited England every year during the period 1978–85. He became acquainted with English potter Michael Cardew during one of these trips.[33]

Bernard Leach (1887–1979), the most well-known twentieth-century English potter, was born in Hong Kong and spent a good part of his life in Japan. Inspired by the ideals of the Arts and Crafts movement, as well as the traditional pottery of Japan, his writing and teaching were highly influential, even though many of his admirers later rejected his strict adherence to utilitarianism in ceramics. In *A Potter's Book*, first published in 1940, Leach called for the joining of Western and Eastern sensibilities to produce pottery:

> It means the use so far as possible of natural materials in the endeavour to obtain the best quality of body and glaze; in throwing and in a striving towards unity, spontaneity, and simplicity of form, and in general the subordination of all attempts at technical cleverness to straightforward, unselfconscious workmanship.[34]

Leach's stoneware *Bottle*, 1956 (cat. 11), utilizes a traditional Japanese form, the square, small-mouthed bottle with rim. A similar bottle (cat. 9), by his close friend and associate, the Japanese potter Kanjiro Kawai (1890–1966), is in the same form and is similar in size as well. The spontaneous, calligraphic design recalls Leach's interest in Zen Buddhism, a spiritual discipline pervasive in Japan that is reflected in traditional pottery. The Zen aesthetic reveres irregularity, asymmetry, simplicity, and austerity in design. In contrast to Western artists, the Japanese traditional potter is more accepting of random and unexplained results produced by the interaction of artist, clay, and kiln. *Bottle*, 1956 (cat. 8) by Toyo Kaneshige (1894–1978), is irregular and nonsymmetrical in shape, with a pitted surface and random coloration caused by salt glazing. Pristine finishes and shapes are rejected, as they interfere with the natural, unrestrained expression of the potter. These elements are evident in examples of Japanese folk pottery in the Marer Collection. The *Lidded Container* (cat. 18) in Shigaraki ware has an imprecisely scored and unfinished surface, showing the original texture of the clay; in the Bizen ware *Vase* (cat. 19), the shape and salt glaze markings are even more irregular than in the Kaneshige bottle.[35]

Leach was an apprentice and associate of the ceramist and Living National Treasure Shoji Hamada (1894–1978), whose pottery in Mashiko

was the inspiration for revitalizing traditional Japanese stoneware. Hamada, along with Kawai and the philosopher Soetsu Yanagi, founded the Mingei movement in Japan in the late 1920s to promote and revitalize traditional Japanese crafts, which had almost disappeared during Japan's rapid industrialization following the Meiji restoration in the early twentieth century. For Barbara Stone Perry, "Hamada's work reveals the spirit of Mingei pottery. It is direct, unself-conscious, informal, and simple...he inspired ceramists from both the functionalist and expressionist camps."[36] Hamada's *Bottle*, c. 1967 (cat. 6), in the Marer Collection is symmetrical and traditional in form; the spontaneous, calligraphic decoration abstractly suggests plant forms. This combination is also seen in Kawai's stoneware bottle (cat. 9). Here the contrast is more extreme, in that the square, small-mouthed bottle is strikingly geometric, while the calligraphic design covers more surface area and is purely abstract. Later in his career, Kawai focused on molded, relief-covered vessels, like *Vase*, c. 1960 (cat. 10). Leach, Hamada, and Kawai shared many common concerns in their articulation of the role of the potter in the twentieth century, although they were trained in different cultural perspectives.

Bernard Leach gave a highly successful lecture tour in the United States in 1949. He returned with Hamada and Yanagi in 1952, again drawing large crowds, especially in Los Angeles where their tour included a stop at Scripps College. West Coast potters were particularly interested in Japanese pottery aesthetics, a relationship that will be discussed further in this catalogue regarding the Otis ceramists.

Interest in Japanese ceramics in the United States first began in the 1880s with use of Japanese surface design at the Rookwood pottery in Cincinnati and later at other potteries in Ohio. It was part of a wider Western fascination with the decorative aspects of Japanese art, often referred to as "Japonisme," because the first manifestation of this taste arose in France in the nineteenth century.[37] It passed from fashion during World War I, but a form of it reemerged in the 1950s as an alternative to the precise geometricism of Bauhaus and Scandinavian design that dominated United States ceramics in the 1930s and 1940s.[38] American potters in the 1950s were drawn to the unfinished qualities of Japanese folk pottery and the Zen aesthetic rather than to the refined decorative qualities exemplified in Japonisme.

Other important English studio potters in the Marer Collection include Michael Cardew (1900–1983) and William Staite Murray (1881–1961). Cardew, who was Leach's first student at his pottery at St. Ives, Cornwall, accepted Leach's ideal of fine craftsmanship but did not seem to be directly influenced by an Asian aesthetic. His work (cat. 3, 4) relates more to the traditions of English and European folk pottery with its symmetrical, utilitarian shapes and simple linear animal and plant motifs.[39] Some of Cardew's other works, not represented in the Marer Collection, show the influence of African design, because Cardew established several potteries in Nigeria in the 1940s and 1950s.[40] Originally trained as a painter and largely self-taught as a ceramist, Staite Murray rejected Leach's functionalism and emphasized the centrality of painting in his ceramics. His *Vase*, 1939 (cat. 12), recalls the directness and free

handling of Picasso's painting, as well as the informally applied dots and lines (although not the green glaze) of Japanese Oribe ware.[41]

Fred Marer also collected works by English potters who stood in direct opposition to the Asian spiritualism and communalism of Leach. The most important potters of this tradition represented in the Marer Collection are Lucie Rie (born 1902) and Hans Coper (1920–1981). Lucie Rie, born in Austria, was a student at the Vienna Kunstgewerbeschüle and produced ceramics for the Wiener Werkstätte. Even though Werkstätte ceramics were decorative and folkloric, Rie was drawn more to the geometric forms of Viennese architects such as Josef Hoffmann.[42]

During World War II Rie emigrated to England and established a pottery studio, where Hans Coper collaborated with her. Rie's ceramics stand firmly in the modernist tradition, through her use of pure, elementary abstract form. Michael Duras and Sarah Bodine assert that "we can view the work of Rie as small-scale architecture with all the formal complexity and definition of a Hoffman building."[43] Rie rejected functionalism and did not use her ceramics as canvases for painting; in her porcelain bowl of 1960 (cat. 14), the thin, sgrafitto lines are completely subservient to the form of the vessel. The pedestal base and flaring sides of this tightly thrown and nontraditional bowl, like much of Rie's work, also echo her interest in ancient Greek pottery.

Like Rie, Hans Coper came to England during World War II as a refugee from Nazism. Trained as an engineer in Germany, he was interested in painting and once considered becoming a sculptor. *Vase*, c. 1970 (cat. 5), recalls Cycladic and archaic Greek sculpture, influences that he often mentioned.[44] The vase, skillfully engineered from two thrown pieces, subtly evokes the human body. Its neutral colors—a matte white, and brown and gray random pitting and scrabbling—emphasize its sculptural qualities and also allude to ancient, universal forms. Like Rie, Coper is a major figure in modernist ceramics, who offered English and American potters an alternative to the Asian and rustic influences of the Leach school.[45] In the United States, Rie and Coper were represented in several important ceramics exhibitions, including a Smithsonian Traveling Exhibition Service show in 1959.

All these works reveal Fred Marer's deep understanding of the complexity of the history of modern ceramics. These examples illustrate that the studio pottery tradition contributed many elements that were crucial to the revolution in clay that occurred at Otis. These included the conviction that pottery was a fine art equal to painting and sculpture; the insistence upon the oneness of designer and maker; the recognition of the cooperative and communal nature of ceramic production; the freedom to discard functionalism and the openness to influences from other aspects of contemporary art as well as other cultures. Even though he was intimately involved with the Otis group, Fred Marer was well aware of the "tilling" that took place before and after those years, and it is well represented in his collection. According to his wish, the collection is widely used for teaching, and one of the most important lessons that it teaches is that artistic change must always be valued for its continuity as well as for its uniqueness.

NOTES:

1 Garth Clark, *American Ceramics: 1876 to the Present* (New York: Abbeville, 1987), 99.

2 Wanda Corn, "Coming of Age: Historical Scholarship in American Art," *Art Bulletin* LXX, no. 2 (June 1988): 192–3.

3 Fred Marer, phone conversation with author, 11 September 1993.

4 Fred Marer, "Reminiscences," *Earth and Fire: The Marer Collection of Contemporary Ceramics*, Kay Koeninger and Doug Humble, eds. (Claremont: Galleries of the Claremont Colleges, 1984), 11.

5 Kenneth R. Trapp, *The Arts and Crafts Movement in California: Living the Good Life* (New York: Abbeville, 1993).

6 Richard Guy Wilson, "Divine Excellence: The Arts and Crafts Life in California," in Trapp 1993, 13–33.

7 Hazel V. Bray, *The Potter's Art in California: 1885-1955* (Oakland, CA: Oakland Museum, 1980), 9–20.

8 Ibid. 23–24.

9 Ibid. 23–24.

10 Garth Clark and Margie Hughto, *A Century of Ceramics in the United States: 1878–1978* (New York: E.P. Dutton, 1979), 251.

11 Fred Marer, phone conversation with author, 11 September 1993.

12 Bernard Kester, "Introduction," *Laura Andreson: A Retrospective in Clay* (La Jolla, CA: Mingei International Museum, 1982), 9.

13 Barbara Stone Perry, *Fragile Blossoms, Enduring Earth: The Japanese Influence on American Ceramics* (Syracuse: Everson Museum of Art, 1989), 100.

14 Kester, 11.

15 Fred Marer, phone conversation with author, 11 September 1993.

16 Vivika and Otto Heino, interview by Elaine Levin, 4 March 1981, Archives of American Art, Smithsonian Institution.

17 Heino interview 1981, 56, 59–60.

18 Barbara Perry, ed., *American Ceramics: The Collection of Everson Museum of Art* (New York: Rizzoli, 1989), 257.

19 Susan Peterson and Gerald Nordland, *Art in Clay: 1950–1980 in Southern California* (Los Angeles: Los Angeles Municipal Art Gallery, 1984), 36.

20 Susan Peterson, "Antonio Prieto 1912–1967," *Craft Horizons* 27 (July 1967): 23.

21 Clark 1987, 292.

22 Marguerite Wildenhain, interview by Hazel Bray, 14 March 1982, Archives of American Art, Smithsonian Institution, 8.

23 Wildenhain, Bray interview 1982, 45.

24 Marguerite Wildenhain, *Pottery: Form and Expression* (Palo Alto: Pacific Books, 1973), 16.

25 Wildenhain, Bray interview 1982, 55.

26 Wildenhain 1973, plates 47–48.

27 Richard B. Petterson, 1979, quoted in Nancy Newmann Press, *Marguerite: A Retrospective Exhibition of the Work of Master Potter Marguerite Wildenhain* (Ithaca, NY: Herbert F. Johnson Museum, 1980), 25.

28 Clark 1987, 87.

29 Beatrice Wood, interview by Paul J. Karlstrom, 26 August 1976, Archives of American Art, Smithsonian Institution, 33.

30 See Naomi Sawelson-Gorse, "Hollywood Conversations: Duchamp and the Arensbergs," in Bonnie Clearwater, ed., *West Coast Duchamp* (Miami, FL: Grassfield Press, 1991), 24–45.

31 Wood, Karlstrom interview 1976, 4–5.

32 Clark 1987, 97.

33 Fred Marer, phone conversation with author, 11 September 1993, and 13 March 1994.

34 Bernard Leach, excerpt from *A Potter's Book*, in Carol Hogen, ed., *The Art of Bernard Leach* (New York: Watson Guptil, 1978), 33.

35 Kenneth R. Beittel, *Zen and the Art of Pottery* (New York: Weatherhill, 1989), 11.

36 Perry 1989, 44.

37 Kenneth R. Trapp, "Rookwood Pottery: The Glorious Gamble," in Anita J. Ellis, *Rookwood Pottery: The Glorious Gamble* (New York: Rizzoli, 1992), 11–17.

38 Perry 1989, 32.

39 William A. Ismay, "Kindred Pots: Michael Cardew," *Crafts* (July–August 1983): 38–44.

40 Garth Clark, *Michael Cardew: A Portrait* (Tokyo: Kodansha, 1976)

41 Tamara Préaud and Serge Gauthier, *Ceramics of the 20th Century* (New York: Rizzoli, 1982), 114; Perry 1989, 113.

42 Michael Dunas and Sarah Bodine, "In Search of Form: Hans Coper and Lucie Rie," *American Ceramics* 3, no. 4 (1985), 15.

43 Ibid., 20.

44 Alison Britton, "Hans Coper 1920–1981," *American Craft* (April/May 1984), 39.

45 Barley Roscoe in "A Commemoration by friends and colleagues for Hans Coper," *Crafts*, (January/February 1982), 34.

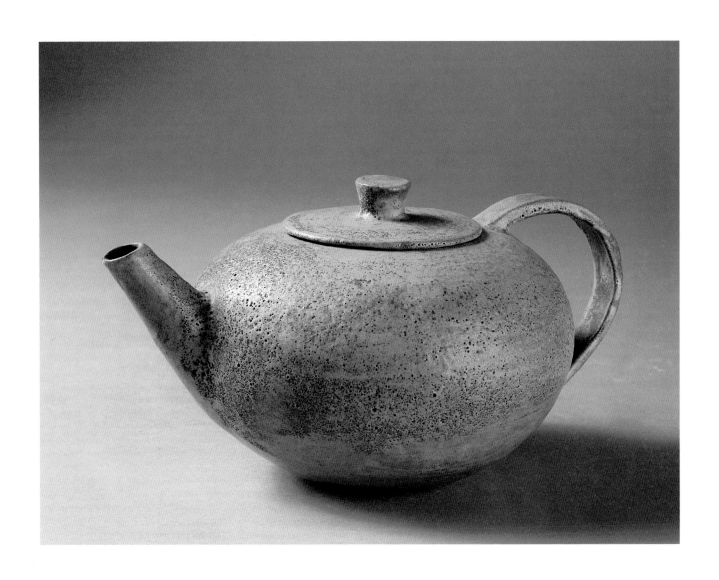

1
LAURA ANDRESON
Teapot, 1944
Earthenware, glazed
5 x 6½ x 9½
(L78.1.387)

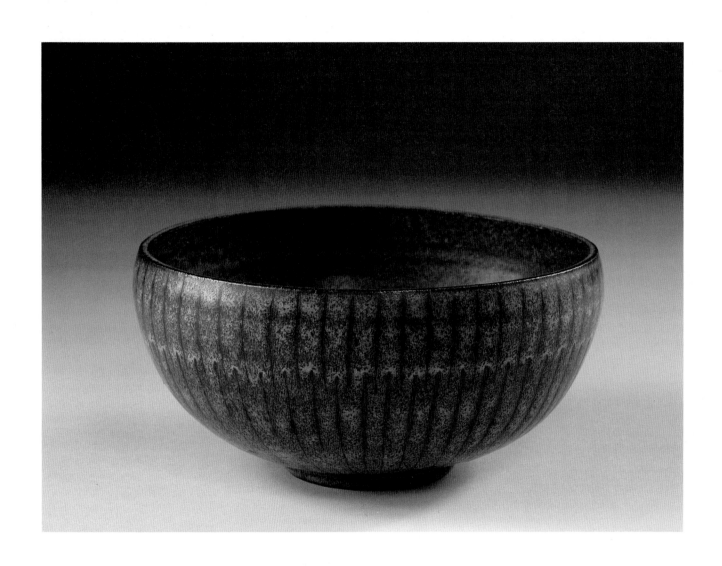

2
LAURA ANDRESON
Bowl, 1954
Stoneware, glazed
4¼ x 9 x 9
(78.1.166)

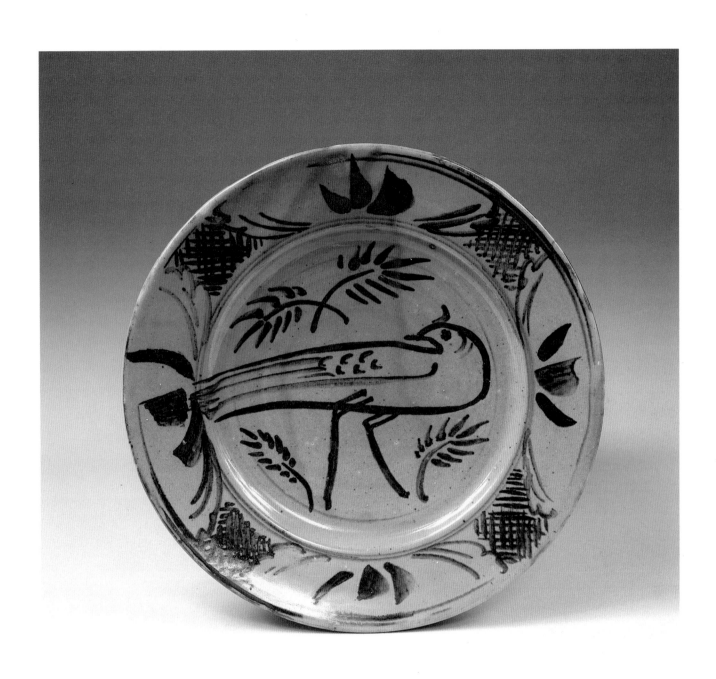

3

MICHAEL CARDEW

Plate, c. 1970
Stoneware, glazed
2 x 11¼ x 11¼
(L78.1.783)

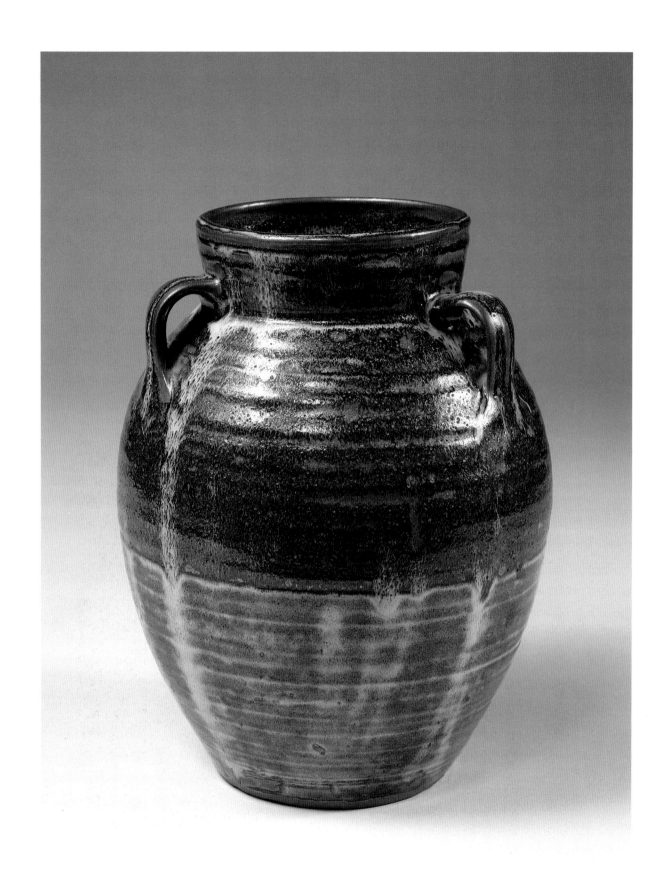

4

MICHAEL CARDEW

Handled Jar, c. 1970

Earthenware, glazed

12 ¼ x 8 ½ x 8 ½

(L78.1.543)

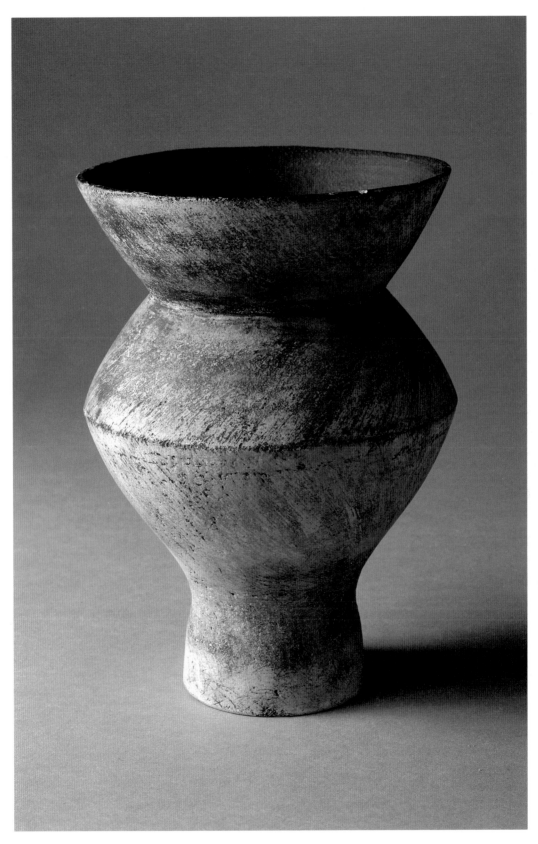

5
HANS COPER
Vase, c. 1970
Stoneware, glazed
9½ x 6½ x 6½
(L78.1.576)

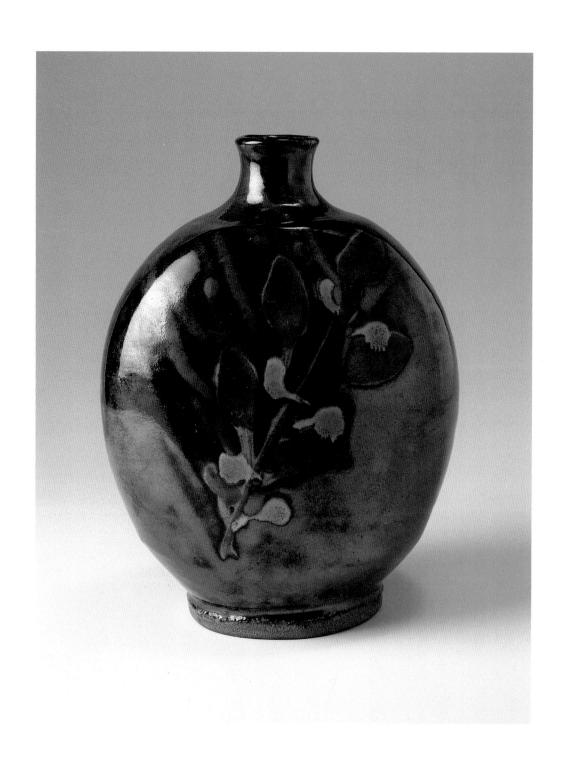

6
SHOJI HAMADA
Bottle, n.d.
Stoneware, glazed
9¼ x 7 x 5¾
(L78.1.417)

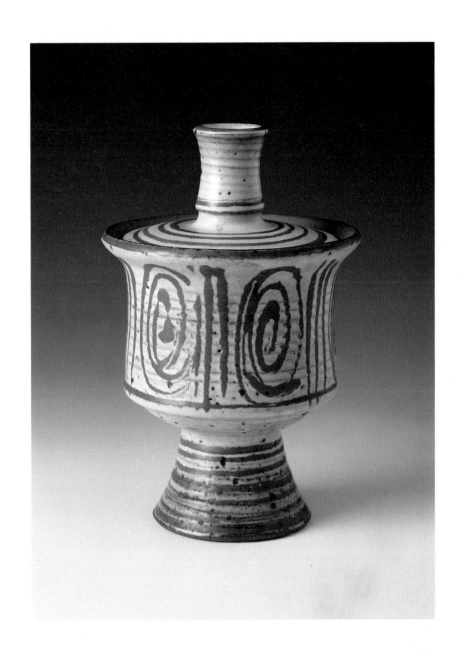

7

VIVIKA AND OTTO HEINO

Lidded Container, c. 1960

Stoneware, glazed

7½ x 5 x 5

(83.2.6 a,b)

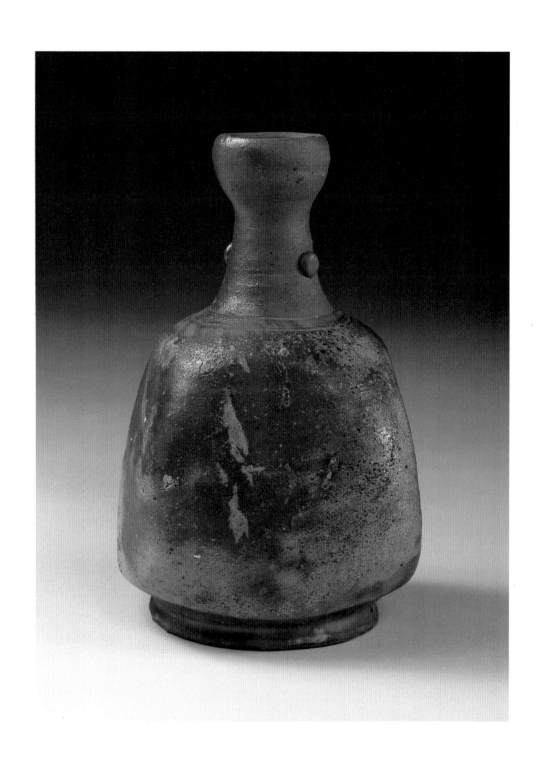

8
TOYO KANESHIGE
Bottle, 1956
Stoneware, salt glazed
8¼ x 4½ x 4½
(L78.1.260)

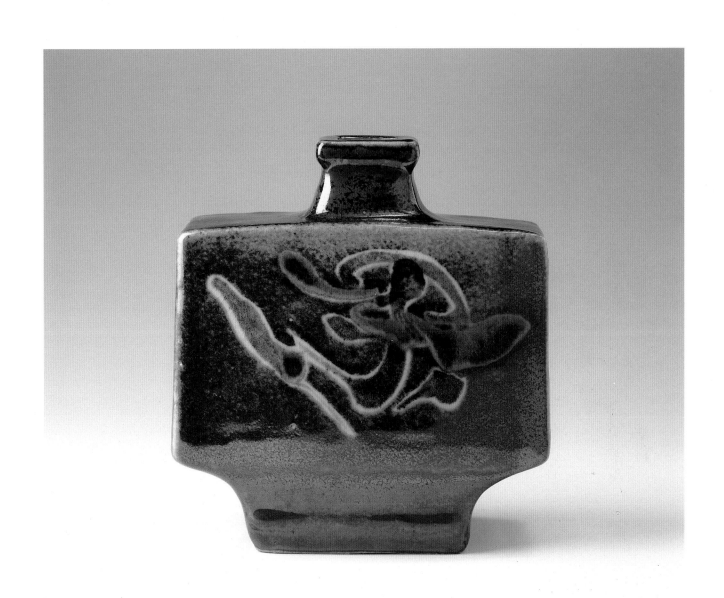

9
KANJIRO KAWAI
Bottle, c. 1950
Stoneware, glazed
8½ x 7½ x 3½
(L78.1.92)

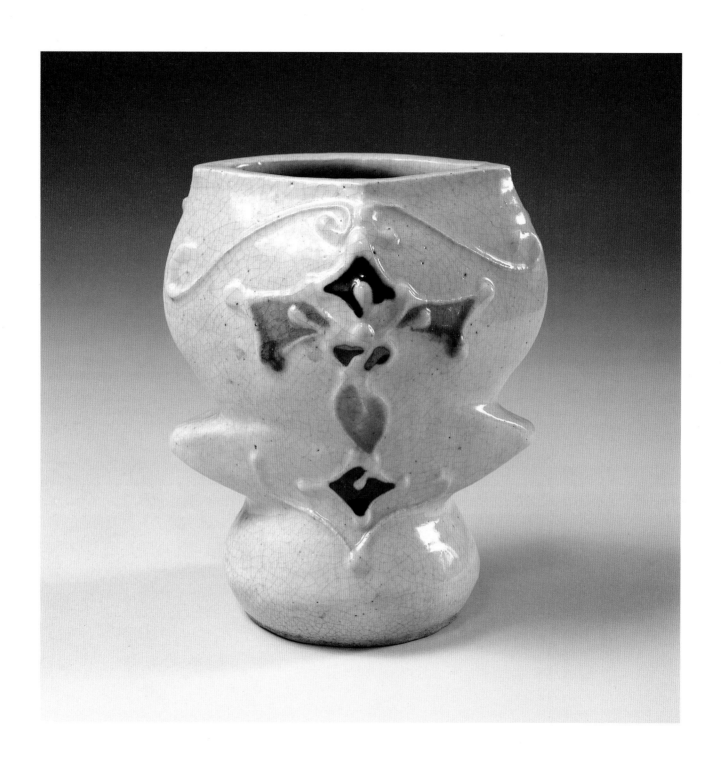

10
KANJIRO KAWAI
Vase, c. 1960
Stoneware, glazed
8¾ x 6¾ x 6
(L78.1.533)

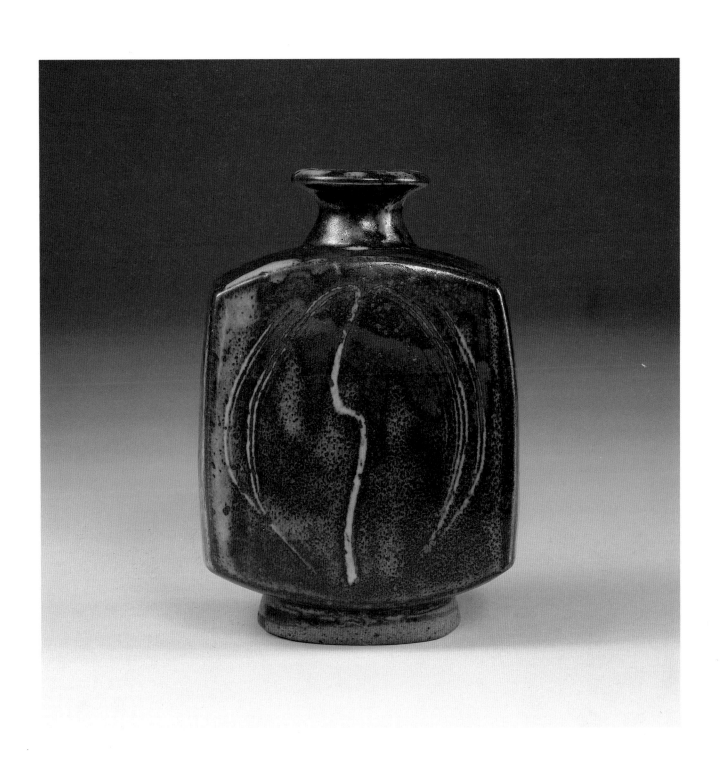

11
BERNARD LEACH
Bottle, 1956
Stoneware, glazed
8 x 5 x 3⅜
(L78.1.264)

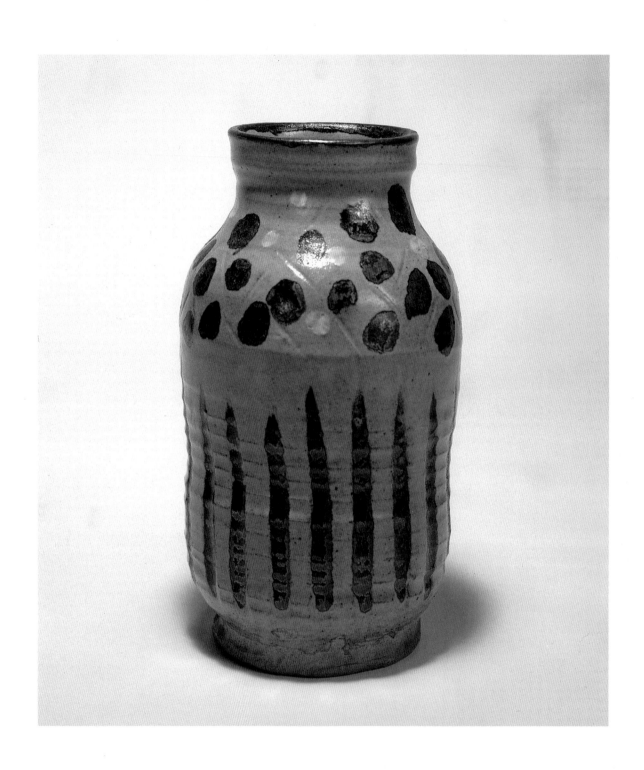

12
WILLIAM STAITE MURRAY
Vase, 1939
Stoneware, glazed
12½ x 7 x 7
(81.8.9)

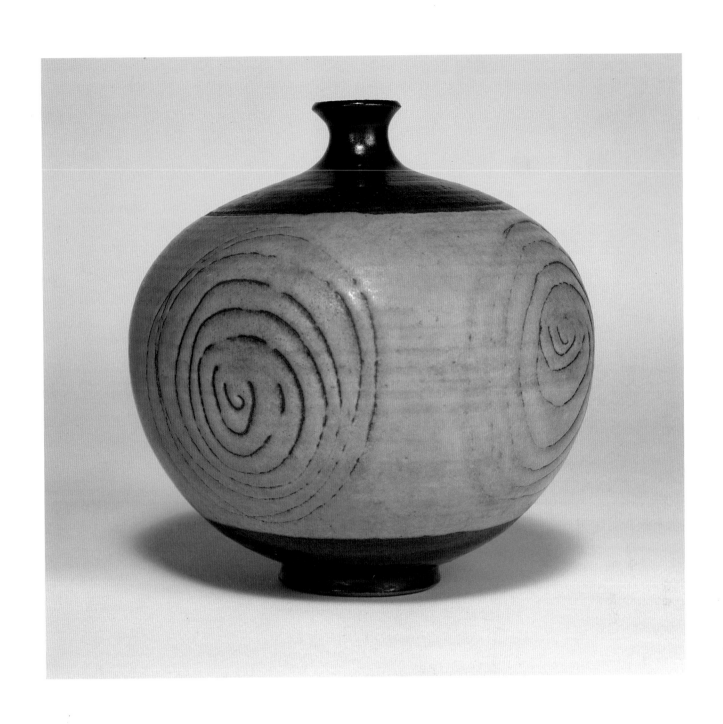

13
ANTONIO PRIETO
Bottle, 1959–60
Stoneware, glazed
8½ x 8¼ x 8¼
(81.8.10)

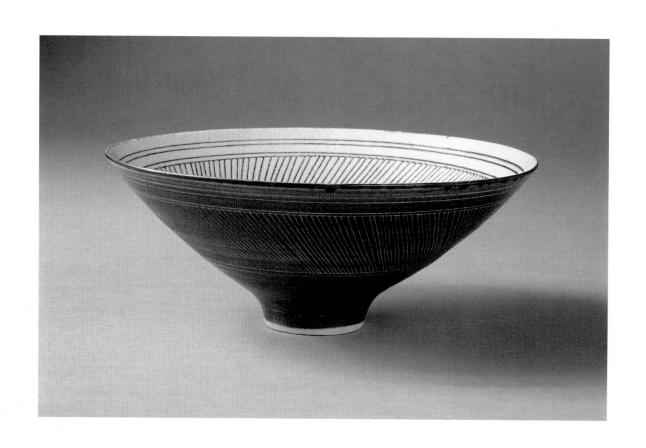

14
LUCIE RIE
Bowl, 1960
Porcelain, glazed
3 x 7¼ x 7¼
(L78.1.263)

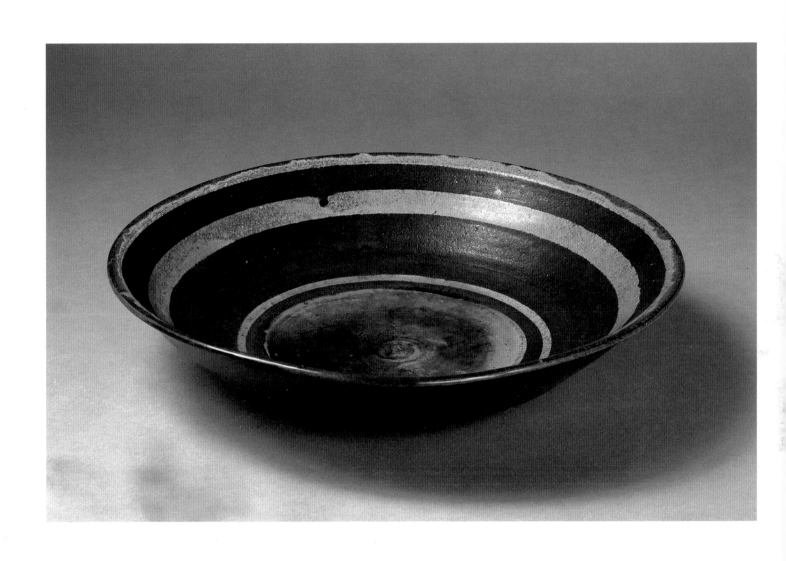

15
MARGUERITE WILDENHAIN

Bowl, 1954
Stoneware, glazed
3½ x 15¼ x 15¼
(L78.1.299)

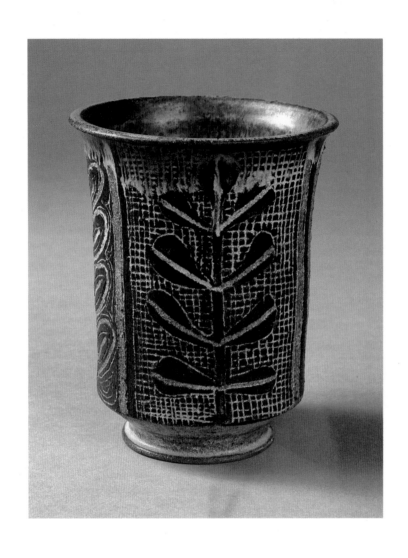

16

MARGUERITE WILDENHAIN

Vase, 1954
Stoneware, glazed
6 x 5 x 5
(L78.1.136)

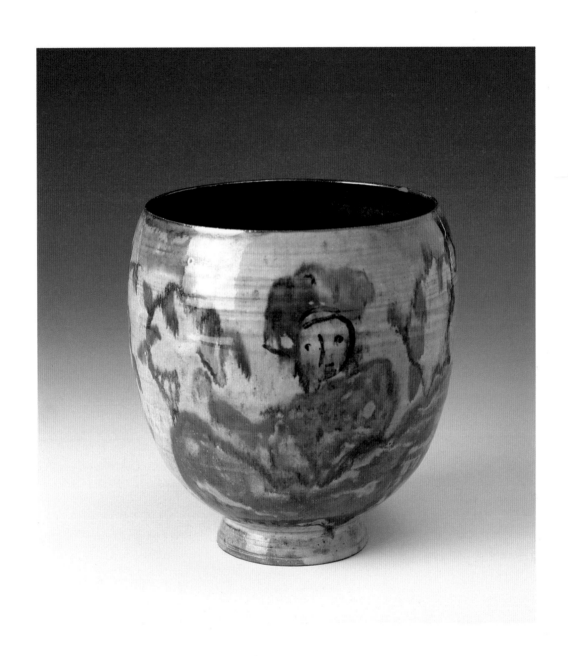

17
BEATRICE WOOD
Vase, 1955
Earthenware, glazed
6½ x 6½ x 6½
(L78.1.442)

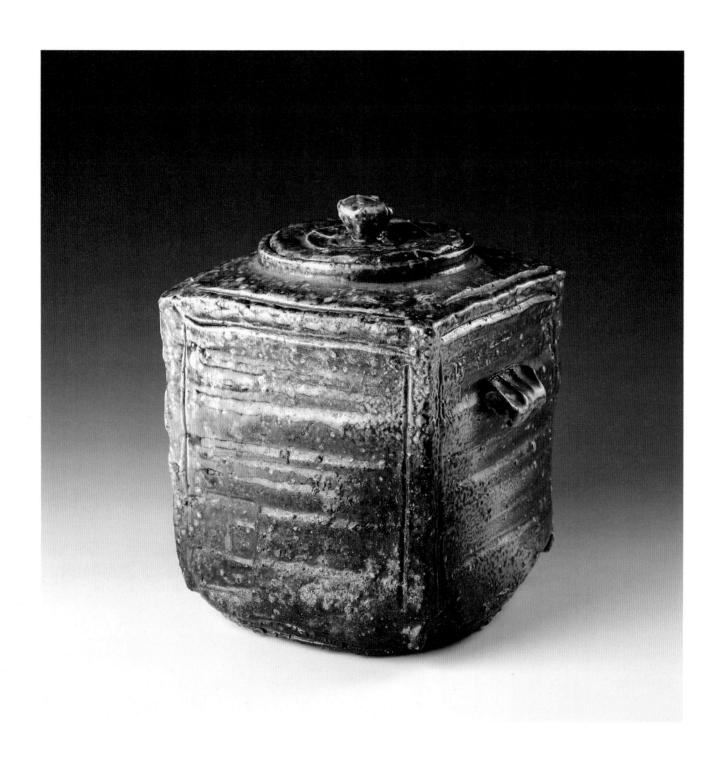

18
ANONYMOUS
Japanese Shigaraki ware
Lidded Container, 20th c.
Stoneware, glazed
8⅜ x 7¾ x 6¾
(L78.1.22a,b)

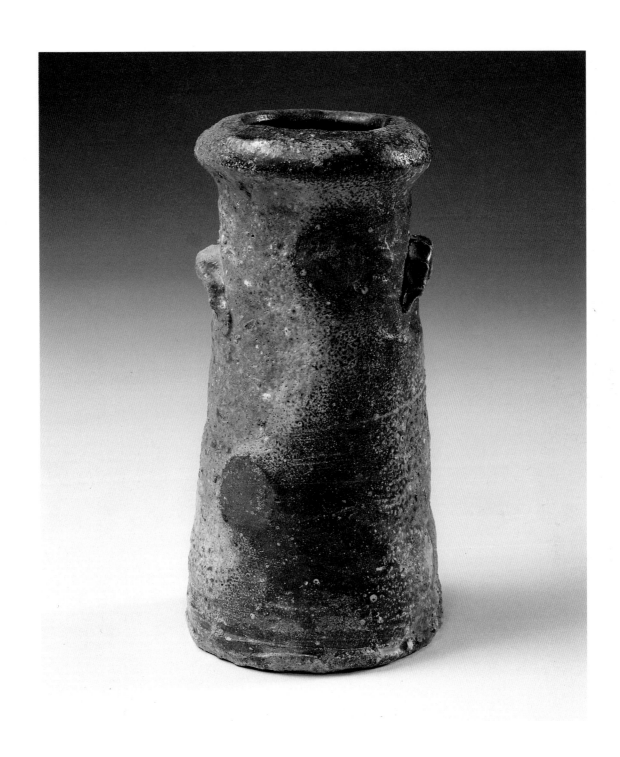

19
ANONYMOUS
Japanese Bizen ware
Vase, 20th c.
Stoneware, glazed
10½ x 5¼ x 5
(78.1.23)

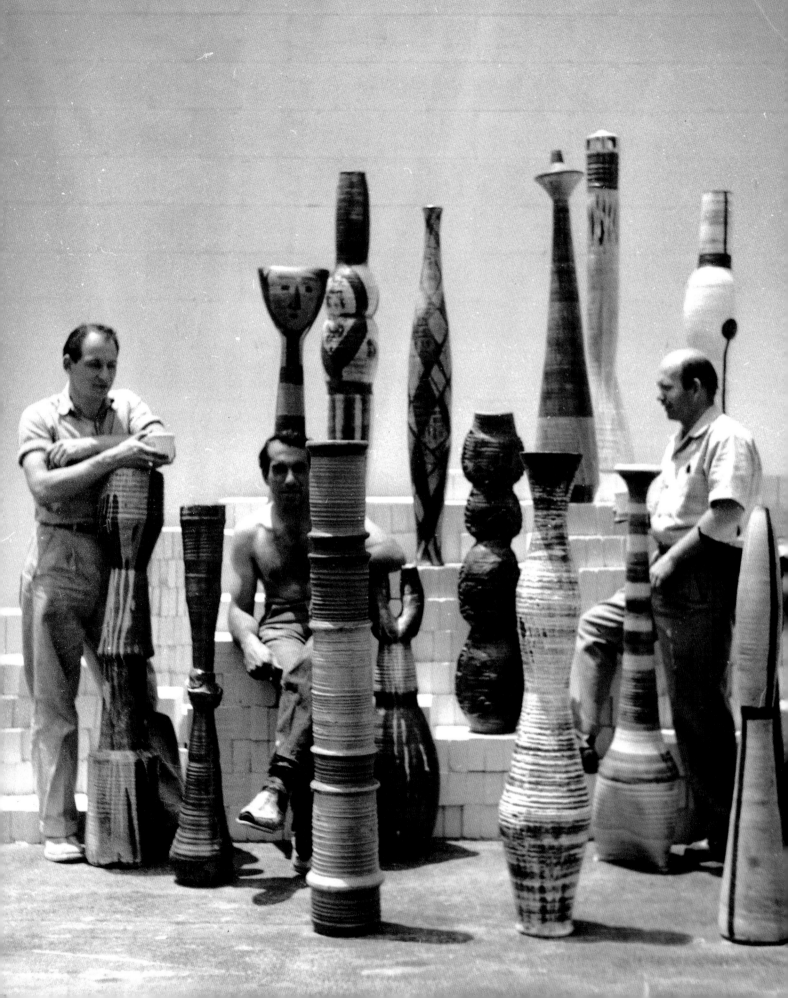

Innovation in Clay:
The Otis Era 1954–1960

Mary Davis MacNaughton

URING THE MID 1950s the ceramics department at Otis Art Institute (then Los Angeles County Art Institute) was a place of artistic vitality and innovative energy. At Otis, Peter Voulkos led a "revolution in clay" by questioning the tradition that ceramic forms must be utilitarian and by creating instead nonfunctional, sculptural works that gave the medium a new freedom of expression. Voulkos attracted a group of talented students to Otis—which included Billy Al Bengston, Michael Frimkess, John Mason, Mac McClain, Ken Price, Janice Roosevelt, Jerry Rothman, Paul Soldner, and Henry Takemoto—who began their own searches for new forms of expression in clay. Although most did not fully develop their mature styles until after they left Otis, it was there that they absorbed many of the attitudes that shaped their thinking as artists.

The ideas that informed their art are reflected in the collection of Fred Marer, who was their principal patron. Because Marer collected the works of the Otis group at the time they were made, these ceramics are seminal documents of the period. The Marer Collection is unparalleled for the depth of work it contains by artists in the Otis group from 1954 to 1960. During this time Marer bought several works by each artist, and so his holdings give a fuller picture of this transformative period than does any other public or private collection. Marer's extraordinary concentration of works provides not only a larger but also a closer look at this "revolution in clay," which was not a sudden event but a gradual process of investigating fresh artistic ideas. For the artists, this endeavor was an exhilarating discovery of expressive freedom in clay. The core of the Marer collection details the Otis group's innovative approaches to the vessel, which shifted the emphasis in ceramics from small, utilitarian objects to larger sculptural forms. As a close friend to many of these artists, Marer purchased some of their most accomplished works. But he was also a collector with daring taste and visual acumen, and he bought experi-

Paul Soldner, Peter Voulkos, and John Mason at Otis (Los Angeles County Art Institute), 1956.

mental works, many of which were at the forefront of this era of change.

What is extraordinary is that Marer assembled this remarkable collection with limited means; he was not a businessman but a teacher. Marer, who in 1938 studied for a Ph.D. in mathematics at UCLA, taught math at Los Angeles City College from 1937 to 1976. During his career, Marer also took on additional teaching jobs at USC and California State College, Los Angeles. He recalls that these "second jobs" provided him funds to collect ceramics.[1] Marer claims that he had no interest in collecting before he became fascinated with ceramics. In the mid 1950s he attended a sale sponsored by Los Angeles City College and made his first purchases, a ceramic bowl piece by Laura Andreson and an enamel and copper work by Pauline Blank. In 1955 he attended an Otis faculty exhibition and was attracted to a small piece by Peter Voulkos, then head of the school's ceramic program. Following this purchase, Marer got to know Voulkos and the other young artists in the studio. During the next year, Marer met John Mason, Mac McClain, Paul Soldner, and subsequently became acquainted with Billy Al Bengston, Ken Price, Mike Frimkess, Janice Roosevelt, Jerry Rothman, and Henry Takemoto. Marer liked the informal atmosphere of Voulkos's studio and was impressed with the work that he saw there. Marer often visited the studio, talked with the artists about their work, and bought pieces from them directly. Marer became not only their patron but also their friend. He played an important role in the development of the Otis group, since he provided these artists with both moral and financial support in the crucial early years of their artistic development. When few others were purchasing their works, Marer's patronage gave the artists at Otis the confidence to pursue new ideas and to take artistic risks, which resulted in innovative work that reshaped contemporary ceramics.

REVOLUTION IN THE MAKING

Voulkos and his circle were brought together at Otis by the G.I. Bill. Voulkos, who had fought in the Pacific, and Paul Soldner and Mac McClain, who had served in Europe, had been transformed by their war experiences. McClain recalls that surviving the war made him resolve that he would live his life as he wanted.[2] These survivors brought an extraordinary intensity to their work at Otis.

The group's center of energy was Voulkos whose charismatic personality and inventiveness had a magnetic impact on his students. At Montana State, where Voulkos studied 1946–51 with Frances Senska, Rudy Autio, a fellow student, remembered, "We all used to hang around Pete and watch him throw."[3] Sculptor Manuel Neri, who was studying ceramics at California College of Arts and Crafts when Voulkos was a graduate student there, recalled: "His attitude toward the material was the main thing; he forced himself onto it...instead of taking that kind of sacred approach to ceramics that most people did."[4] In 1954 when Millard Sheets, director of the new program at Otis Art Institute, was looking for a chairman of the ceramics department at Otis, Voulkos, a young artist with an impressive record,[5] seemed like the perfect candidate for the position.

Voulkos's technical virtuosity is evident in early works in the Marer

Collection like *Vase*, 1955, (cat. 36), which displays a mastery of large-scale classical form and balance. He recalled the influences during this phase of his work: "At that time Scandanavian countries were producing...pottery with fine design—elegant pristine things. So that's what I began producing."[6] This kind of work would have appealed to Sheets, a leader of the Regionalist painting movement in Southern California, who had formed his ideas about art in 1930s. In painting Sheets preferred realist imagery; and in ceramics he liked classical form. Before coming to Otis, Sheets had built the art department at Scripps College, where he emphasized ceramics by making the ceramist William Manker his first appointment. But Sheets's conservative attitudes later clashed with Voulkos's experimental approach, and their conflicting viewpoints eventually led to Voulkos's departure from Otis.

Had Sheets looked more closely at Voulkos's experience up to that date, he might have seen elements that indicated Voulkos was questioning everything about traditional ceramics. Even in his early work, Voulkos eschewed the modest scale of studio pottery for large-scale work. For example, Neri recalled that at California College of Arts and Crafts, where Voulkos received his MFA in 1952, Voulkos was "doing traditional things...like Greek pots...except instead of being a foot high they'd be four feet high."[7] It has been said that Voulkos worked big because he misunderstood the scale of Chinese and Korean vessels that he saw in books,[8] but from the beginning, he clearly had the ambition to make large statements.

Voulkos's early work also reveals his view of clay as another surface for painting and drawing. As a student, he first focused on painting and has continued to paint at various points throughout his career. His painterly sensibility is evident in his early works; for instance, on *Vase*, 1955 (cat. 36), Voulkos draws on pottery with liquid clay, called slip. On other early pots, Voulkos also drew designs with wax-resist techniques and inlaid lines. Although Voulkos's work of the early 1950s was traditional, his interests in modern art prepared him to move in another direction. As a student at Montana State, he searched books for illustrations of modern painting and sculpture: "I still had never set foot in a museum," Voulkos recalled. "Whatever master painting we saw were reproductions in books. I was influenced by Picasso, Matisse, Morandi, Giacometti—especially Picasso."[9] Voulkos liked Picasso's painterly approach to ceramics, which offered an expressionistic alternative to the Scandinavian tradition of ceramics.

EAST MEETS WEST AT ARCHIE BRAY FOUNDATION

During the summer of 1951 Voulkos lived in Helena, Montana, where he met Archie Bray, Sr., the owner of a large brickyard. In return for making salt-glazed bricks in his factory, Mr. Bray agreed to let Voulkos and ceramist Rudy Autio use his equipment to build a pottery studio where they could make and teach ceramics. The pottery studio became known as the Archie Bray Foundation. After graduating from California College of Arts and Crafts in 1952, Voulkos spent several months at the Foundation, where he and Autio worked in the brickyard

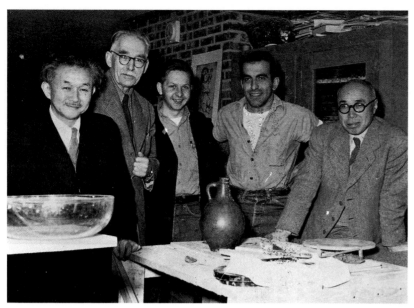

Left to right: Soetsu Yanagi, Bernard Leach, Rudy Autio, Peter Voulkos, and Shoji Hamada at Archie Bray Foundation, Helena, Montana, 1952. Photograph courtesy of Rudy Autio

and made production pottery. During this time Voulkos's interest in Miró and Picasso was reinforced by Antonio Prieto, who taught at the Foundation, and whose own work was influenced by Miró, Picasso, and Spanish ceramist José Llorens Artigas. The works of these European ceramists offered Voulkos an artistic direction outside of the Scandinavian ceramic aesthetic, which he felt was confining. Voulkos saw another alternative in the Japanese folk pottery tradition. Proselytizing this tradition were Bernard Leach, an English studio potter, and his mentor, Japanese ceramist Shoji Hamada, as well as philosopher Soetsu Yanagi, who founded the Mingei movement in Japan, which reasserted the value of traditional Japanese crafts. In 1952 Leach, Hamada, and Yanagi visited the U.S., arriving in October at Black Mountain College, near Asheville, N.C. There they conducted a ten-day session hosted by Marguerite Wildenhain, who had studied at the Bauhaus and established her own studio at Pond Farm, California. This group included a stop at the Archie Bray Foundation in Montana, following an invitation from Archie Bray and Branson Stevenson, a businessman, potter, and trustee of the Foundation, who offered to pay their rail passage across the country.[10] American ceramists had been familiar with Asian ceramics since the nineteenth century, but through the 1930s and 1940s most were drawn to the elegant shapes and flawless glazes of Chinese ceramics. Following the visit of Leach and Yanagi, however, the organic forms and cracked surfaces of Japanese folk pottery became popular, and, more importantly, ceramists began to study Zen ideas about the creative process, which these forms embodied. Voulkos was a leader in this shift of sensibility. Dissatisfied with the expressive limits of the Scandanavian and Chinese traditions, Voulkos was receptive to Leach and Hamada's ideas, which he absorbed from their writings and their visit.

Bernard Leach's somber pots, which owed a debt to Hamada, encouraged a shift from clear, jewel tones to murky, earth-colored glazes. But for Voulkos, Leach's controlled, tight forms would not be as influential as the looser, energetic shapes of Japanese folk pottery. Ultimately, Leach's ideas left a more lasting impression on American ceramics than his work. These ideas were expressed not only in his talks but also in *A Potter's Book* (1940), which had a major impact on many ceramists. Leach advocated making art that had a "vital force" and "sincerity," and emphasized the importance of feeling: "The art of the craftsman is intuitive" and pots "are the projections of the minds of their creators."[11] Eventually, the Otis group rejected Leach's belief that pottery should be utilitarian, but they adopted the idea that artistic expression should be direct. Voulkos and his students were part of a groundswell of artists, including many of the abstract expressionists, who in the mid 1950s combined western modernism with

eastern philosophy, finding new avenues for exploration in the ideas of Asian art and Zen.[12]

BLACK MOUNTAIN COLLEGE AND NEW YORK

Voulkos was stimulated by the intersections of western art and eastern ideas that he encountered when he taught a three-week session in ceramics at Black Mountain College during the summer of 1953.[13] Voulkos saw abstract expressionism first hand in the work of Esteban Vicente, who taught painting that summer and also met artists Marca-Relli, Robert Rauschenberg, and Jack Tworkov, who visited Black Mountain composer John Cage, who was also in residence.[14] By this time, Cage's own work embodied chance and spontaneity. For example, in 1952 Cage had staged a now-famous multimedia and multiple-focus performance that included unrehearsed readings by Cage and poet Charles Olson, art by Robert Rauschenberg, and choreography by Merce Cunningham. Thus, Voulkos's openness to the intuitive and improvisational in art would have been strengthened during his summer at Black Mountain where making art in clay took place in a multidisciplinary setting. Voulkos began to think of clay as art, not craft, as "another way to invent form."[15] Most important, Voulkos appreciated that the permissive learning climate at Black Mountain was an environment that encouraged experimentation. Voulkos would later recreate this spirit of permission and experimentation in his studio at Otis.

Following the summer session at Black Mountain, Voulkos visited New York and saw more contemporary art. He was a guest of pianist David Tudor and was accompanied by poet M. C. (Mary Catherine) Richards, who had studied ceramics at Black Mountain. Voulkos recalled, "I...went to the Cedar Bar. I met Franz Kline, de Kooning, Guston."[16] Among the exhibitions in New York museums and galleries, he was impressed by the works of Artigas and Catalan artist Joan Miró, especially his technique of decorating with slip coating.[17]

His experiences at Black Mountain College and New York in the summer of 1953 had a major impact on Voulkos. He returned to Archie Bray in the fall and conducted a workshop with ceramist Marguerite Wildenhain who, since 1942, had been teaching ceramics at her studio at Pond Farm, in Guerneville, California. Voulkos also held workshops with F. Carlton Ball, who was then teaching at Southern Illinois University, and ceramists Nan and James McKinnell, who had been working in Boulder, Colorado. But Voulkos was a changed person; Rudy Autio remembers that Voulkos was suffused with new energy and inspiration.[18]

BEGINNING THE CERAMICS PROGRAM AT OTIS

In 1954 Voulkos received an invitation from Millard Sheets to head the ceramics program at Otis Art Institute. Attracted by the prospect of having his own program and, as at Black Mountain, teaching clay in a curriculum that featured painting and sculpture, Voulkos accepted. But Otis was not Black Mountain. Sheets had assembled a faculty that reflected his realist aesthetic taste, with Richard Haines in painting, Renzo Fenci in sculpture, Herbert Jepson in drawing, and Leonard Edmonson

in design. Arthur Ames, who also taught design, was more open to contemporary art than Sheets. Sheets, who had been commissioned by Home Savings to design their branch offices and embellish them with sculpture and mosaics, hired Otis faculty members, such as Fenci, to produce sculpture for this commission. In the process Sheets began to view the arts as a means to decorate architecture and the students at Otis as artisans in training, a view directly at odds with Voulkos who championed the artist's freedom to make nonutilitarian art. When Sheets hired Voulkos, neither realized how far apart their thinking was.

In September 1954 Soldner became Voulkos's first and only student, followed by Joel Edwards, who joined the studio in October.[19] Because the degree requirements at Otis precluded focusing on ceramics until a student's junior year, Voulkos began with few ceramic students. Intended for students who had already completed two years of college, the four-year program skipped the BFA and offered only a MFA. During the first two years, students had to take drawing, painting, and design; only in the third year could they focus on painting, sculpture, printmaking or ceramics. Paul Soldner, who had a MA, was admitted as a senior.

Voulkos not only had few students, he had primitive facilities. Promised a studio in a new $75,000 art building, during the first year Voulkos was given an empty room in the old building and no equipment. Voulkos began designing his program by studying others in Los Angeles. In the first few weeks, he and Soldner visited the teaching studios of Laura Andreson at UCLA, Susan Peterson at Chouinard, and Vivika Heino at USC. Voulkos soon realized that he had a different philosophy about equipment. For example, Laura Andreson, who was grooming students to be teachers, offered a variety of wheels, even inferior ones, in order to prepare her students for any situation. Voulkos, who cared more about training students to be artists than teachers, wanted the best equipment for his studio. Because he worked on a larger scale than Andreson, he also needed wheels with greater power. Voulkos preferred the compact, variable-speed "Denver-Fire Clay Company" electric wheel, which he had used in Montana. Voulkos also designed a kick wheel, which he used in the Otis studio. Although his wheel was strong, it was too heavy to move around. Soldner addressed that problem in designing another model, using light-weight pipe construction and trussed frame, a steel flywheel, and a wooden kicking top. Subsequently, Voulkos designed a more forceful electric wheel based on the "Denver Fire Clay Company" model by increasing the horse-power from one-quarter to one-half, which enabled him and his students to work with bigger amounts of clay and produce larger works.

Voulkos, who had experience building kilns at the Archie Bray Foundation, wanted information on kilns in Los Angeles. He consulted Susan Peterson and subsequently contacted ceramics engineer Mike Kalan at the Advanced Kiln Co., who had designed an updraft kiln at Chouinard. Kalan and his partner Mel Nordstrom built a forty-cubic-foot, soft brick, updraft kiln that could fire to 2,300 degrees. Until the new building was finished in the spring of 1956, the kiln had to be located in the parking lot outside the basement window, and pots were passed out the studio to someone who loaded the kiln.

THE PROGRAM EXPANDS

Voulkos soon began to attract other students to the program. During a visit to Chouinard, Voulkos and Soldner met John Mason, a teaching assistant for Peterson at Chouinard, and encouraged him to come by Otis.[20] Mason wanted to work with Voulkos, but as an accomplished ceramist who had already studied at Chouinard, he was not interested in taking the two-year preliminary program at Otis before entering Voulkos's class. Because Mason worked for Vernon Kilns during the day, designing ceramic dinnerware, he could only register for evening classes with ceramists Wayne Long in 1955 and Harrison McIntosh in 1956. But, beginning in the spring of 1955, he worked on an informal basis in Voulkos's studio.[21] In March 1955 Mac McClain, who had graduated from Pomona College, joined the group.[22] In the fall of 1956 Billy Al Bengston and Mike Frimkess enrolled, followed by Ken Price in the spring semester of 1957. In the fall of 1957 Jerry Rothman and Henry Takemoto entered the class.[23]

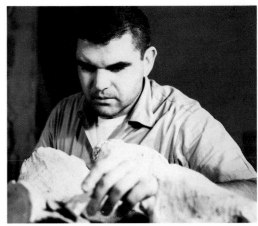

Jerry Rothman, c. 1957

Most of the literature on Otis has treated the circle around Voulkos as an all-male enclave, but there were women in the group. In addition to special students Kayla Selzer and Martha Longenecker, who were not in the degree program, there were two full-time female students: Janice Roosevelt, who studied with Voulkos from fall 1956 to spring 1959; and Carol Radcliffe, who studied from 1957 to 1959. Roosevelt has been briefly mentioned in the literature,[24] but Radcliffe, who finished her degree at Otis in painting not ceramics, has been overlooked. Radcliffe had graduated in 1957 from Scripps College, where she worked with Millard Sheets. As a scholarship student at Otis, she studied painting with Haines, design with Ames, and ceramics with Voulkos. After graduating from Otis, Radcliffe (now Carol Radcliffe Fisher) received an MA at UCLA in architecture. Following Otis, Roosevelt (now Janice Roosevelt Gerard) taught ceramics at San Fernando High School from 1960 to 1971, then received a Ph.D. in psychology in 1986 and set up a private practice in psychology. Both Radcliffe Fisher and Roosevelt Gerard recall feeling accepted in the Otis ceramic group. Roosevelt Gerard said, "I was treated as an equal, and very fairly."[25] The student who may not have felt as if he belonged was Joel Edwards, who wanted to make functional pottery and was not comfortable with the experimental direction at Otis.[26]

FRED MARER BEGINS COLLECTING

Late in the spring of 1955, Fred Marer, a math teacher at Los Angeles City College, became interested in Voulkos and his group of students when he saw Voulkos's work in an Otis faculty show. "There was a small piece, no more than four inches high, that I liked. So I wrote him a note, asking whether I could buy it. He sent back a note, saying, 'Sure, come down.' When I got down there, the piece had been stolen. But then I got to know Pete and Paul, John and Mac."[27] He often visited the studio on evenings and weekends. Soldner remembered, "He would come down and just kibbutz, drink coffee, and see what we'd done the week before."[28] Marer not only got to know the artists but also engaged them in dialogue about their work and began buying it. Radcliffe Fisher recalls that Marer

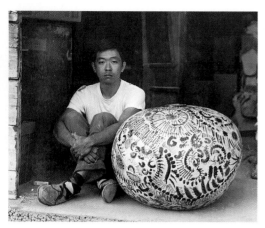

Henry Takemoto at Otis, c. 1957

acquired works during the Otis group's ceramic sales, which were held in the parking lot. Because Marer visited the studio regularly, he also bought works immediately after they had been fired. For example, Ken Price recalls that when the kiln was unloaded, Marer was often there.[29] John Mason also remembers that Marer would browse through the studio and find works to buy.[30] Often these were experimental pieces; for example, Radcliffe Fisher remembers that Marer bought a plate of hers with a hole in it.[31] Marer modestly claims that all he contributed to the studio were three-pound tins of coffee, which were prepared hobo-style in empty cans.[32] However, Marer not only bought their work, he and his wife, Mary, often invited artists to their house on Kenmore Street. Roosevelt Gerard recalls, "Mary would cook us wonderful dinners. We were poor artists, so that meant a lot."[33] At these dinners, which often included Mason, McClain, Roosevelt Gerard, Soldner, Voulkos, and occasionally others in the Otis group, the artists came to know Marer as a friend. Ken Price remembers Marer's generosity: "When I lived on Pier Avenue in Ocean Park, I shared a studio with a painter. Fred came to visit and brought me food. He knew I was tapped out at the time. His timing was good."[34] Because Marer's means were limited, he was conscious of price when buying art. But when Billy Al Bengston wanted to go to the Bay Area and didn't have the funds, Marer paid him an extra sum for his work.[35] Marer also made interest-free loans to artists and often took repayment in ceramics. No other collector at the time had such a keen and continuing interest in their work. Marer's financial support and emotional encouragement at the beginning of their careers helped the Otis group at a critical point.

VOULKOS THE TEACHER

In contrast to Marguerite Wildenhain's program of formal lectures and critiques, Voulkos's casual style featured teaching by example. Marer recalls, "I can't remember Pete giving a formal lecture, except to demonstrate glazing. Generally, the atmosphere was informal. Pete considered his students as friends and colleagues. They all looked up to him."[36] Voulkos did teach glaze calculation, but he didn't break the course into sections on throwing or glazing. Roosevelt Gerard said that Voulkos was available for technical assistance, but did not instruct in the conventional sense. She recalled that Voulkos "taught through his presence. He really didn't come and tell you what to do unless you asked a technical question. He just assumed that you would watch what was going on and develop your own creativity."[37]

In order to build students' self-confidence and the skills needed to work independently, Voulkos made them responsible for mixing their own clay and firing their own kilns. Voulkos also put students in situations that encouraged them to be resourceful. For example, he told Soldner and McClain that they could fire the kiln on their own one weekend when he was absent. Voulkos left only one instruction: "Don't lose the reduction." Soldner and McClain were so concerned about controlling the reduction—that phase of the firing in which oxygen supply is limited so as to integrate the clay body and glaze—that they could not get the tem-

perature high enough to reach 2,300 degrees. Consequently, the firing continued for three long days. Eventually they smelled asphalt burning and realized that the reduction was forcing flames out of the bottom of the kiln, which was beginning to sink into the asphalt. So they finally stopped the reduction, and the kiln quickly reached the correct temperature. Soldner, who appreciated the lesson Voulkos had taught him, in turn gave his students responsibility: "I know that after they leave school," Soldner said, "they can manage without [me], whereas in the schools that buy all the clay premixed and fire all the kilns...the student is still going to have to learn it."[38]

Students learned techniques by watching Voulkos work: Ken Price said, "Technically, he was a master. Like Charlie Parker, who could play in any key, Voulkos had tremendous facility. His hand and eye skills were built up from huge amounts of labor."[39] Voulkos also set an example for intense, long sessions of work with a prodigious output. His studio work was mostly nocturnal, beginning late at night and continuing until dawn. Soldner recalled that in the studio on a morning following a Voulkos work session, they would find "twenty to thirty teapots, all lids and spouts and bodies thrown, ready to be assembled the next day. When he worked, it was intense...many, many pots. [Pete] always said, 'You can't learn anything from one thing.'"[40] The studio was open twenty-four hours, seven days a week.

Because Voulkos felt that the arts were interrelated, music was an important part of the Otis clay studio. Voulkos wanted to be a jazz guitarist and studied classical guitar from Theodore Norman whom he met through his student Kayla Selzer. From Norman, who had studied with Andres Segovia, Voulkos learned technically difficult twelve-tone music and poured huge amounts of energy into practicing guitar. Voulkos strove for the Zen goal of achieving an "artless" art, believing that in music, as in art, technical expertise would lead to a transcendence of technique.[41] Anyone who came by the ceramics studio would have heard both classical and jazz music. Bix Beiderbecke, Bunny Berigan, Billie Holiday, and Django Reinhardt were among Voulkos's favorites. Mike Frimkess recalled that "Pete used to bring his guitar and play Bach and flamenco."[42] Other members of the studio were also musicians: Price played piano and Frimkess played saxophone. The improvisation and dissonance of jazz appealed to Voulkos and his circle who were exploring similar ideas visually in their own work.

Improvisation was a way to enact spontaneity, a goal of Zen philosophy. Another attitude Voulkos absorbed from Zen was acceptance of the accidental. Voulkos taught students to embrace the unexpected by modeling this approach in his own work. For example, Soldner remembers that during the first year at Otis, Voulkos was disappointed that the glazes he had brought from Montana fired to a matte instead of glossy finish. Soldner recalled, "I remember him [Voulkos] kind of rolling with it instead of fighting it....Once he discovered that it was going to be different, he took advantage of that, and the work demanded more control in a drawing sense than reliance on the sexy glazes."[43]

Voulkos taught indirectly, obliquely, and encouraged his students to

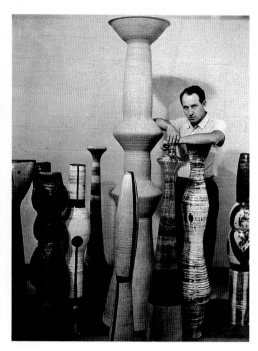

Paul Soldner's M.F.A. exhibition at Otis, 1956.

set higher goals for themselves. In 1956 Soldner was making tall pots, which were the subject of his graduate show in the spring of 1956, seen at left. One morning in the studio he found several slightly taller cylinders Voulkos had made the night before. Although Voulkos never commented on them, Soldner understood that they were meant to get him to stretch himself further. When Voulkos did comment, he gave students an idea to consider rather than a personal criticism. For instance, Soldner recalled a pot that he had covered with calligraphy in imitation of Voulkos's brushwork. As Voulkos and Soldner unloaded the kiln, without picking up Soldner's piece, Voulkos gently said, "You don't have to decorate pots unless you feel a real need for it."[44]

Instead of the detailed dissection of works favored by Wildenhain, Voulkos and students resisted verbal analysis, believing that art should be experienced intuitively rather than intellectually, a point of view also derived from Zen. A well-known Zen saying is, "The instant you speak about a thing you miss the mark."[45] Voulkos's reluctance to critique work also echoed the abstract expressionist attitude, shaped by Zen and the New Criticism, that art should speak for itself. The underlying assumption was that words cannot communicate the meaning of visual images.[46] Soldner explained, "if your work was being critiqued...you'd throw it right back in their face, 'Well, there it is...Don't ask me; it's finished.'"[47] Voulkos and his circle were part of a generation, which included the abstract expressionists, who shared a resistance to interpretation.

In the Otis clay program, play was emphasized as part of the creative process. By contrast, the tone in Marguerite Wildenhain's studio was serious, as she described in 1982: "In the beginning, you have to be strict so that they learn all those things belonging to the craft, just like a doctor has to know how to bandage."[48] The contrasting attitude in Voulkos's studio was demonstrated in a skit performed before the American Ceramics Society that parodied the earnestness of studio pottery and skewered the analogy of the craftsman and the doctor. John Mason threw a pot, then asked for someone in the audience to help decorate it by incising. Ken Price volunteered and, together with Mason, sliced the pot to shreds. Another student, dressed in a white nurse's uniform, assisted the operation, providing tools as they called for "sponge," "needle," and "scalpel."[49] Soldner recalled that Voulkos also poked fun at the seriousness of the demonstration by preparing a ball of clay with a pocket inside, in which he placed a plastic bag filled with water and a goldfish. Half-way through throwing the large pot, he stopped and said, "There's something in this clay. I don't know what kind of junk it is,"[50] and he pulled out the bag with the swimming goldfish. Voulkos remembered that he pulled a section of rope out of the clay. Their irreverent skits rejected the earnestness that characterized studio pottery and also demonstrated the liberating qualities of play, which to them was an expression of spontaneity and freedom from constraint.

The irreverence of Voulkos and company was not appreciated by Sheets, who also objected to the expressionist direction in their work. For the 1955 student exhibition, Sheets rejected all but Joel Edwards's work out of Voulkos's class, claiming that their work was inferior by his stan-

dards. Then he assembled the entire student body at Otis and gave a general lecture directed at the potters he had rejected, warning them to pull out of their subjectivity. He said, "Get out of your ivory tower and come down to earth."[51] Instead of dissuading the students, however, Sheets's lecture strengthened their resolve to follow their own direction. Soldner, Frimkess, and other Otis students rented a storefront on Sunset Boulevard and created a cooperative exhibition space, which they named The Ivory Tower Gallery. The artists collectively paid the rent and organized monthly one-person shows for themselves, which, to Sheets's dismay, were reviewed in the *Los Angeles Times*.[52] The Ivory Tower Gallery also offered informal classes in drawing from a model. Although the Gallery lasted only from 1956 to 1957, it was an important expression of the independent thinking and self-reliance of the artists who worked with Voulkos.

Voulkos's independence and Sheets's conservatism were on a collision course. Sheets complained not only about the work but also the working methods of the clay studio. Voulkos recalled, "By then, Mason was slapping clay all over the walls. Sheets would come into the classroom,...call me into his office and holler, 'You can't do that! Clean up that studio!'"[53] Voulkos continued to resist Sheets's agenda to make Otis students into assistants for his public art projects. Finally, in December 1958, Sheets's and Voulkos's disagreements over the direction of the ceramic program led Sheets to request Voulkos's resignation.[54] Soon after, Voulkos began discussions with Erle Loran, Chairman of the Art Department at the University of California at Berkeley, and accepted a position there beginning in the fall of 1959, as assistant professor of ceramics with a joint appointment in the Art and Decorative Art Departments. Voulkos was also attracted to this program because of his friendship with Harold Paris, who taught sculpture at Berkeley.

By the time Voulkos left Otis, many of his students had dispersed. Soldner began teaching at Scripps College in 1957; in the same year McClain worked briefly firing kilns at San Diego Ceramics, then accepted a teaching position at the Art Center in La Jolla, where he worked until 1964. Mason had been sharing a studio in Glendale with Voulkos since 1957 and continued to work independently. Bengston left Otis in June 1957, followed by Price in December 1957. Remaining students Henry Takemoto (MFA 1959), Janice Roosevelt (MFA 1960), and Jerry Rothman (MFA 1961), all completed their ceramics thesis projects under the direction of Voulkos's replacement, the more traditional ceramist Helen "Whitie" Watson. To her credit, Watson did not try to redirect the work of Voulkos's students but encouraged them to realize their projects.

THE WORK AT OTIS

Early writers saw ceramics at Otis as an outgrowth of abstract expressionism. Rose Slivka, then editor of *Craft Horizons* magazine, focused in a 1961 article on the painterly aspect of contemporary ceramics, emphasizing artists' interest in the "energy and excitement of surface, and the attack on classical formal rendering."[55] John Coplans's introduction to a 1966 exhibition, "Abstract Expressionist Ceramics," subsumed

Otis-era ceramics under New York School painting, claiming that this work was "the most ingenious regional adaptation of the spirit of Abstract Expressionism that has yet emerged." [56]

In 1993 Cheryl White asserted that the "codification of the ceramics of Voulkos and his students in the 1950s as Abstract Expressionist" [57] was evidence of the critical prejudice against ceramics, that such a "minor medium" could not have an independent aesthetic. But it is undeniable that in the 1950s Voulkos and his circle were influenced by abstract expressionism. In 1978 Voulkos compared his process to that movement: "Much like an abstract expressionist, I go from gut feelings." [58] Other sources of inspiration for the ceramics revolution were modern European ceramics, Japanese folk pottery, contemporary assemblage sculpture, and eastern philosophy. [59] Neither abstract expressionism nor these influences alone shaped the aesthetic at Otis. Instead, the cross-fertilization of these ideas and the way artists fused disparate traditions produced new creative expressions and created the energy identified with clay art at Otis. A similiar aesthetic hybridization also informed abstract expressionism, which drew ideas from surrealism, cubism, existentialism, and Zen. Voulkos and his circle responded to this crosscurrent of artistic and philosophical ideas in ways related to but distinctive from many painters and sculptors of the 1950s. They gave these ideas individual expression in clay and, rejecting many of the aesthetic ideals of the previous generation, turned clay in a new direction. Replacing the classical ideals of studio pottery with subjective ones derived from expressionist art, the Otis group led the shift in ceramics from an art based on preconception to one inspired by improvisation.

The works produced by Voulkos and ceramists who studied with him document a period of transition in American ceramics from an aesthetic of constrained refinement to intuitive roughness. In many cases, these early works, best seen in the Marer Collection, contain the seeds of ideas that emerge later in different ways in each artist's mature work. This pattern is especially true for Voulkos, whose major series of the 1970s and 1980s—the stack pots, plates, and ice buckets—all have their roots in the work at Otis. Voulkos's work from 1954 to 1959 shows that these years at Otis were a fertile time of experimentation in which he began to formulate ideas that continue to occupy him today.

When Voulkos arrived at Otis in 1954, he was an accomplished production potter, who made elegant symmetrical forms, as seen in *Vase*, 1955 (cat. 36). Sheets so admired Voulkos's work of this period that he bought several pieces. [60] But in the spring of 1955 Voulkos's work began to move in an expressionist direction, in response to the art and ideas he had absorbed at Black Mountain and New York, as well as from exhibitions he saw in Los Angeles. Voulkos later acknowledged that his experience in Los Angeles was a turning point in his artistic development: "The biggest thing that ever happened to me...was moving to L.A. Everything started falling into place. I began to go to all the shows, all the openings and galleries and museums—painting shows and sculpture shows I had never been to before." [61] An exhibition at the Los Angeles County Museum of Art in the fall of 1955 offered stimulating new visual ideas: contemporary

European painting was featured in "The New Decade," which included post-war European expressionist painting by Jean Dubuffet, Pierre Soulages, Alberto Burri, and others. This exhibition affirmed a less reserved expression and offered an invigorating alternative to the tightly thrown forms Voulkos had mastered.

Voulkos's works of 1955 show him absorbing new ideas, especially primitivism. His forms become more awkward, and transitions between sections are no longer hidden but obvious. Voulkos also creates forceful, simplified forms, with cruder designs. In 1956 Voulkos described his departure from production pottery: "The minute you begin to feel you understand what you are doing [you] lose that searching quality....You finally reach a point where you're no longer concerned with keeping this blob of clay centered on the wheel and up in the air. Your emotions take over and what happens, happens."[62] Mason recalls that both he and Voulkos were strongly unfluenced by primitive art. They saw exhibitions of African art at Primus-Stuart Gallery and pre-Columbian art at Stendahl Gallery in Los Angeles. In 1956 Voulkos borrowed pre-Columbian sculpture from Stendahl Gallery for an exhibition at Otis.[63] Two other sources of inspiration for this new direction were Picasso and Japanese folk pottery. Two works in the Marer Collection—*Vase,* 1955 (cat. 37) and *Covered Jar,* 1956 (cat. 38)—reveal Voulkos's interest in Picasso's painterly approach to ceramics and his attempts to adapt it to his work: "I was very interested in Picasso, and I looked at his ceramics and his painting on clay. I was influenced quite a bit by it. I made a series of big jars one time where I painted clear down over the foot."[64] Both *Vase* and *Covered Jar* are vessels solidly covered with paintings, a technique Voulkos used to transgress boundaries separating vessel and foot. Voulkos saw that in Picasso's work, unlike most studio pottery, painted decoration was a forceful element, whose expressive value was not subservient to the form but equal to it. In *Vase,* the Picasso-esque face echos the oval form of the mid-section; in *Covered Jar,* design operates independently of form. In 1971 Voulkos concluded, "I think looking at Picasso's paintings and ceramics, I became interested in the powers of color in three-dimensional form....How to destroy a form by the use of color."[65] Voulkos also responded to the humor in Picasso's art and parodied the master's bullfight imagery in *Plate (Bullfight),* 1957 (cat. 41). Like Picasso, Voulkos treats the plate not as a surface for eating but as a surface for drawing. This work is an early example of Voulkos's interest in the expressive possibilities of the plate, which he has continued to explore from the 1970s to the present. There are also hints here of his later plate style (cat. 67, 69), in the way he pulls the form out of round, cuts into the surface, and slices the rim.

Voulkos's growing interest in Picasso was not welcomed by Sheets, who did not like Picasso's ceramics. Soldner recalled an incident that illustrated the growing rift between Voulkos and Sheets:

> During discussion over luncheon, Mr. Sheets got in an argument with Pete about Picasso ceramics. Sheets's point of view was that he (Picasso) didn't have the right to be considered a ceramist because he had no training and he didn't make the pieces. He hired a potter to make the pieces and all

Picasso did was paint them. Voulkos argued with him just a little, saying, 'Well, that doesn't make any difference. They're good pots.' And the argument got a little heated and ended by Pete just clamming up. But when we got back to school, he went over to the library and he checked out all of the Picasso drawings that he could find of the ceramics and stuck them around the wall of the studio. Nothing was said, but that was it."[66]

Voulkos was also impressed by the cutouts of Matisse. Soldner mentioned that they saw the collages of European artist Conrad Marca-Relli at the Los Angeles County Museum of Art and Voulkos studied his techniques for creating shapes with color—"putting slips under clay, then squishing it so it would come out...around the edges"[67]—and transformed them for his own purpose.

Already familiar with Japanese folk pottery from illustrations in books, Voulkos saw this kind of work firsthand during the visit of Hamada and Yanagi. Voulkos also took his students to Little Tokyo to see mingei pottery. But its impact was not immediate; only after seeing work by Rosanjin[68] in a Los Angeles gallery did he view the mingei movement as a source for primitivism and a catalyst for change. Vivika Heino, who had taught at Chouinard from 1952 to 1955 and moved to USC in 1955, took students to visit the Otis studio and recalled a change in Voulkos's work following his exposure to the work of Rosanjin.[69] The Japanese influence is clearly evident in *Vessel,* 1956 (cat. 39), whose reductive, simple, asymmetrical shape draws strongly on the Japanese tea bowl. Also Japanese in spirit is Voulkos's acceptance of accident, seen here in the dripping glaze, an effect which rejects the perfect surfaces of Scandinavian ceramics. *Vessel* is an early example of a group of small bowls inspired by the Japanese tea ceremony, which Voulkos first made in 1955 and returned to periodically throughout the 1960s and 1970s. These small bowls show him working with the Japanese aesthetic of slumping, sagging clay, which lets the material respond to gravity instead of resisting it. This Japanese aesthetic emerges fully in the heavy, squat forms of later works that Voulkos named Ice Buckets.[70]

In 1955–56 Voulkos reached his turning point and began to transform his work from production pottery to nonutilitarian forms. During this period, he also saw in abstract expressionism another model of spontaneity: "After seeing all the New York stuff, I really got excited about the possibilities of clay. I [realized] it [pottery forms] didn't have to be really straight. I started maneuvering clay, much as the painters were doing at the time."[71] His interest in abstract expressionism was reinforced by two exhibitions at the Los Angeles County Museum: in 1956, "Younger American Painters" and in 1958, "Nature in Abstraction." In these exhibitions paintings by Jackson Pollock, Willem de Kooning, Franz Kline, and other abstract expressionists displayed a freer, more subjective expression. Voulkos brought a gestural sensibility, inspired by abstract expressionism, to his forms and surfaces. Like the impastoed surfaces of paintings by de Kooning and Kline, Voulkos's incised lines and liquid brushstrokes of *Bird Vase,* 1958 (cat. 44), are traces of his creative thought. Voulkos had begun experimenting in the spring of 1955, but when he returned from spending the summer of 1955 at Archie Bray, his work clearly showed a new

direction. Mason recalls that Voulkos "came back with some combination forms he had made, thrown things he had assembled."[72] In this work, Voulkos began to improvise, working in a looser way, deliberately distorting the shapes. Voulkos's affirmation of a rougher expression was a conscious departure from the refined aesthetic of the previous generation. For example, Vivika Heino had drummed it into her students at USC that good work had to have "life and lift." Voulkos remembered that when Ken Price, who had studied with Heino, came to Otis, he kidded him saying, "'Hey Pete, this piece hasn't got enough life and lift.' Price teased him so much that one day Pete just kind of exploded and said, 'Dammit, I don't want lift and life; I want dump and death.'"[73]

Voulkos found energy not in refinement but in rawness, rejecting the aesthetic of smooth, flawless glazes. In *Plate*, 1957 (cat. 42), he applied rust to the plate with epoxy, producing a broken, craggy, surface. In so doing, he again denies the function of the plate as a plate and affirms it as a surface for image making, as he had in his Picasso-esque *Plate (Bullfight)* (cat. 41). Another Voulkos strategy for creating visual energy was to jettison round symmetry and fabricate angular asymmetry by paddling wheel-thrown forms. This technique is evident in *Bird Vase* (cat. 44), whose blocky stonelike forms suggest the influence of the Viennese sculptor Fritz Wotruba, which Soldner confirmed had a big impact on Voulkos after the 1955 Wotruba exhibition at the Los Angeles County Museum.[74] "Pete went back to the studio and started stacking rocklike forms. You could see the influence right away."[75] In Wotruba, Voulkos saw sculptural, jagged forms and rough, matte surfaces, which were a tonic to the traditional, curvilinear shapes and smooth, high-gloss glazes of studio pottery. Voulkos also noted that Wotruba did not attempt to create organic wholeness through additive parts, that the pieces were no longer seamlessly merged but abruptly juxtaposed. This method of splicing compositional components, first explored by Gauguin and later by Picasso, was revived in new form in the mid 1950s in assemblage sculpture, which asserted that the process of making a work should be revealed not concealed. In assemblage, as in Zen, Voulkos found a way out of the European aesthetic of the well-made objet d'art, and a way into an aesthetic that embraced the discarded and ugly. Unlike John Chamberlain's crashed car bodies and Mark di Suvero's railroad ties, however, Voulkos's sculpture materials were not found objects but clay fragments. Nevertheless, Voulkos brought the sensibility of assemblage to clay, creating a large body of work that asserted the expressive power inherent in all materials.

Voulkos valued spontaneity, an artistic approach with roots in both surrealist automatism and Zen, and a method that puts the artist in touch with the unconscious and natural self. Voulkos makes process and spontaneity visible in *Sculpture*, 1957 (cat. 43), in which he stacks three, round, thrown forms, then alters them by cutting gaping holes and adding jagged protrusions. The result is a strange, anthropomorphic form. The formal components of *Sculpture*—three separate, spliced-together sections with gouged surfaces—are the basic elements of Voulkos's later stack pots, a body of work which he continues to this day.

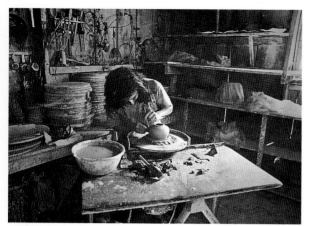

Janice Roosevelt Gerard working at the wheel, mid 1960s.

The strange creatureness of *Sculpture* recalls Miró's mysterious personages, which offered Voulkos an example of the surreal assemblagist imagination. Miró's work encouraged Voulkos to move in a more sculptural direction and work on a larger scale, tendencies seen in *Cat/Bird,* 1957 (p. 66), a bizarre hybrid animal. The smaller work, *Sculpture (Walking Man),* 1956 (cat. 40), is more whimsical and distinctly human but still reminiscent of Miró's fantastic beings. As a figure, *Walking Man* would seem to be an anomaly in Voulkos's early work because since the 1970s his forms have been dominated by stack pots, plates, and ice buckets. But the figure is an early and enduring theme in his art: it appears clearly in the painted faces on his pots of the mid 1950s, in his monumental clay assemblages of the late 1950s, and in his small bronze sculptures of the early 1960s such as *Bather* (p. 67). *Walking Man* is a precursor to more recent small figures, six to eleven inches in length, which Voulkos calls "dolls." The archaism of these figures, which recall prehistoric fertility goddesses, is a return to the primitivism begun in the mid 1950s. Voulkos's recent figures are female, whereas *Walking Man* is definitely male. Like kiln gods, figures which Voulkos made and put into the kiln as part of the ritual of firings, *Walking Man* was assembled from scraps of clay, a method he has continued in the archaic "dolls." In contrast to his recent unglazed surfaces, however, *Walking Man* wears high-keyed, glossy colors. This bright palette owes a debt to Miró's colorful ceramic sculptures, which Voulkos admired. Brighter glazes enter Voulkos's work in 1956 and continue into the early 1960s. During this period, he searched for ways to break away from the subdued color range of traditional high-fire stoneware production pottery. One method, seen in *Walking Man,* was to use commercial glazes fired at a lower temperature. Mason recalled that Voulkos was interested in color and, as early as 1954–55, he bought lustres and china paints.[76] Soldner recalled that in 1956, when he needed bright color for a tile mural commission, Voulkos took him to buy low-fire glazes. After Soldner had finished the work and was about to throw away the leftover glazes, Voulkos asked if he could use them.[77] Voulkos applied the glazes over stoneware that had been fired to a high temperature, then refired the work at a lower temperature. About the same time in other works, Voulkos created vivid color by applying pigmented epoxies directly on fired work, which produced a more opaque surface than did glaze.

Walking Man anticipates the turn to bright color and low-fire glazes, which transformed ceramics in the 1960s and 1970s. While bright color was only one of several areas of experimentation for Voulkos, it became the primary focus for later artists. Whereas Voulkos applied low-fire glazes to high-fire stoneware, the next generation used low-temperature glazes on low-temperature clay. These artists also turned away from expressionist form and returned to identifiable objects, inspired not by Zen but by popular culture. In retrospect, Frimkess said, "I see 1958 as the momentous divergence from the high-fire tradition established with Voulkos a few years earlier."[78] Although Voulkos was a forerunner in the move to low-fire glazes, he did not pursue this direction, but turned his attention in the early 1960s to bronze sculpture.

Another forerunner in the turn to low-fire glazes was John Mason, who also recalled the Miró exhibition as significant. He was impressed that Miró, a painter, was interested in ceramics.[79] Mason had turned his attention to color when he was studying at Chouinard in 1953–54, before he saw the Miró show and before he came to Otis. He recalled that "Generally, the direction at Otis was monochromatic. A few times, I started to mix glazes and I got quizzical looks. But when I had some success, I got different reactions. These pieces were high-fire but in fairly bright colors."[80] Examples of Mason's high-keyed colors are seen in two works from the Otis period, *Vase,* 1958 (cat. 23) and *Container ("X"),* 1958–60 (cat. 24). These works also demonstrate Mason's interest in revealing the process of making the work, an attitude he could have found in Zen. Mason summarized that "Zen was tangible." Mason had heard Alan Watts lecture on Zen and also absorbed Zen attitudes from his own reading and from meeting a Zen master when he was at Chouinard.[81] Mason's fascination with process was also reinforced by abstract expressionism, which emphasized gestural impasto. This painterly sensibility is most evident in Mason's large ceramic murals, in which he explored the fluid malleability of clay. Like Voulkos, Mason was interested in creating works that blurred the boundaries separating painting, sculpture, and ceramics. Thus, *Vase* and *Container* are vessels, but their forms are sculptural and their surfaces painterly. These works are the precursors of Mason's large ceramic sculptures of the late 1950s and early 1960s, in which he challenged traditional assumptions of clay's scale limitations as a sculptural medium. In 1957, along with Rothman and Soldner, Mason exhibited his works, including ceramic murals at Ferus Gallery, founded by Walter Hopps and Ed Kienholz. This show indicated the growing interest in the Otis group. In 1961 Mason's ceramic sculptures were featured in a solo show at the Pasadena Art Museum. In this exhibition Mason demonstrated that clay was a powerful medium for large-scale sculpture.

Mac McClain had worked as a teaching assistant to Richard Petterson at Scripps, where he had produced functional pottery; but soon after he arrived at Otis in March 1955, he began to destroy the symmetry of the wheel-thrown form. In *Vase,* 1957 (cat. 25), for example, McClain flattened the vessel with a board and left the edge marks visible to expose both his process of working and the texture of the material because, he says, "We were interested in the nature of clay itself."[82] Marer acquired this piece from McClain's first exhibition at Otis, which helped McClain earn enough that year to support himself from the sale of his work.[83] After a dispute with Sheets over a commission, McClain left Otis at the end of 1955. In January 1956 he began working at San Diego Ceramics in La Jolla. In 1957 McClain started the ceramic program at the Art Center in La Jolla, which he ran until 1964. During this period McClain continued to move away from functional pottery to create wheel-thrown forms that he tranformed into sculptural vessels. In 1964 McClain taught sculpture and drawing at Pomona College, sculpture at the Claremont Graduate School, and ceramics at University of California at Berkeley. From 1965 to 1986 McClain taught sculpture and ceramics at California State University, Los Angeles. In addition to ce-

ramics, McClain pursued painting and poetry, artistic interests which he continues today. Not only has McClain been an artist and teacher, but he has also written art criticism for *Artweek,* publishing under the pen-name Mac McCloud. From 1976 to 1981 McClain taught both poetry and sculpture at the Otis Art Institute.

As a student at Otis, Soldner experimented with the vessel, but he did not question the symmetry of traditional thrown forms as much as their modest scale. During 1954–56 Soldner created narrow, vertical cylindrical pots, most of which were four to six feet tall (p.56). Soldner did not produce these forms by attaching preformed sections, but by adding a ring of clay to the rim and melding the clay as he worked on the wheel. This "extended throwing" technique, as he called it, was possible because he had designed a special wheel with a foot pedal, which he could control even when he was standing on a stool.[84] Soldner began to experiment with more freely formed vessels in the late 1950s and early 1960s. When he began experimenting with raku in 1960 at Scripps, he fully embraced the Zen aesthetic of the accidental, which he had first encountered at Otis. Although Soldner had been exposed to a freer way of working at Otis, he recalls an impromptu visit by Kaneshige to Scripps in 1958 as a turning point. Kaneshige couldn't speak English, but Soldner "gave him clay and was fascinated to watch him throw. He made little pots but with a freedom I hadn't seen. He also trimmed the pots with a twig he had broken off an orange tree outside the studio." Soldner, who put Kaneshige's pots up on a shelf, remembered, "They were small but had a presence. Over the next two weeks, they grew in my head to be huge. That was the beginning of a new freedom in my work."[85] This freedom is first seen in such works as *Vase,* 1961 (cat. 32), in which Soldner alters the thrown pot, attaching pieces of clay to the neck and body. This work is an early example of his technique of throwing a vessel then changing its shape by attaching sections of clay. In Soldner's works of the 1980s and 1990s, these additions transform the vessel into sculpture, but the sense of the container remains. Another precursor of these later works is seen in *Bottle with Face (Sophia Loren)*, 1958–59 (cat. 31), in which Soldner pinched the neck and hit the side of the pot. Marer was interested in buying this work, but Soldner told him it wasn't available, because it was cracked and therefore was a "second." But Marer, who wanted the work, answered, "Then give me a first." Soldner says that Marer's comment helped him to see his work in a new way.[86] The face on the pot, inspired by Sophia Loren and drawn in a loose, Picasso-esque manner, introduces the theme of the female figure, which re-emerges in the popular imagery of Soldner's later wall sculptures of the 1960s.

The figure also appears in Ken Price's Otis-era works, such as *Vase,* 1956 (cat. 26), and *Vase,* c. 1958 (cat. 27). Price had studied in 1953–54 with Susan Peterson at Chouinard and at the University of Southern California in 1956. From Peterson, who had been trained at Alfred University in New York, Price learned high-fire stoneware and glaze calculation, but he was drawn to Voulkos's program at Otis. Price recalled that he was aware of Voulkos before he went to Otis; he used to visit the Otis studio and watch Voulkos work. Price and Bengston saw Voulkos give a demon-

stration and were impressed with his skill.[87] During 1957, when Price worked with Voulkos, he used the dark, matte glazes that dominated at Otis, but he felt limited by this dark palette and attracted by the bright colors in the work of Miró, Matisse, and Mexican art.[88] After leaving Otis, Price served in the military reserves for six months and went to New York, where he was impressed by an Arp exhibition at the Museum of Modern Art. In 1959 Price completed an MFA at Alfred; there he learned the glaze technology that he used to create the brilliant colors of his mature works. As he recalled, "I didn't like the dark brown [at Otis]. I went to Alfred to figure out how to make color."[89] But the seeds of his mature style are seen in such Otis-era works as *Vase*, 1956 (cat. 26), whose hard-edged design looks ahead to the controlled forms of his later work.

Clay studio, new art building, Otis, 1956

Like Price, Billy Al Bengston's Otis works are also decorated with figures drawn in dark glazes, as seen in *Flower Pickers*, 1956 (cat. 20). Bengston's nude male and female figures and the title of *Moontan*, 1957 (cat. 21), convey the high-spirited hedonism of that time. The free brushwork of the latter reflects Bengston's interest in abstract expressionism, which he and Price saw in exhibitions in Los Angeles. Bengston was also interested in Japanese ceramics, especially Oribe, Bizen, and Karatsu ware.[90] After leaving Otis in June 1957, Bengston abruptly turned from ceramics to painting because he said, "I had no interest in being a folk artist and I had no interest in being a school teacher."[91] By 1957 Bengston was also exhibiting at Ferus Gallery, then the most avant-garde exhibition space in town. Through his involvement with the other Ferus artists, including Craig Kaufmann, Bengston helped shape the "finish fetish" movement. The terms seems an apt description of his paintings from the 1960s in lacquer and polyester resin on aluminum.

Michael Frimkess also decorated pots with figural imagery, but he used incised drawing to create a cruder style. Frimkess, who had begun studying sculpture at Otis in 1954, studied with Voulkos from the fall of 1956 to the spring of 1957. During this time, following Voulkos's lead, he used a stencil technique to create flat shapes that bridged the gap between abstraction and figuration. Marer recalls that Frimkess was smitten with the dancer Allegra Kent and alluded to her in *Plate*, 1960 (cat. 22).[92] At Otis, Frimkess admired Greek amphorae that Voulkos had made for a Hollywood movie, and in the summer of 1957, Frimkess was further impressed by Etruscan amphorae, which he saw while living with his wife in southern Italy. During travels in New York, Frimkess saw more amphorae, which inspired his own turn to classical vessel forms in the mid 1960s. Although his Otis works don't predict the shapes of his later works, they do reveal his focus on drawing, which emerges fully in his later cartoon style.

Drawing was also important for Jerry Rothman who, at Otis, worked in ceramics with Harrison McIntosh (September 1956 to June 1957) and Wayne Long (July-August 1957), before entering Voulkos's

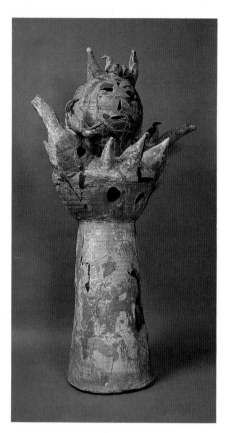

Peter Voulkos, *Cat/Bird,* 1957.

class in September 1957. In *Shallow Bowl,* 1958 (cat. 29), Rothman drew a portrait of himself with a painting student at Otis, Karen Neubert. Here Rothman applied his design in white slip, cobalt and iron oxides under a clear glaze. But like Price, he began to feel limited by the dark colors that were prevalent at Otis. As he recalled, "I never liked brown. I used to make everything as colorful as I could."[93] From 1958 to 1960, Rothman worked as an industrial designer in Japan, where he saw firsthand the work of Shoji Hamada and Kanjiro Kawai. In Japan, Rothman also discovered beautiful color effects produced by sand on clay slabs fired in large wood-burning kilns. He returned to Otis in 1960 and developed a technique, seen in *Sky Pot,* 1960 (cat. 30), which achieved a similar range of color. Rothman recalls that he mixed sand with colored oxides on a piece of paper, then rolled the clay onto the paper, transferring the image onto a vessel form. Rothman did not discover this technique by accident. He said, "It's about being open to what's around you. Artists are disciplined observers who learn from what they see."[94] The abstract imagery, evoking clouds, points to his interest in nature, which was strengthened during his stay in Japan.

Janice Roosevelt began studying with Voulkos in September 1956 and worked with him until he left in 1959. She credits Voulkos with showing her how to build larger pieces and join sections together so they would not crack. But she learned more about glazing from John Mason, who was also interested in brighter color. Roosevelt developed skills not only in inventing glazes but also in firing the kiln to achieve her desired results. Like others in the Voulkos circle, she was interested in Japanese pottery and was impressed by a visit to Otis in 1958 by Kaneshige, a Living National Treasure (an honor awarded by the Japanese government), who lectured and gave a demonstration. The natural, organic shapes of Roosevelt's *Candelabra,* 1959 (cat. 28), reveal the impact of the Japanese aesthetic on her work of that period.

Henry Takemoto also remembered the visit of Kaneshige, which he said attracted ceramists from all over Los Angeles. Takemoto, who had received his BA in 1957 from the University of Hawaii, studied briefly at California College of Arts and Crafts, in Oakland, before coming to Otis in the fall of 1957. At CCAC he had been impressed with the writings of Kandinsky, whose concept of the intuitive in art shaped his own aesthetic.[95] At Otis, Takemoto also found a subjective approach in abstract expressionism, which he saw during excursions with Voulkos to exhibitions at the Los Angeles County Museum. Voulkos also encouraged Takemoto to work intuitively to find his own personal expression embodied in clay. Takemoto's works from this period—*First Kumu,* 1959 (cat. 33), *Flag,* 1960 (cat. 34), and *Plate,* 1960 (cat. 35)—reflect his search for self-expression through fluid decoration, which he created in lyrical patterns with a Chinese brush.

In the late 1950s and early 1960s, the Otis artists dispersed. By 1958 when Voulkos resigned, Mason, McClain, Soldner, Frimkess, Bengston, and Price had left; only Takemoto, Roosevelt, and Rothman remained to finish their degrees. During this period, these artists experienced change not only in their own lives but also in the art world, which

underwent an aesthetic transformation from the inward focus of abstract expressionism, guided by existentialism and eastern philosophy, to the outward concentration of pop and minimalism, inspired by popular culture and modern technology. This change of values in art—from the metaphysical to the mundane and from the psychological to the physical—created a corresponding shift in styles from those stressing spontaneity to those emphasizing preconception. This turn away from a free subjectivity to a controlled objectivity is evident in the hard-edge forms of pop art, systemic painting, and minimal sculpture.

THE OTIS LEGACY

Although thirty years have passed, the Otis era continues to have an impact on these artists. For Soldner, part of the legacy of Otis has to do with technical lessons learned from Voulkos, such as how to both rip and mend the clay surface: "One thing I saw Pete do was to gouge the surface...then to heal the raw tear in the surface with another touch. He didn't talk about it, but I saw him do it. So when I push something patterned into clay, I then...mute the impression. It's not as rough and it becomes part of the piece."[96] For Rothman, the lessons were philosophical. In the spirit of Zen, Voulkos's goal was to stop being a teacher; instead, Voulkos created a studio where everyone learned from each other. Voulkos also encouraged his students to learn from failure by modeling that attitude in his own work. In 1978 he expressed his philosophy, "I said a long time ago, there's no such thing as a mistake. It's just a continuation of your thinking. If something doesn't come off, think about it and jump ahead next time."[97] The courage to experiment, which Voulkos gave his students at Otis, has sustained them through their careers. Voulkos himself reaffirmed the expressionist values that had motivated his early work. In 1983 he reiterated the importance of process to his artistic method: "Maybe the best label is abstract expressionist. That means I have to get into my material before I know exactly where I am going. I am not a conceptual artist."[98] Voulkos still finds meaning in the expressionist gesture that embodies risk and spontaneity: "When I started thirty years ago or so, I tried all kinds of things, but...I'm still trying to get it down to a very simple gesture, one where the risks are great, but spiritually rewarding."[99]

Although Voulkos was a powerful presence, as a teacher he encouraged his students to follow their own artistic directions. Bengston, Frimkess, Mason, McClain, Rothman, Roosevelt, Soldner, and Takemoto all created distinctly different bodies of work. Their strong sense of individualism has its roots in their experience at Otis, where Voulkos created an environment that gave them the opportunity to develop in their own ways and to make their own artistic decisions. In other words, Voulkos helped turn his students into artists. He also acknowledges the impact of teaching on his own work: "I have learned more from my students than they have from me."[100]

The Otis group had a significant influence on contemporary ceramics not only as artists but also as teachers. Voulkos taught at University of California, Berkeley (1959–1985); Mason at Pomona College

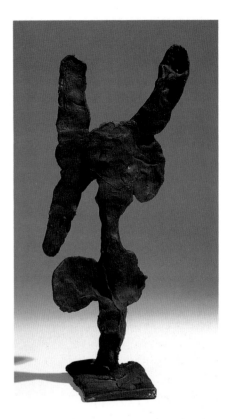

Peter Voulkos, *Bather,* 1960, bronze.

(1960–1967), University of California, Irvine (1967–1974), and Hunter College (1974–1985); McClain at California State University, Los Angeles (1965–1985); Rothman at California State University, Fullerton (1971–present); and Soldner at Scripps College (1957–1965 and 1968–1991). During thirty years of teaching these artists influenced thousands of young ceramists.

The expressionist moment at Otis lasted only six years, from 1954 to 1960, but its creative energy was documented in the works collected by Fred Marer, who with astute foresight recognized the importance of this dynamic chapter in contemporary ceramics. During the last three decades art in clay has seen a proliferation of styles, many of which have rejected the expressionist aesthetic associated with the Otis era. Like painters and sculptors of our time, ceramists have embraced a stylistic pluralism which points to an underlying belief, modernist in origin, that heterogeneity is preferable to homogeneity. Even many artists working today who never studied with Voulkos have benefitted indirectly from his example because at the heart of the "revolution in clay" he began at Otis is a sense of permission and possibility. What Voulkos gave to his students at Otis—and what they, in turn, have given to later generations of artists—is a feeling of freedom, which encourages artists to develop their own visions, often in contradiction to those of their teachers. Most important, Voulkos and the Otis group revolutionized contemporary ceramics by refusing to accept clay's traditional status as craft and by insisting instead that clay be seen as art. As Voulkos said in 1981, "I don't teach students how to make pottery. I teach them how to think."[101] This ultimately is the Otis legacy, the revolutionary idea that clay—like paint and stone—is another medium for thought.

NOTES:

1 Fred Marer, conversation with Mary Davis MacNaughton and Martha Drexler Lynn, Los Angeles, 12 April 1994.

2 Mac McClain, telephone conversation with the author, 12 November 1993.

3 Rudy Autio, interview by Lamar Harrington, 10 and 12 October 1983, Archives of American Art, Smithsonian Institution, 9.

4 Manuel Neri, quoted in Thomas Albright, "Peter Voulkos, What Do You Call Yourself?" *Art News* (October 1978), 120.

5 In 1949 Voulkos won a prize at the Ceramics National Exhibition in Syracuse, New York. In 1952 he won again at the Wichita Decorative Arts Annual show and in that same year had a solo show at American House in New York. Rose Slivka, *Peter Voulkos: A Dialogue with Clay* (New York: New York Graphic Society in association with American Crafts Council, 1978), xiii.

6 Peter Voulkos, quoted in Taylor, "Voulkos' Clay Explodes from Craft Into Art," *Boston Sunday Globe* (17 May 1981), A3.

7 Manuel Neri, quoted in Albright, 120.

8 Ibid, 121.

9 Voulkos, quoted in Albright, 120.

10 Letter from Rudy Autio to the author, 1 June 1994.

11 Bernard Leach, "Towards a Standard," in *A Potter's Book* (London: Faber & Faber, 1940), reprinted in Garth Clark, ed., *Ceramic Art: Comment and Review, 1882–1977* (New York: E.P. Dutton,.1978), 61, 70.

12 See David J. Clarke, *The Influence of Oriental Thought on Postwar American Painting and Sculpture* (New York: Garland Publishing, Inc., 1988), 85–131.

13 For a history of the ceramic program at Black Mountain College, which was begun by Karen Karnes and David Weinrib, see Martin Duberman, *Black Mountain: An Exploration in*

Community (New York and London: W.W. Norton, 1972, reprint, 1993), 362–365. For a discussion of the summer session of 1953, during which Daniel Rhodes, Warren MacKenzie, and Peter Voulkos each taught a three-week class, see also Mary Emma Harris, *The Arts at Black Mountain College* (Cambridge: MIT Press, 1987), 234 .

14 Telephone conversation with Peter Voulkos, 4 June 1994. In 1952–53 Cage was engrossed in Zen. Writer Francine du Plessix Gray recalled Cage lecturing on the Buddhist idea of undifferentiation between ugliness and beauty and the role of accident in art and life. For a discussion of Cage, Zen, and various accounts of the mixed-media event, see Duberman, *Black Mountain,* 368–378. Cage recalled, "I had the good fortune to attend Daisetz Suzuki's classes in philosophy at Columbia University in the late forties. And I visited him twice in Japan....The Buddhist texts to which I often return are the *Huang Po Doctrine of Universal Mind...*first published by the London Buddhist Society in 1947...." in John Cage, "An Autobiographical Statement," *Rolyholyover: A Circus* (Los Angeles and New York: Museum of Contemporary Art and Rizzoli, 1993), n.p.

15 Voulkos, interview with Mary Emma Harris, 24 December 1971, in Harris 1987, 234, 262.

16 Albright, "Peter Voulkos," 120.

17 Voulkos, untranscribed taped interview, conducted by Elaine Levin, 1971, Berkeley, Department of Special Collections, University Research Library, University of California, Los Angeles.

18 Autio, interview by Lamar Harrington, Archives of American Art, Smithsonian Institution, 36.

19 Registrar's records, Otis School of Art, show Soldner in Voulkos's class Sept. 1954–June 1956; Soldner also took a post-graduate level with Voulkos, Sept. 1956–Jan. 1957; Edwards was registered Oct. 1954–June 1957. In order to get funding from the GI Bill, Soldner had to find an MFA program. He wrote for advice on programs to potters Jim and Nan McKinnell, whom he had met in Boulder, Co. Their return letter came from Archie Bray, where they were working with Voulkos. They recommended that Soldner study with Voulkos, who was heading a new program at Otis. At the same time, Soldner had been impressed with Voulkos's prize-winning work, which he had seen illustrated in *Craft Horizons.* Paul Soldner, in "Vessels of Celebration: Paul Soldner," interview by Elaine Levin, transcribed oral history, 3-4 September 1980, Department of Special Collections, University Research Library, University of California, Los Angeles, 51.

20 John Mason, telephone conversation with the author, 16 September 1993.

21 Registrar's records, Otis, indicate that Mason was registered in Long's evening ceramics, May–June 1955; in McIntosh's evening ceramics, Sept.–June 1956; and in Voulkos's class, Sept. 1956–June 1957.

22 Registrar's records, Otis, list McClain studying with Voulkos, March 1955–Jan. 1956.

23 According to the Registrar's records, Otis, Bengston was registered Sept. 1956–June 1957; Frimkess, Oct. 1956–mid-spring 1957; Price, Jan.–Dec. 1957; Rothman Sept. 1957–June 1958; and Takemoto, Sept. 1957–Jan. 1959. Other students during this period were Lou Bertrando and Annette La Porte.

24 See Cheryl White, "Towards an Alternative History: Otis Clay Revisited," *American Craft* 53, no. 4 (August 1993), 121.

25 Janice Roosevelt Gerard, telephone conversation with the author, 15 September 1993.

26 Paul Soldner, conversation with the author, 20 September 1993.

27 Fred Marer, untranscribed taped interview by Brian Yancey, Los Angeles, 1983.

28 Soldner, in "Vessels of Celebration," 97.

29 Ken Price, telephone conversation with the author, 3 September 1993.

30 John Mason, conversation with the author, 18 March 1993.

31 Carol Radcliffe Fisher, conversation with the author, 10 November 1993.

32 Marer, "Reminiscences," in Doug Humble, et.al., *Earth and Fire: The Marer Collection of Contemporary Ceramics* (Claremont: Galleries of the Claremont Colleges, 1984), 11, and conversation with the artist, 12 April 1994.

33 Janice Roosevelt Gerard, telephone conversation with the author, 15 September 1993.

34 Ken Price, telephone conversation with the author, 3 September 1993.

35 Fred Marer, conversation with the author, 12 April 1994.

36 Fred Marer, interview conducted by the author and Doug Humble, Los Angeles, 22 July 1993.

37 Janice Roosevelt Gerard, telephone conversation with the author, 15 September 1993.

38 Paul Soldner, conversation with the author, 20 September 1993.

39 Ken Price, telephone conversation with the author, 3 September 1993.

40 Levin, "Vessels of Celebration," 74–75.

41 Voulkos was inspired by the fusion of disparate artistic forms in Japanese folk pottery and flamenco music. As he said, "It was all the primitive stuff like Yamamoto and the old potters of Japan, who arrived at a certain point, then transcended it. It's very difficult to do in music, especially in flamenco." Voulkos, statement in Jim Leedy, "Voulkos by Leedy," *Studio Potter,* supplement to vol. 21, no. 2 (June 1993): 3.

42 Mike Frimkess, "From a Whiteware to a Stoneware Mentality," in Garth Clark, ed. *Michael and Magdalena Frimkess: A Retrospective View* (Los Angeles: Garth Clark Gallery, 1982), 8.

43 Levin, "Vessels of Celebration", 77.

44 Ibid., 72.

45 Capra, *The Tao of Physics* (Boston: Shambala, 1991), 34.

46 Gibson, "Abstract Expressionism's Evasion of Language," *Art Journal* 47, no. 3 (Fall 1988), 208-214.

47 Levin, "Vessels of Celebration," 104.

48 Marguerite Wildenhain, interview by Hazel Bray, 1982, Archives of American Art, Smithsonian Institution, 42.

49 Levin, "Vessels of Celebration," 107.

50 Ibid., 106. Voulkos, telephone conversation with the author, 4 June 1994.

51 Levin, "Vessels of Celebration," 100.

52 Ibid., 100–101.

53 Albright, "Peter Voulkos," 121.

54 Voulkos, telephone conversation with the author, 4 June 1994. In 1977 Sheets recalled: "In my life I've never seen anything like what Pete Voulkos achieved in the first two years at Otis. It was incredible. He was at his height, as far as I'm personally concerned, in his work. His pots were magnificent....He had a great spirit, and the students were crazy about him. Then something happened. Pete became disinterested completely in ceramics as he had practiced it up to that point. He almost rebelled against everything that was skillful. He started just taking house paint and painting his pots if they had a low fire on them. He wasn't interested in the high fire. He just became a completely different kind of artist and immediately turned the department around. It's an unfortunate fact that I had to let him go after another year. The department was simply headed for the rocks. The respect for the medium, for the discipline, for what could be done in fine ceramics just went out the window. And it was tragic." Sheets in "Los Angeles Art Community: Group Portrait," interview by George M. Goodwin, Oral History Program, UCLA, 1977, 330–331.

55 Rose Slivka, "The New Ceramic Presence," *Craft Horizons,* no. 4 (1961) , reprinted in Garth Clark, ed., *Ceramic Art,* 142. The illustrations for this article feature several works by the Otis group from the Marer Collection. Like Harold Rosenberg, whose best known article coined the phrase "action painting" but did not discuss its practitioners, Slivka described a ceramic movement without commenting on specific artists or their works.

56 John Coplans, "Abstract Expressionist Ceramics," from catalogue by the same name, Art Gallery, University of California, Irvine (October 28–November 27, 1966) and The San Francisco Museum of Art (January 11–February 12, 1967), reprinted in Garth Clark, ed., *Ceramic Art,* 154. Although Coplans illustrated and discussed individual works by artists at Otis, he gave an incomplete picture of the group. He focused on Voulkos and Mason, briefly mentioned Frimkess, McClain, Bengston, and Price, and omitted Paul Soldner, who was Voulkos's first student at Otis. Coplans echoes Clement Greenberg in his claim that "ceramists set themselves to rediscover the essential characteristics of the medium."

57 Cheryl White, "Towards an Alternative History: Otis Clay Revisited," 122.

58 Peter Voulkos, untranscribed taped interview by Elaine Levin, Berkeley, 1978, Department of Special Collections, University Research Library, University of California, Los Angeles.

59 See Slivka, "The New Ceramic Presence,"139. Although Slivka mentions Picasso, Miró, and Zen as sources for the "new expression in American pottery," she does not demonstrate how they are reflected in specific works. Bernard Pyron also mentions these sources, but focuses most of his discussion on the impact of Zen on American artists. He examines Voulkos but not other artists in the Otis group. See "The Tao and Dada of Recent Ceramic Art," *Artforum* (March 1964), reprinted in Garth Clark, ed., *Ceramic Art,* 143–152.

60 See two *Vases,* both 1954, nos. 11–12 in Slivka, *Peter Voulkos,* checklist, n.p.

61 Ibid.

62 Voulkos, quoted in Conrad Brown, *Craft Horizons* (October 1956): n.p.

63 John Mason, telephone conversation with the author, 15 June 1994.

64 Voulkos, in Levin, untranscribed taped interview, 1971, University Research Library, University of California, Los Angeles.

65 Ibid. Voulkos also saw colorful decoration in the ceramics of Italian artist Salvatore Meli whose works were exhibited in the mid 1950s at Dalzell Hatfield Gallery in Los Angeles. The Marer Collection contains four works by Meli (see nos. 393–396).

66 Levin, "Vessels of Celebration," 78.

67 Ibid., 84. Soldner recalled, "We'd go to a Matisse show, come back, and there would be a Matisse-like focus. Never a copy, but the influence was there....One time we went to the County Museum and saw a [Conrad] Marca-Relli collage; and within a few days, Pete had worked out some Marca-Relli-like technique." In 1955, Voulkos could have seen an article by Parker Tyler, "Marca-Relli Pastes a Painting," *Art News* 54, No. 7 (November 1955): 44–47.

68 Levin, "Vessels of Celebration," 83.

69 Elaine Levin, interview with Vivika and Otto Heino, 4 March 1981, Archives of American Art, Smithsonian Institution, 60.

70 Voulkos named these works ice buckets after using one to store liquor. See Leedy, "Voulkos by Leedy," 36.

71 Voulkos, untranscribed taped interview conducted by Elaine Levin, Berkeley, 1971.

72 John Mason, quoted in Slivka, *Peter Voulkos,* 29.

73 Soldner, "Vessels of Celebration," 93. Voulkos, conversation with the author, 4 June 1994.

74 Soldner, conversation with the author, 20 September 1993.

75 Ibid.

76 John Mason, phone conversation with the author, 16 September 1993.

77 Soldner, conversation with the author, 20 September 1993.

78 Frimkess, "From a Whiteware to a Stoneware Mentality," 9.

79 Mason, conversation with the author, 16 September 1993.

80 Ibid.

81 Ibid.

82 Mac McClain, phone conversation with the author, 11 November 1993.

83 Ibid.

84 Elaine Levin, "A Life in Art," *Paul Soldner: A Retrospective* (Claremont, CA: Scripps College, in association with University of Washington Press, 1991), 16.

85 Paul Soldner, conversation with the author, 13 July 1993.

86 Paul Soldner, conversation with the author, 20 September 1993.

87 Ken Price, telephone conversation with the author, 3 September 1993.

88 Ibid.

89 Ibid.

90 Billy Al Bengston, interview conducted by Susan C. Larsen, 9 September 1980, California Oral History Project, Archives of American Art, Smithsonian Institution, 10.

91 Ibid., 8.

92 Fred Marer, conversation with the author, 22 July 1993.

93 Jerry Rothman, telephone conversation with the author, 18 March 1993.

94 Jerry Rothman, telephone conversation with the author, 14 November 1993.

95 Henry Takemoto, telephone conversation with the author, 14 November 1993.

96 Soldner, conversation with the author, 20 September 1993.

97 Voulkos, untranscribed interview conducted by Elaine Levin, Berkeley, 1978, Oral History Program, UCLA.

98 Voulkos in Bill Woodcock, "Voulkos on Voulkos," *Ceramics Monthly* (Sept. 1983): 54.

99 Ibid.

100 Voulkos, conversation with the author, 4 June 1994.

101 Voulkos in Taylor, "Voulkos Clay Explodes from Craft into Art," *Boston Sunday Globe* (17 May 1981), A3.

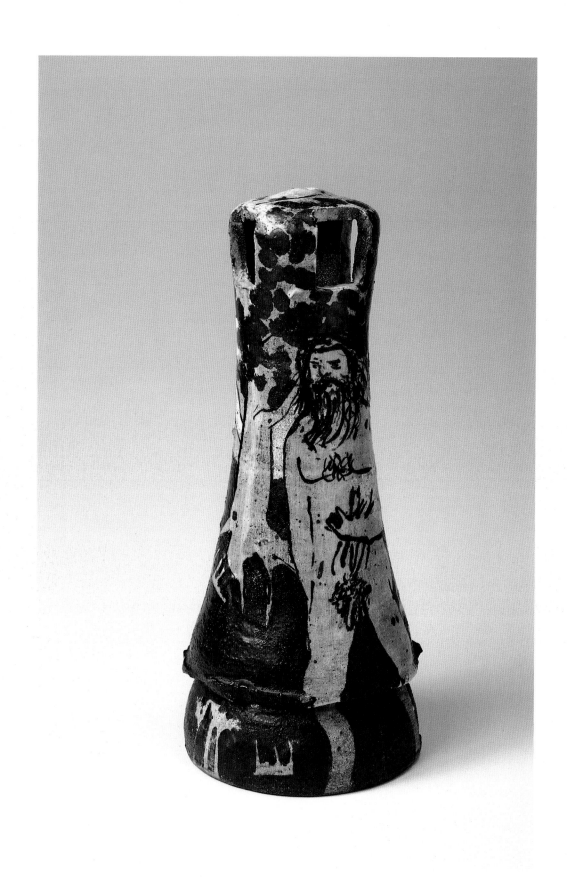

20
BILLY AL BENGSTON
Flower Pickers, 1956
Stoneware, glazed
13½ x 6 x 6
(87.1.3)

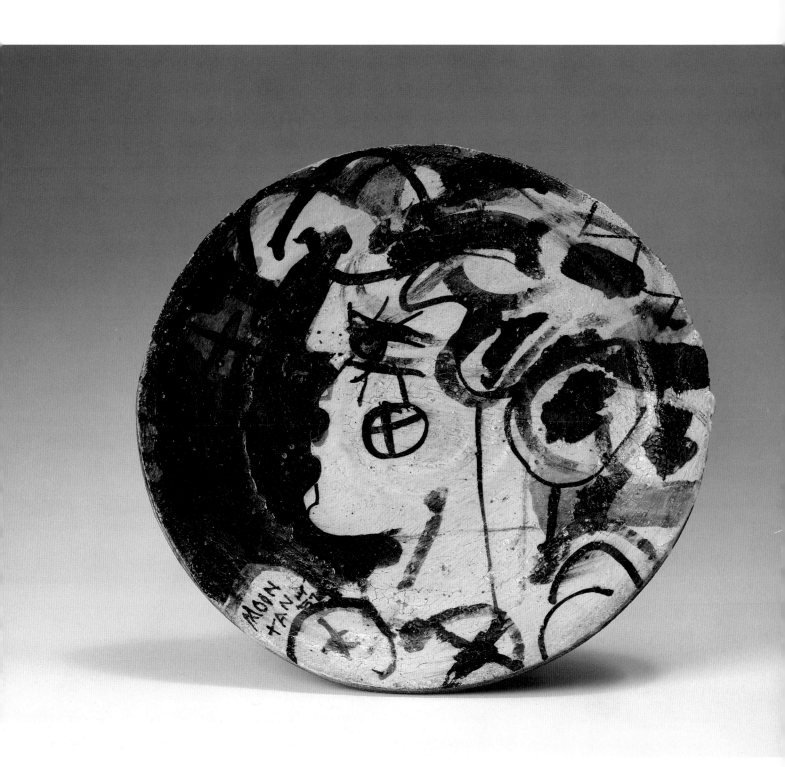

21
BILLY AL BENGSTON
Moontan, 1957
Stoneware, glazed
13 x 13 x 1¾
(87.1.4)

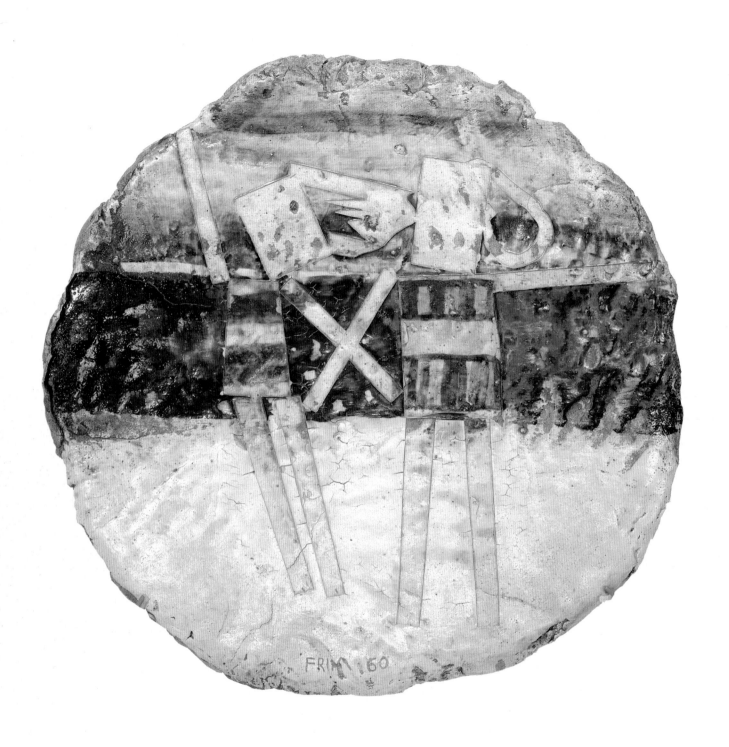

22
MICHAEL FRIMKESS

Plate, 1960
Stoneware, glazed
19 x 19 x 3
(92.1.2)

23
JOHN MASON

Vase, 1958
Stoneware, low-fire glazed
24 x 8 x 6½
(92.1.51)

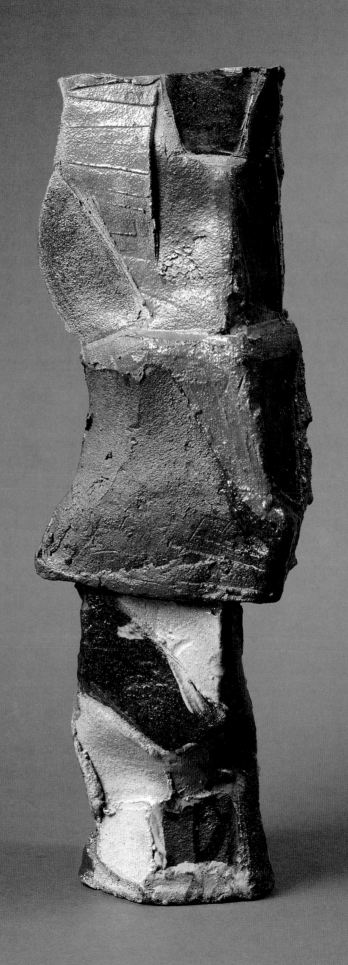

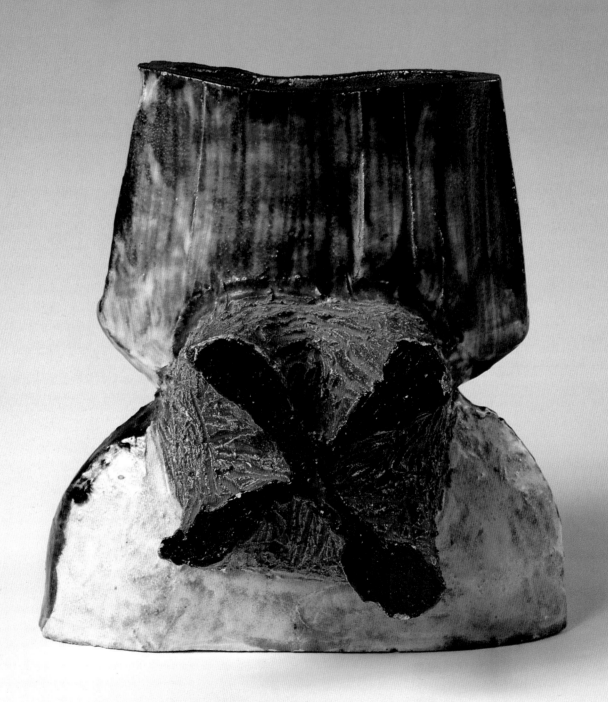

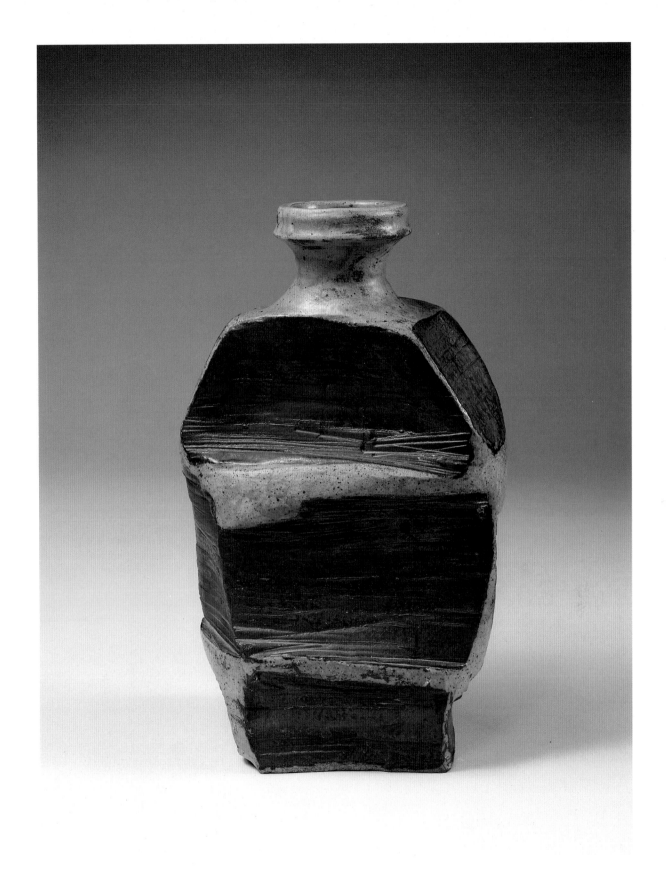

24
JOHN MASON
Container ("X"), 1958–60
Stoneware, low-fire glazed
12 x 11½ x 10
(92.1.47)

25
MAC McCLAIN
Vase, 1957
Stoneware, glazed
14⅝ x 8½ x 5½
(92.1.43)

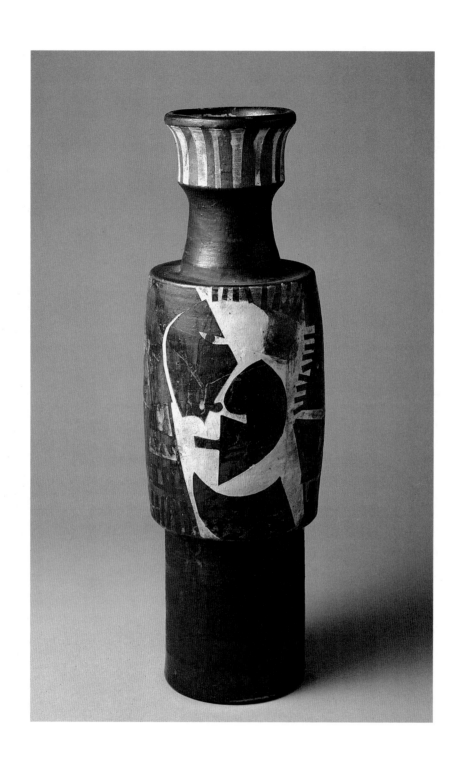

26

KENNETH PRICE

Vase, 1956

Stoneware, glazed

17½ x 5 x 5

(84.9.7)

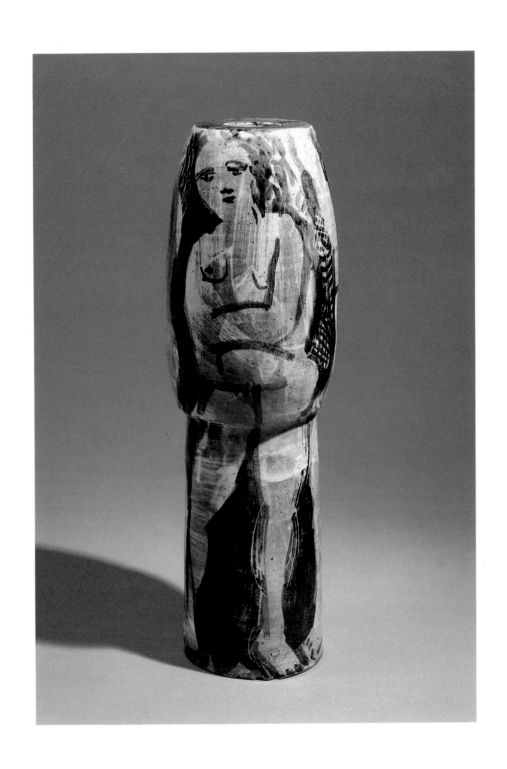

27
KENNETH PRICE
Vase, c. 1958
Stoneware, glazed
20 x 6 x 6
(92.1.62)

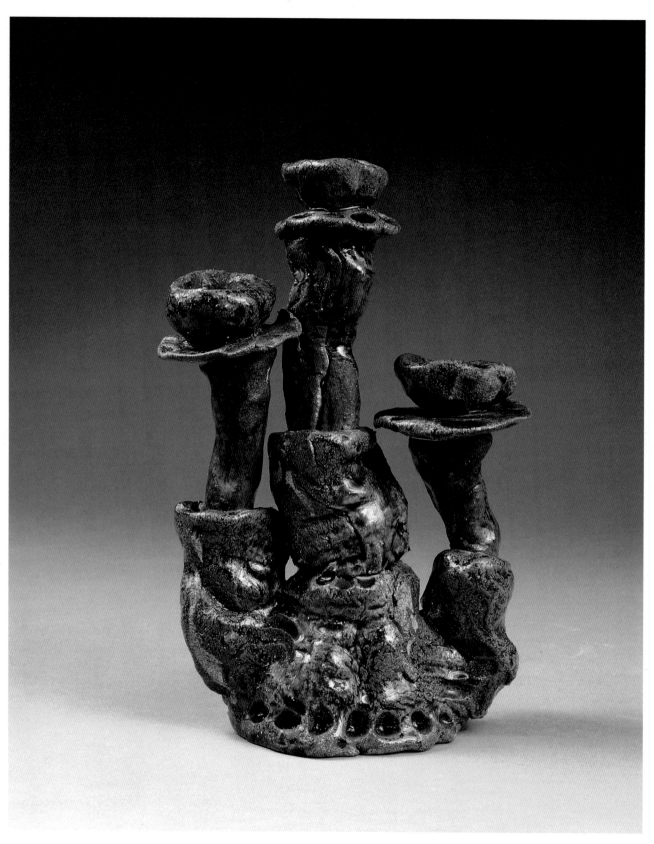

28
JANICE ROOSEVELT
Candelabra, 1959
Stoneware, glazed
10½ x 6½ x 3½
(81.8.11)

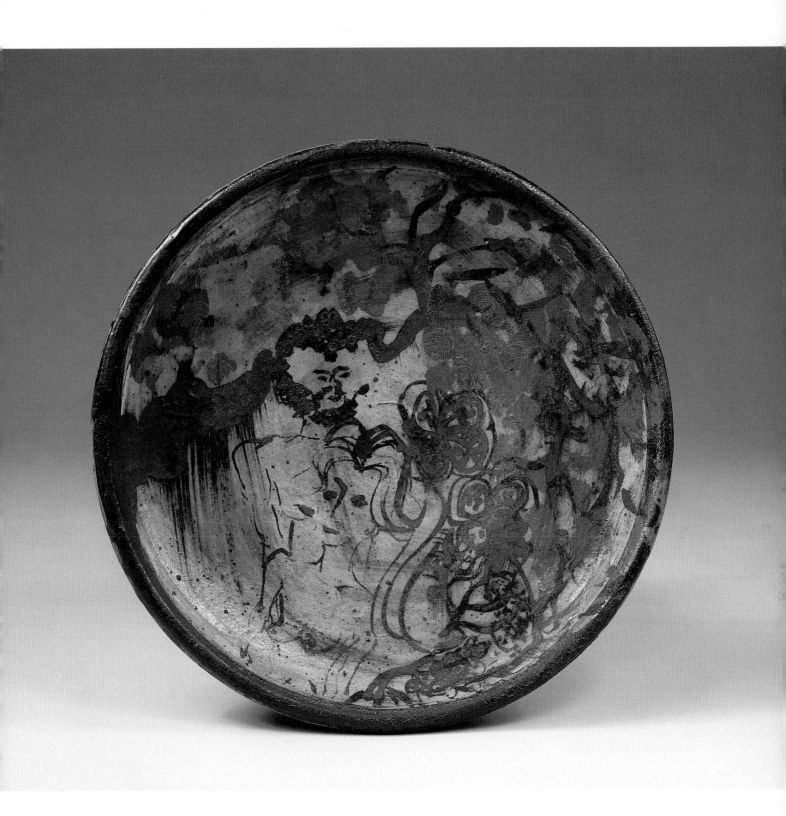

29

JERRY ROTHMAN

Shallow Bowl: Self-Portrait with Karen Neubert, 1958
Stoneware, glazed
16¼ x 16¼ x 3¼
(92.1.70)

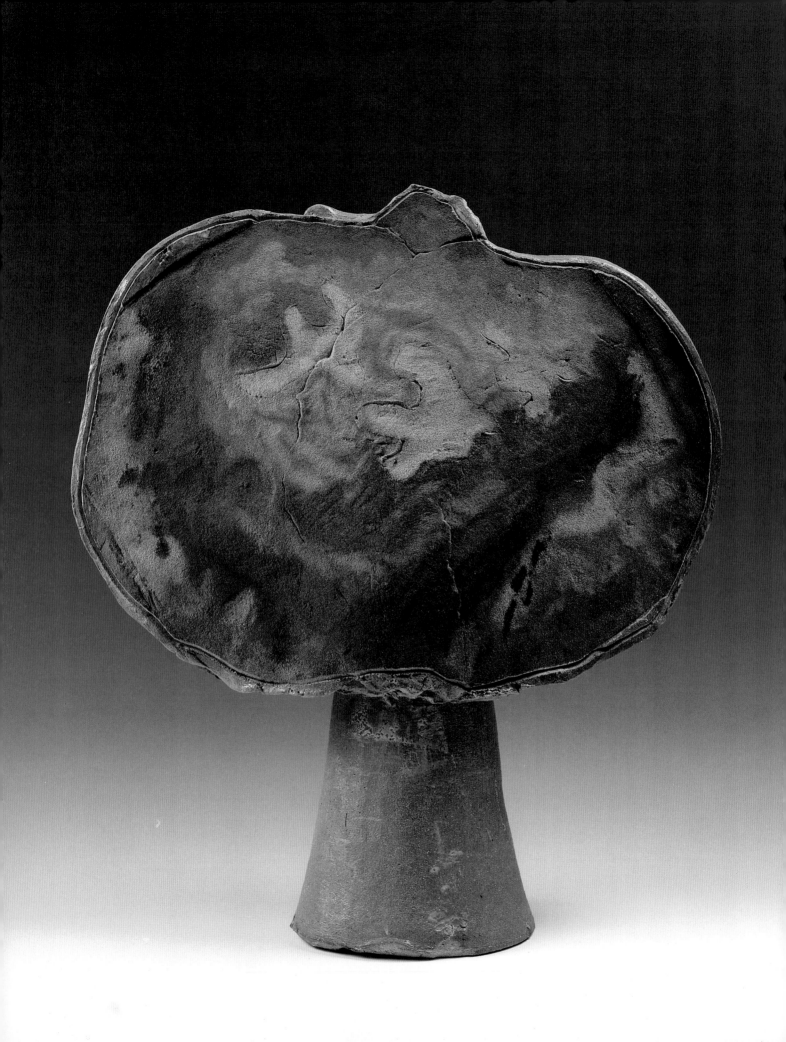

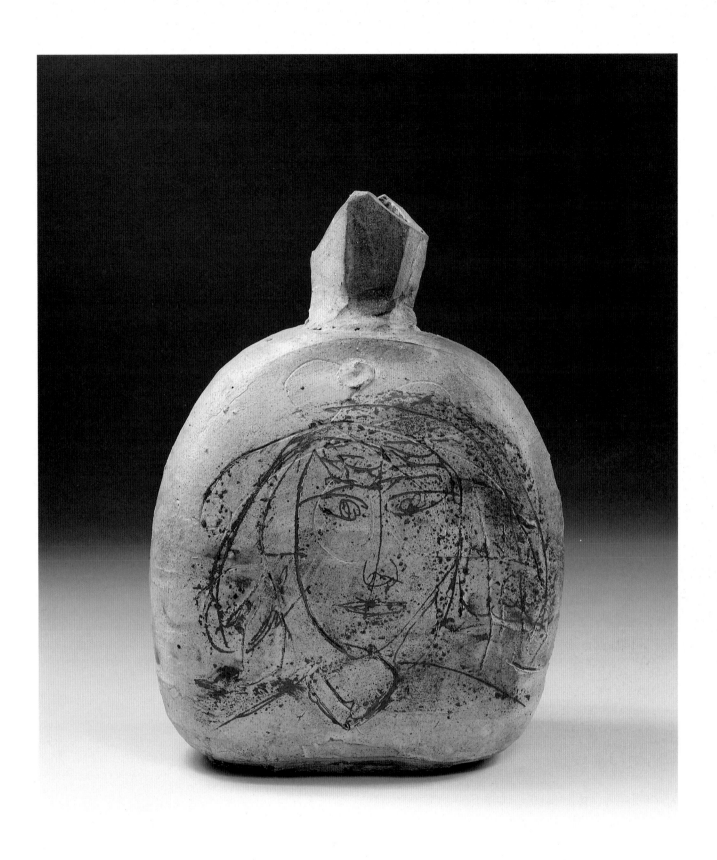

30
JERRY ROTHMAN
Sky Pot, 1960
Stoneware, unglazed
28½ x 25 x 9
(92.1.82)

31
PAUL SOLDNER
Bottle with Face (Sophia Loren), c. 1958–59
Stoneware, glazed
17 x 12 x 8
(92.1.94)

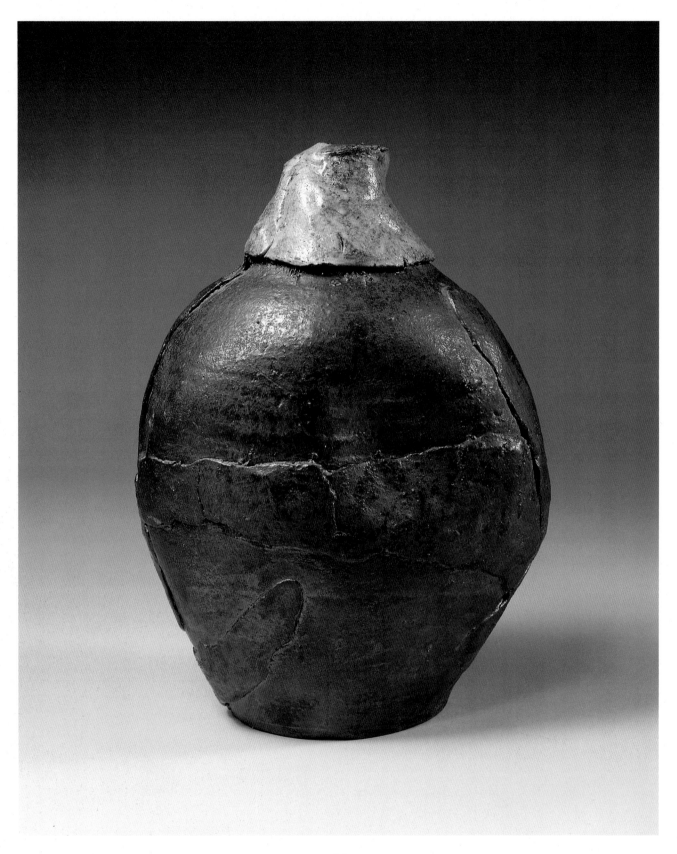

32
PAUL SOLDNER

Vase, 1961
Stoneware, glazed
18 x 11 x 9
(92.1.90)

33
HENRY TAKEMOTO

First Kumu, 1959
Stoneware, glazed
21¾ x 22 x 22
(92.1.113)

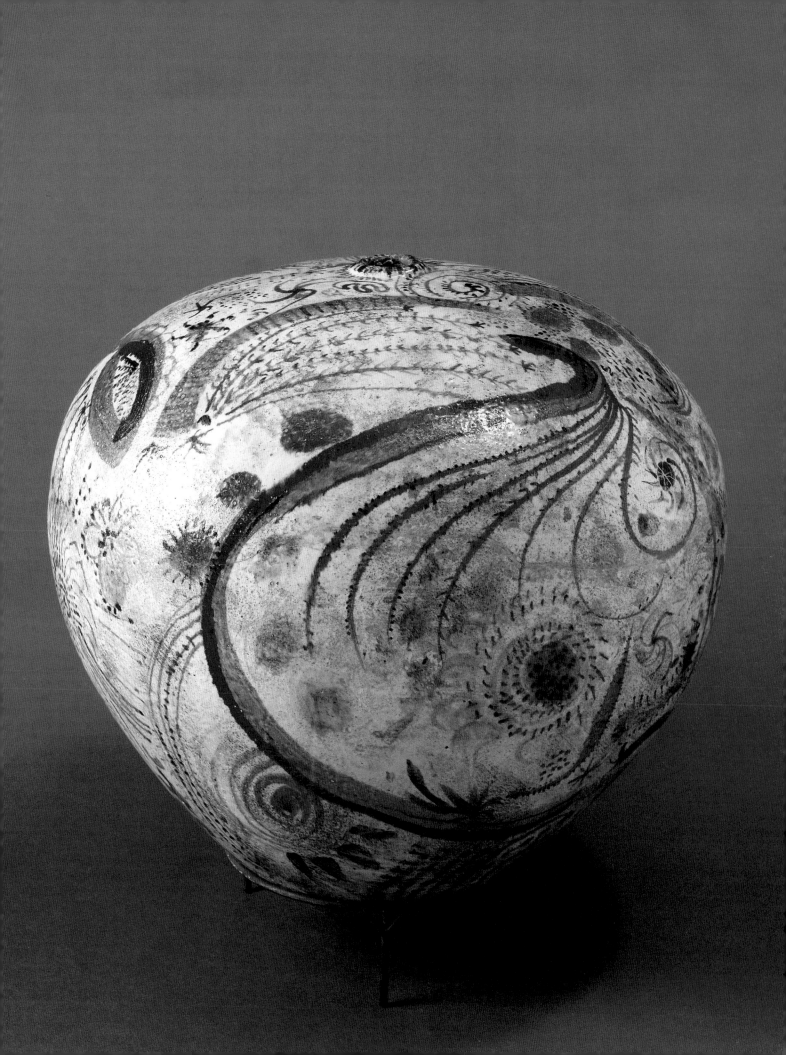

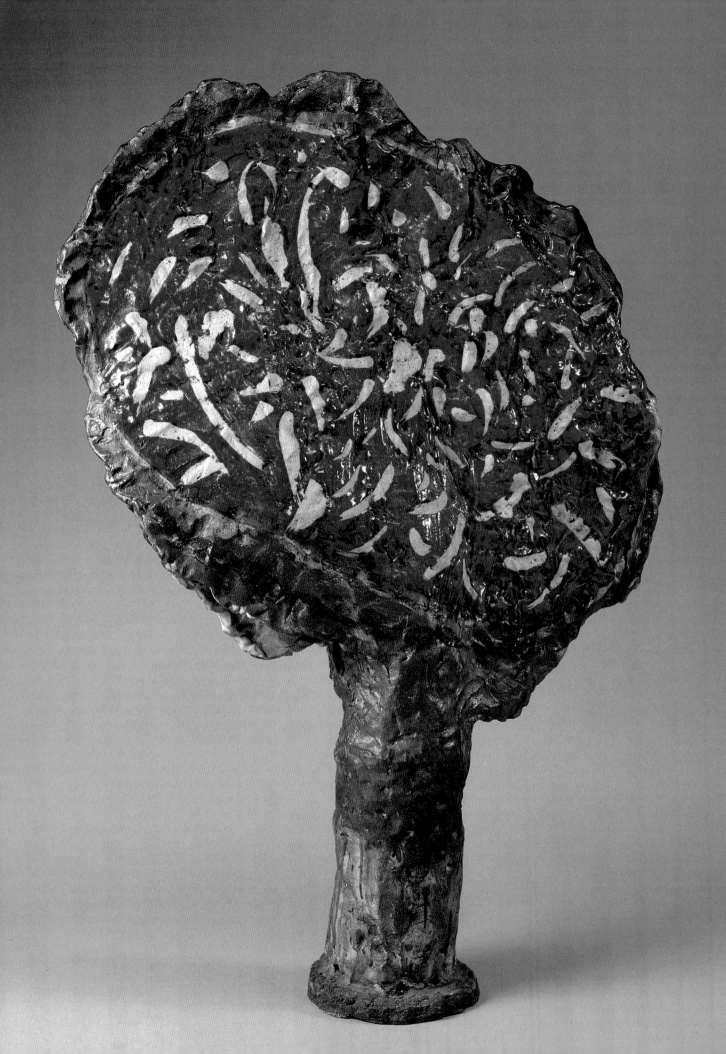

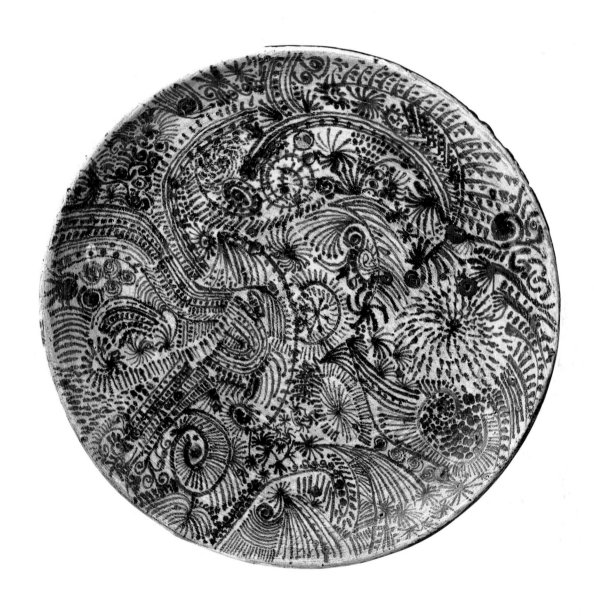

34

HENRY TAKEMOTO

Flag, 1960
Stoneware, glazed
36¾ x 26 x 7¼
(92.1.109)

35

HENRY TAKEMOTO

Plate, 1960
Stoneware, glazed
2½ x 16 x 16
(83.2.18)

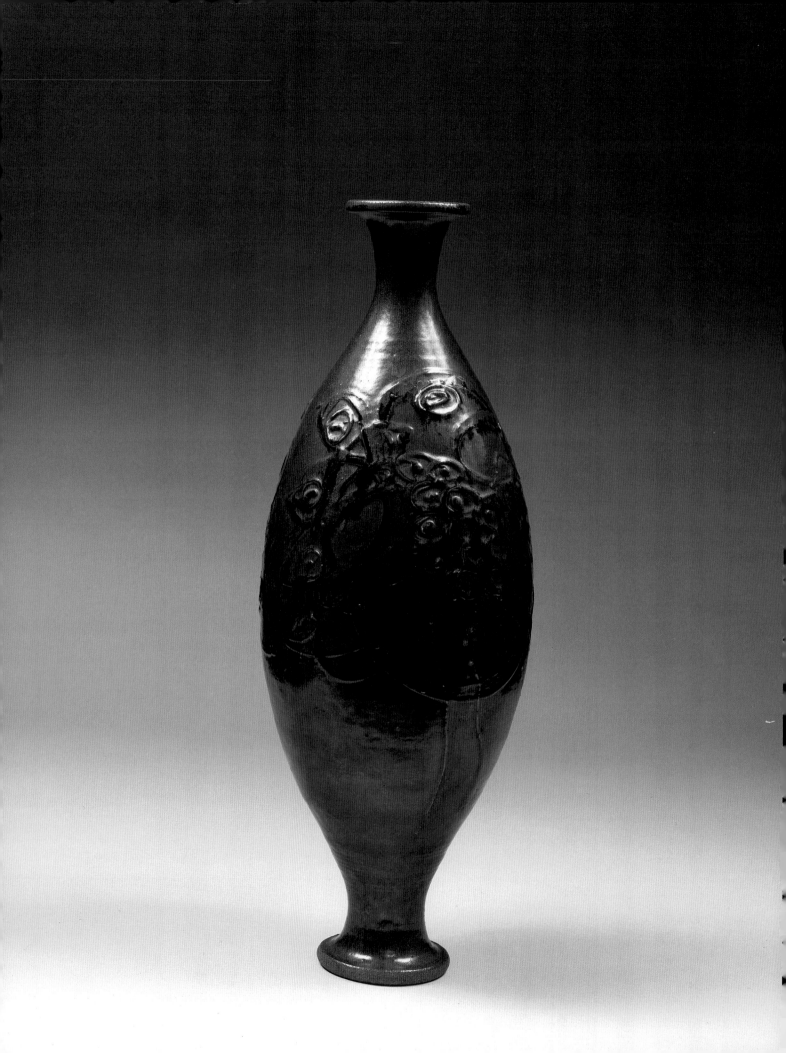

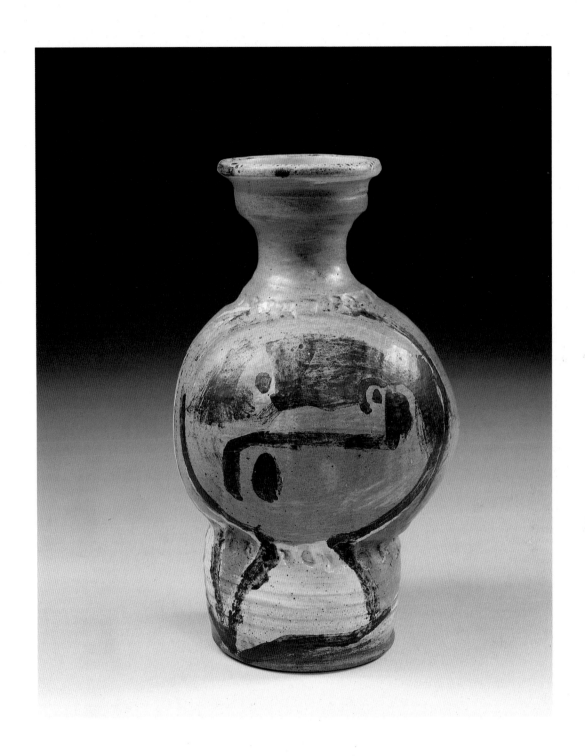

36
PETER VOULKOS
Vase, 1955
Stoneware, glazed
26¾ x 9½ x 9½
(92.1.149)

37
PETER VOULKOS
Vase, 1955
Stoneware, glazed
12¾ x 7½ x 7½
(92.1.135)

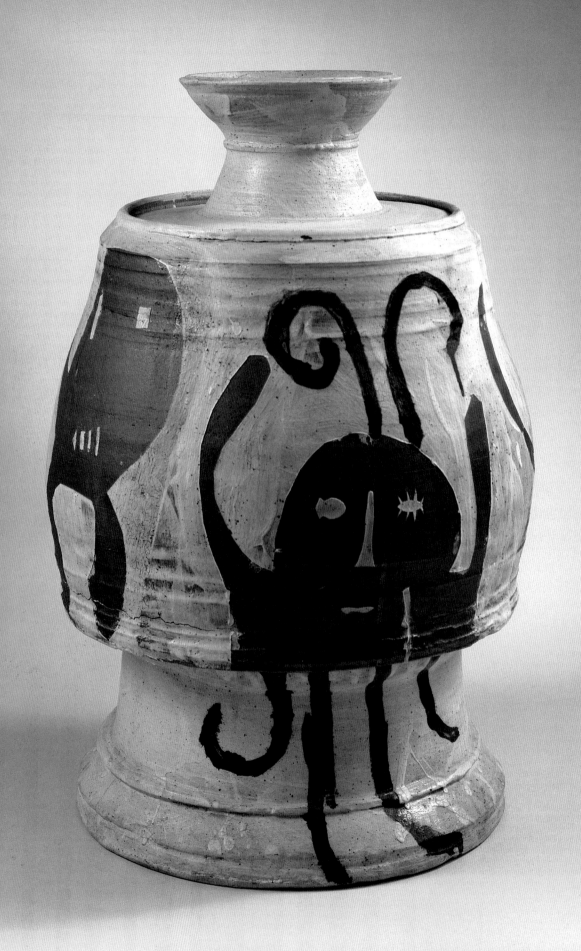

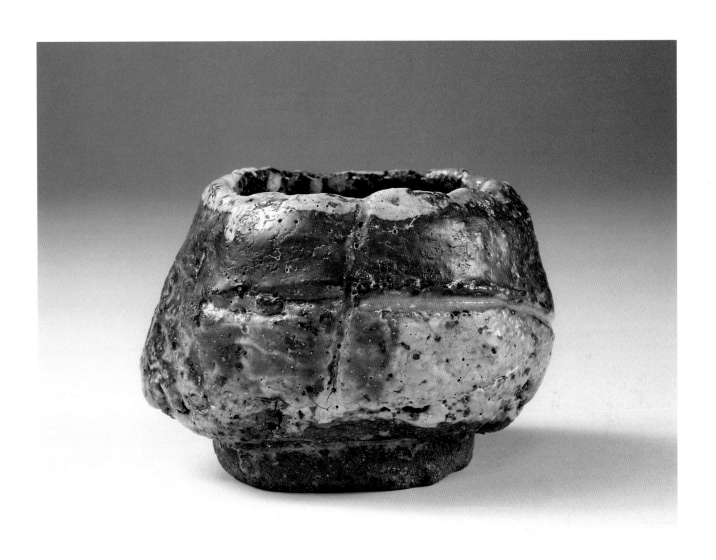

38
PETER VOULKOS
Covered Jar, 1956
Stoneware, glazed
26½ x 18 x 18
(91.4.1)

39
PETER VOULKOS
Vessel, 1956
Stoneware, low-fire overglaze
3¾ x 5 x 4¾
(92.1.129)

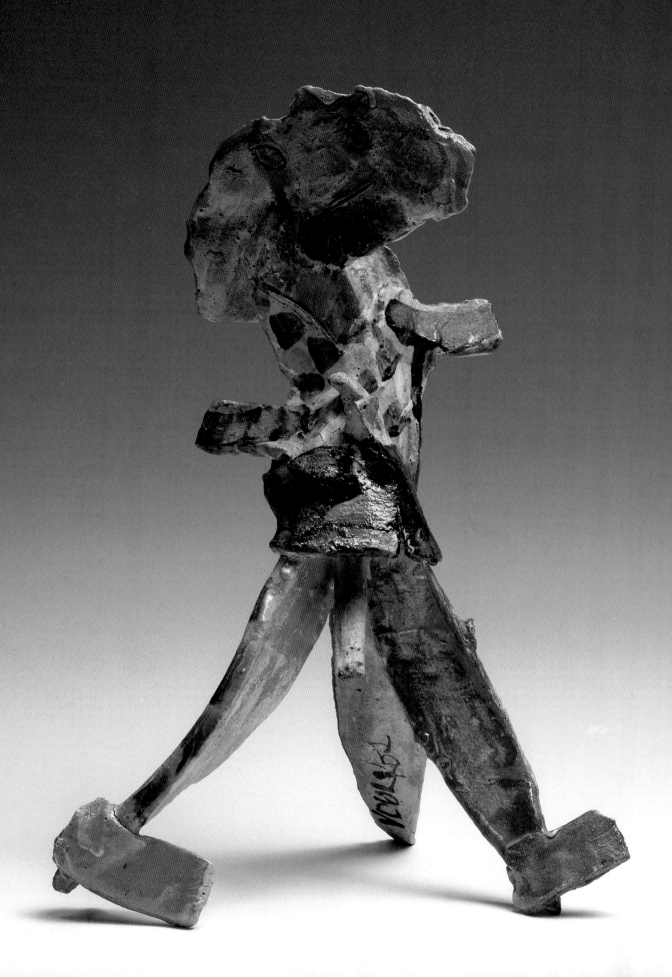

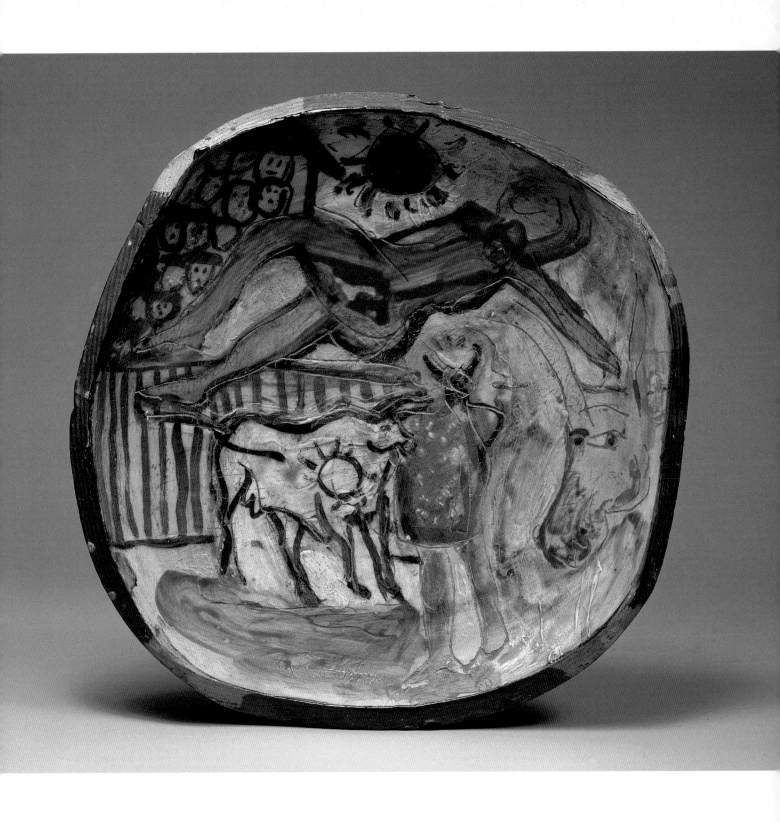

40
PETER VOULKOS

Sculpture (Walking Man), 1957
Stoneware, low-fire overglaze
17 x 12 x 8
(92.1.136)

41
PETER VOULKOS

Plate (Bullfight), 1957
Stoneware, glazed, painted
3 x 17 x 17
(92.1.153)

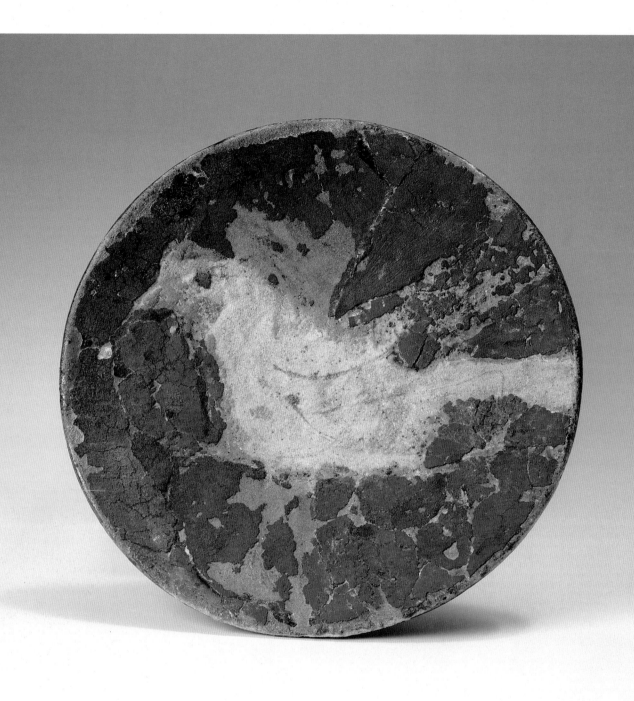

42
PETER VOULKOS
Plate, 1957
Stoneware, glazed
2 x 12 x 12
(92.1.122)

43
PETER VOULKOS
Sculpture, 1957
Stoneware, thin colemanite glaze
35 x 21 x 21
(82.2.1)

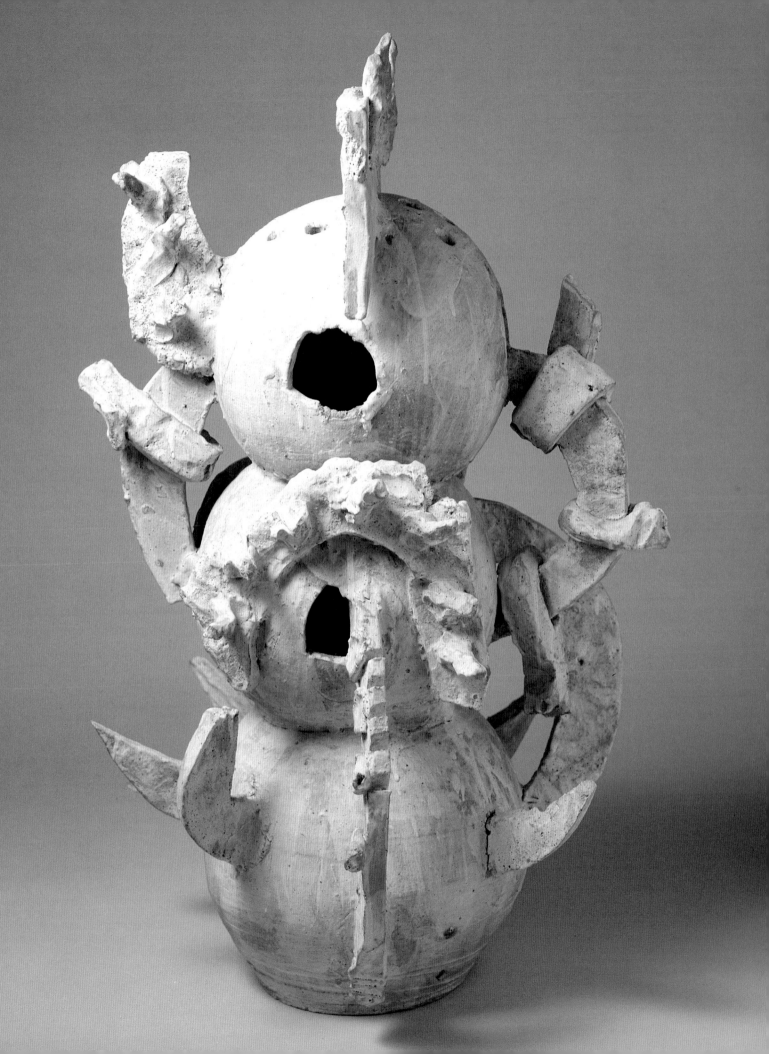

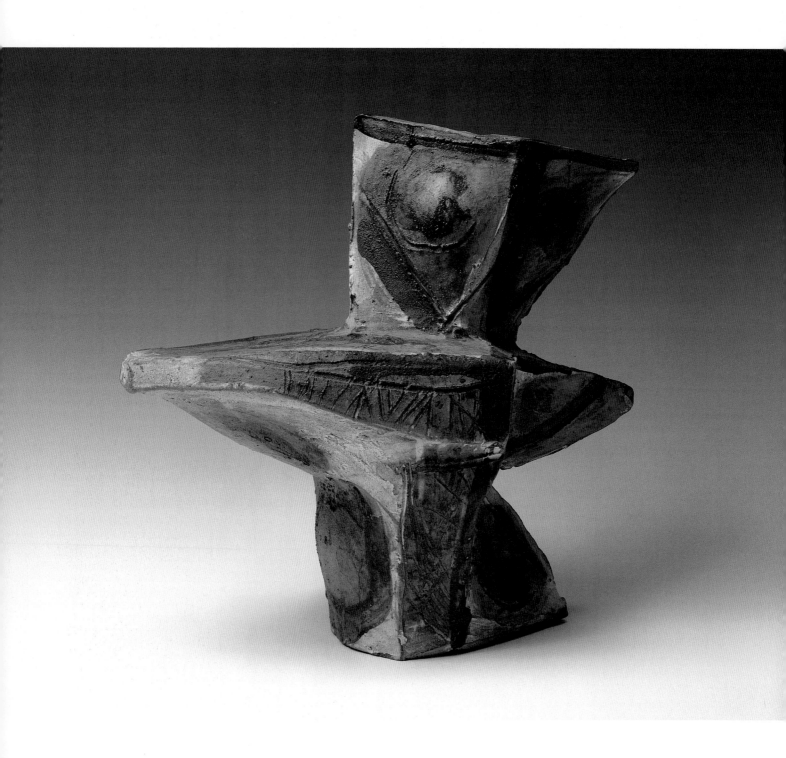

44
PETER VOULKOS
Bird Vase, 1958
Stoneware, glazed
9 x 15 x 15
(91.4.2)

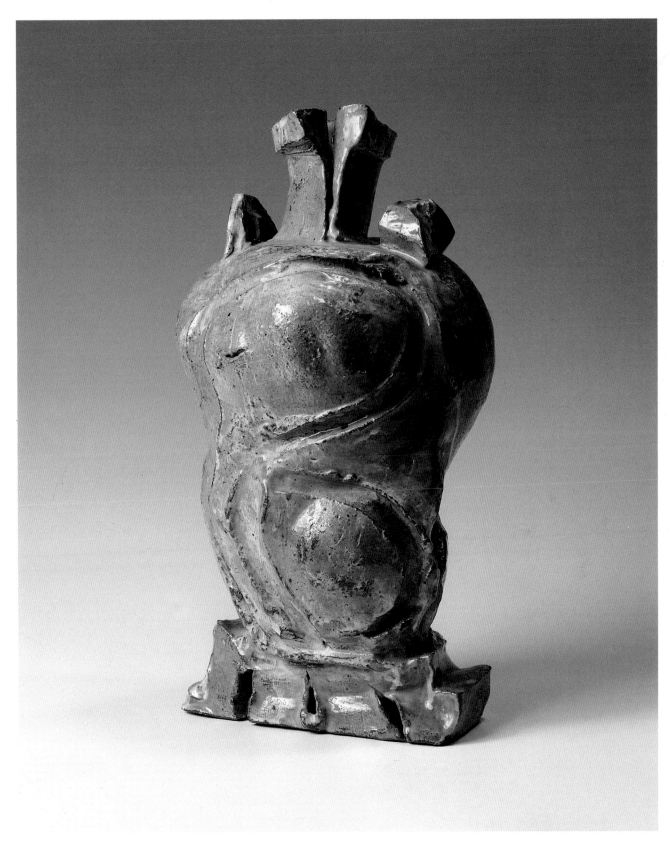

45
PETER VOULKOS
Bottle, 1961
Stoneware, glazed
17 x 8 x 8
(92.1.138)

Contemporary Ceramics in the Marer Collection, 1960–1990

Martha Drexler Lynn

THE PERIOD AFTER 1965 was a particularly fertile time for artists who worked in clay. Beginning in the 1960s and continuing to the present, the artistic goals of ceramists were diverse and marked by a variety of approaches—many of which are represented in the Marer Collection. This period also marks the acceptance of clay as an art medium by the larger art world. Clay's entrance into this larger arena also affected the formation of Marer's collection.

The Marer Collection is an intensely personal one. While knowledge of ceramics history helps us to understand the individual pieces, an appreciation of the Marer Collection is possible only through an examination of Marer's interests and collecting habits. Guided by a love of the medium and enriched by the friendships he nurtured with many of the artists, Marer made selections as the result of serendipitous personal connections. Fred was drawn to "things not done before"[1] in clay, and the Marer Collection reveals his brave eye and an affinity for powerful yet casually crafted works. Ties of friendship and artistic respect also guided Marer's in-depth collecting of a select few.

Marer began collecting during the years when Peter Voulkos and his students at the Otis Art Institute were leading the "revolution in clay" that Mary Davis MacNaughton chronicles in her essay in this volume. After the artists he had known at Otis Art Institute scattered geographically, Marer continued collecting and followed their careers and artistic development. Building on his earlier relationships, Marer augmented his holdings by Otis-formed artists Peter Voulkos, Paul Soldner, John Mason, Jerry Rothman, and Michael Frimkess. He also sought out works by artists connected to Scripps College and in later years, artists he met while travelling. Throughout, Marer's distinctive collecting style shaped his wide-ranging collection.

Anne Scott Plummer in the Kohler Company studio in Sheboygan, Wisconsin, 1986

ARTISTS OF THE OTIS GROUP AFTER 1959

Fred Marer's relationship with Peter Voulkos continued uninterrupted even after Voulkos moved to northern California in 1959 to teach ceramics at the University of California at Berkeley. Marer's habit was to visit Voulkos, stay with him, and while there select a work to purchase, which a friend would then bring to Los Angeles for him. *Large Vessel*, 1967 (cat. 65) was acquired in this manner and delivered months later by Scripps ceramist and, later, Marer Collection curator Doug Humble. In this way Marer assembled works by Voulkos from each decade and in both clay and metal.

A network of intricate financial arrangements figured into many Marer purchases. Although not a man of great means, Marer often lent money to financially strapped ceramists of his acquaintance—a pattern developed during the Otis years and continued afterward. The debt would be worked off though a gift/purchase of works. The works were often acquired below market values, and the debts versus payments were never monitored with a banker's eye by either the ceramist or the collector. Created out of a fusion of kindness and necessity, this fortuitous and mutually beneficial relationship was satisfactory to all involved.

It was in this manner that Marer added Voulkos's *Plate*, 1975 (cat. 67), to his collection. A strong work evidencing the influence of Italian artist Lucio Fontana, *Plate* features a torn and punctured surface similar to Fontana's canvases. As with many works Marer acquired, it confirms the collector's penchant for gutsy works.

In contrast, the later Voulkos *Plate,* 1990 (cat. 69), came into his collection through the intercession of the Louis Newman Gallery in Los Angeles. Marer seldom dealt with galleries because he felt no need to be introduced to artists already known to him. He also objected to what he characterized as the gallery hype that touted sometimes doubtful works as art. When an artist previously collected by Marer veered too much toward acceptance by the larger art world, Marer would lose interest and stop collecting their work.

Similarly, he discounted art magazines as "too conventional."[2] It is this singular approach—coupled with his direct access to the artists—that separates Marer from other, gallery-formed collectors. His approach allowed Marer to see such works as *Vessel (Ice Bucket)*, 1982 (cat. 68), and to appreciate it on his own without being told of its teabowl antecedents and textural interest. Following his own knowledge and eye and working outside the formal art-marketing system, Marer created his unique mix of objects. It was always his personal relationships with the artist that propelled his selections.

Nowhere was this more true than with Otis-trained ceramist Paul Soldner. Begun in the early days at Otis their relationship has continued, nurtured by respect, timely loans, and propinquity. Soldner's *Vessel*, 1966 (cat. 63), from the post-Otis period is a mature raku work. Expressive of Soldner's interest in an ever-shrinking base joined to a dominant top, the work features a running, reaching figure stretched across the body of the vessel. Casually rendered, the figure has both a primitive and evocative quality typical of Soldner's best work.

Peter Voulkos trimming plate, c. 1970

Pedestal Piece (907), 1990 (cat. 64), features Soldner's more recent low-fire work. Slab-built sections are added in layers to create a vessel balanced on top of a precariously small base. The layered components are torn and assembled into a finished product unified by color and profile. While still adhering to the formality of the vessel, the work shows Soldner's desire to explore ambitious sculptural concerns.

Another artist whom Marer met at Otis and then followed was Jerry Rothman. Trained initially as a cabinetmaker, Rothman found himself drawn to art. The first show of his constructivist sculptures was held in 1957 at Ferus Gallery where his works were displayed alongside Otis artists John Mason and Paul Soldner. After that show, Rothman started to study ceramics with Peter Voulkos at the Otis Art Institute.

Throughout his career, Rothman has worked with both vessel and sculptural (often figurative) forms. He has been characterized as a maverick in both arenas because he does not accept limitations on what should be made in clay. He has also designed and made ceramics for production, inventing several new clay bodies and developing techniques in which ceramic forms can be worked on high-fire metal armatures.

The Marer Collection contains twenty-two Rothman pieces that range in date from *Vase,* 1956, to *Lidded Container,* 1975. Marer recalled that Rothman quickly found his own artistic voice while working with the charismatic Peter Voulkos, an independence he admired.

Rothman's early style can be seen in *Sky Pot,* 1960 (cat. 30). Here the vessel form is clearly defined by its front and back decorative panels. The surface of the piece is organically suggestive rather than specific in its visual content. To create this effect, Rothman used a technique in which muted pigments "seep" to the surface of the clay after firing. Taking inspiration from the Japanese respect for the accidental, the colors and patterns are allowed to be random. While clearly a vessel form, this

John Mason making ceramic mural, 1960.

piece (and the series of works it represents) blurs the distinction between vessel and sculpture.

In the piece *Drink Me,* 1961 (cat. 62), Rothman moves toward organic abstraction. Purchased from the artist by Marer before Rothman joined a gallery, the work sports sexual organs of all types (a vulva form flanked by breasts form the lower half). The loosely rendered and rounded forms presage the organic abstraction movement of the late 1980s. It is typical of Rothman's work and evidence of his importance that he began an exploration that was taken up by other ceramists only much later. As Rothman's work has become increasingly intellectual and political, Marer has been less drawn to collecting it.

After studying at Otis with Voulkos, John Mason remained in Los Angeles making boldly sculptural ceramics. Having met first at Otis, Mason and Marer were always on friendly terms. Closest to Voulkos in his ability to create powerful vessel-based forms with jutting appendages, Mason's *Sculpture,* 1961 (cat. 56), in the Marer Collection illustrates this quality. With its clearly defined and powerfully sculpted sections, the work shows the expressive potential latent in the clay's earthiness. This interest in raw clay, advanced by Voulkos during the Otis years, had not been seen since the innovative and forthright works of the 1930s and 1940s by Los Angeles ceramist Glen Lukens. Like other works in the Marer Collection, the early Mason pieces were obtained through a series of interlocking loan/debt and purchase arrangements.

Mason's *Vase,* 1964 (cat. 57), illustrates Marer's brave eye. The shiny red vessel, rising from its crude base, twists upwards to the casually crafted lip. Powerfully constructed and energetically scored with vertical gashes, Mason's work would mature from this contorted piece into coolly colorful, geometric "torque" works of the mid-1980s. Such an assertive glaze color was unusual at the time and prefigured Mason's later work. For Marer, however, the larger sculptural works of Mason's middle period

were linked too closely to what he saw as the gallery-driven art world, and consequently, they were not included in his collection.

Youngest of the original Otis group, Michael Frimkess entered Otis/Parsons Art Institute at the precocious age of seventeen to study sculpture. While at Otis he had a revelation about pot throwing while under the influence of the peyote and decided to join the ceramics department to study with Peter Voulkos. It was here in 1957 that he met Fred Marer, whom he described as "a wonderful guy [who] furthered talent wherever he saw it."[3]

Like other artists working in clay, Frimkess was knowledgeable about ceramics history, as well as the larger art world. In music he found an inspiration and a source for some of the rhythms expressed in his work. By the late 1960s Frimkess was making large vessels decorated with comic-book imagery that commented on social issues. Influenced by Lichtenstein's use of commercial graphics and familiar with publications like *Mad* magazine, Frimkess enjoyed expressing his satirical and biting sense of humor in his work.

Of the Marer Collection's twenty-six pieces by Frimkess, *Jumpin' at the Moon*, 1968 (cat. 50), is the most impressive. Purchased directly from the artist at the time it was made (Marer's favorite method of acquiring works), it captures the artist at his best. Here Frimkess made use of his familiarity with classical Greek vases.[4] The ancient works inspired him to learn the difficult technique of throwing clay on the potter's wheel without adding additional water as the pieces are thrown. Throwing dry is a difficult technique and has been mastered by few.

After creating the form in this manner, Frimkess chose to decorate the surface with low-fire china paints with characters and images depicted in comic-book style. *Jumpin' at the Moon* depicts a war of the gods. Pictured at the moment of supreme action, gods (armed with swords) and Africans (armed with spears) are locked in battle so intently that they are at a standstill and unable to continue fighting. Another panel features Santa Claus and Hitler, juxtaposed in acknowledgment of their common German heritage.[5] A third panel has Superman interacting with a pair of monkeys. The lid (painted by a friend) is decorated with figures dancing around a "moonlodge" symbolizing peace.[6] By commenting on contemporary realities in the vernacular of popular culture, Frimkess establishes a sophisticated dialogue about the human condition as depicted by art history and pop culture.

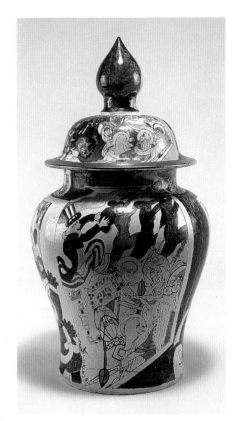

Michael Frimkess, *Jumpin' at the Moon*, 1968. View of the back of cat. 50.

NORTHERN CALIFORNIA ARTISTS ADDED TO THE MARER COLLECTION AFTER 1959

By 1959 a new sensibility was forming within the ceramics world. Artists moved away from vessel-based pieces and explored the sculptural potential of ceramics. This trend would subsequently differentiate clay art from craft and move it toward acceptance in the larger art world. At this time the center of innovation shifted north to the areas surrounding San Francisco Bay and Sacramento. As this happened Marer expanded his collecting area and conscientiously kept abreast of evolving techniques and intellectual underpinnings.

Marilyn Levine in her studio in
Oakland, California, 1979

One of the first artists to explore clay's sculptural qualities was Bay
Area artist Robert Arneson. While Marer does not have any of Arneson's
famous "funk" pieces of the early and middle 1960s, Marer bought an
early utilitarian work by Arneson. Marer saw the bowl at the San Fran-
cisco housewares store, Gump's, and purchased it. *Footed Bowl,* 1955 (cat.
46), is a large teabowl form, crudely modelled in stoneware. Although it
predates by several years Arneson's more distinctive contribution to clay's
history, this work shows that Arneson was familiar with Voulkos's expres-
sive vessels.

Meanwhile, at the San Francisco Art Institute Jim Melchert and later
Ron Nagle, artists Marer began to collect, were working in whiteware.
Melchert's *Container,* 1960 (cat. 58), illustrates his interest in the casually
crafted nonutilitarian vessel pioneered by Voulkos. This work with its white
glaze and crudely modelled form again shows Marer's taste for such pieces.
After 1962 Melchert shifted from the vessel to molded figurative pieces.

Ron Nagle's work is represented in the Marer Collection with the
wonderful *Perfume Bottle (Bottle with Stopper),* 1960 (cat. 60). Urged at the
time by Voulkos to purchase it, Marer was lucky enough to obtain one of
Nagle's most memorable early works. *Perfume Bottle (Bottle with Stopper)*
has an expressionist sensibility, reflecting the Voulkos ethos but moving it
forward by the inclusion of decorative color. The squat bottle is domi-
nated by its overscale, frontal stopper.[7] Large, imperfectly shaped handles
sit on top of the bottle's squared body. By selecting the form of a perfume
bottle, Nagle pokes fun at the craft world's inclination to emulate the
forms of status objects. Nagle's use of such unexpected forms in new
ways led him to the hobbyist china-painting technique and photo-decal
decoration. Horrifying the traditional ceramics world with these, he con-
tinued to explore concepts of preciousness through his later perfectly
crafted, multicolored works.

Another Bay Area artist who interested Fred Marer was Marilyn Levine, whose studio was located in the same area of lower Berkeley as that of Peter Voulkos. Ceramics had become a passion for her after she had studied chemistry in the late 1950s. After moving to Regina, Saskatchewan, Levine audited ceramics courses rather than seeking a job in chemistry. She then secured a Canada Council grant and travelled to Los Angeles to visit the West Coast ceramic movement principals: Peter Voulkos, John Mason, Jerry Rothman, James Melchert, and Ron Nagle.

Levine's work was greatly influenced by Jack Sures, from whom she got her interest in slab construction. By 1965 they began experimenting with high-fire reduction and the reinforcing of clay slabs with nylon fibers for greater plasticity. Through a unique confluence of circumstances Levine was able to work with a sympathetic chemist from the DuPont Corporation, and she became the first ceramist to perfect the use of fibers in clay.

Levine's *F.M. Case,* 1981 (cat. 55), is at first glance a worn leather suitcase. In actuality it is a treatise on the tangible "traces"[8] of human life found in items we use. Characterized by their unintentional and personal nature, these evidences of time constitute an indirect history. To make the piece, Levine constructed an ordinary suitcase, but in order for the work to communicate the history it embodied rendered the physical details with more intensity than found in the actual object.

Viola Frey is another Marer artist who makes sculptural clay pieces. Frey received her BFA in painting from the California College of Arts and Crafts, Oakland, in 1953. Although she studied with painter Richard Diebenkorn (and later Mark Rothko), Frey found that what interested her was being addressed more often in the pot shop than in her painting classes. Frey produces three general types of work: figurine-based forms that often incorporate vessel shapes; plates; and large, menacing figures with outsized feet and hands.

Drawn to the junkyard for inspiration, *bricoleur*[9] Frey selects bits of cultural debris and assembles the personally potent images, signs, and trivia into a snapshot of the moment. Her work often draws from the mosaic of her daily life. In *Plate,* 1979 (cat. 49), Frey depicts herself as a blue silhouetted head with large, ruby lips displayed on a bright yellow, heavily textured plate. One disembodied hand holds a poised paintbrush, while the other hand tentatively holds a mouselike form. Her juxtaposed and disparate signs for woman, hand, and artist are part of her vocabulary of found images. In this and other pieces, her use of a heavily textured surface (similar to those of Jean Dubuffet) contradicts the implied functionality of the form; instead, it must be classified somewhere between a plate and sculpture.[10]

Marer purchased this work from the Garth Clark Gallery in 1985. This out-of-character gallery purchase illustrates another of Marer's collecting tenets. On the rare occasions when Marer did buy from a gallery, he liked to select his piece after a show had closed. This allowed him to take advantage of what he termed "the poor taste of other collectors."[11]

The Marer Collection has only a few Rudy Autio works. Although he is not part of the northern California ceramist circle, Autio had a

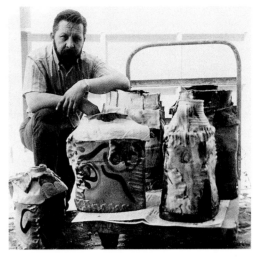

Rudy Autio outside pottery shed, University of Montana, 1961.

Betty Woodman in her studio in Colorado, 1980

long-term relationship with Peter Voulkos that began in the mid 1950s. Born in Butte, Montana, Rudy Autio studied, along with Voulkos, under Frances Senska at Montana State University, Bozeman. In 1952 Autio became a resident potter and cofounder with Voulkos of the new Archie Bray Foundation in Helena, Montana. After they had worked together for two years, Voulkos left for Los Angeles to head up the new ceramics department at Otis and Autio remained in Helena.

Doll Vase, 1968 (cat. 47), is from Autio's early figurative vessel period. The surface is decorated in a manner reminiscent of both the Fauves and Jean Dubuffet.[12] Autio translated their styles into his own by combining volumetric and structural elements on the surface of a vessel. Here a kewpie-doll form, emerging from the vessel itself, is outlined in painterly black china paint. Color is added to give greater form and liveliness. Marer was attracted to its strength of form and graphic sensibility.

LATER SOUTHERN CALIFORNIA ARTISTS

While "funk" and sculptural clay were developing in northern California, southern California artists were continuing to develop their own styles. One of those was the "finish fetish" school, which evolved in response to the "funk" movement. Valuing fine craftsmanship, the finish fetish ceramists used commercial glazes and paints on their clay pieces. This use of nonceramic materials on clay was abhorrent to modernist potters and was deemed overly decorative by many clay sculptors.

The finish fetish school also manifested itself in the exploration of the concept of the "super object." Derived from pop art, everyday items (often enlarged) were presented sporting sleek, commercial glazes. Betty Woodman, a ceramist trained at Scripps College who had previously made utilitarian vessels, began making super objects in the 1970s. The Marer Collection has a number of her early vessels, which show her involvement with abstract expressionism and the then-popular disinterest in craftsmanship.

The purchase of *Pitcher*, 1978 (cat. 71), was the result of Marer's friendship with Woodman, which was furthered during her 1979 teaching stint at Scripps College. In this work Woodman returns to craftsmanship, not as the central issue but as a vehicle for combining colors and patterns drawn from an eclectic mix of cultural antecedents. Aware of the emerging multicultural trend in the arts, Woodman's pieces of this period express a transcultural lineage. Applying green and brown semitransparent glazes reminiscent of sixth-century T'ang tomb sculptures to a whiteware body, Woodman uses a shape derived from Etruscan pottery. Formed through throwing and extruding, this overscale vessel brings these traditional elements into the present. Postmodern in its sensibility, *Pitcher,* 1978, further develops the break with mid-century pot-making begun by Voulkos during the Otis years.

Another southern California artist interested in the super object was Mineo Mizuno. In *Sculpture (Screw),* 1973 (cat. 59), he created a perfectly crafted, "metal" screw in clay. Its sculptural presence is created by its size: at 37 inches in length, it is more than ten times the size of a utilitarian piece of hardware. Marer, long familiar with his work, respected Mizuno's

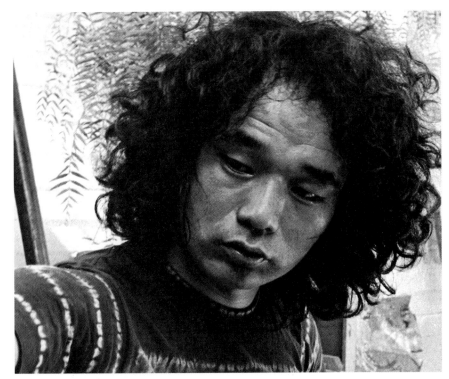

Jun Kaneko, c. 1971

craftsmanship and felt that he had to have this particularly strong piece to mark this period in Mizuno's career.

Marer began collecting early works by Philip Cornelius when he was studying with Paul Soldner at Claremont Graduate School. These vessels, executed in either earthenware or stoneware, were functional and well-made, with a utilitarian sensibility.

In the early 1970s Cornelius discovered that when he rolled porcelain slabs for his hand-constructed pieces, a residue of clay was left on the table. Upon examination Cornelius found that this thin sheet was pliable and when fired became very strong. With it he constructed eggshell-thin porcelain forms, which he called "thinware." The Marer Collection *Enterprise*, 1976 (cat. 48), is executed in thinware and decorated with contrasting vivid bands of colored clay. The form is that of teapot cum battleship with a turret-shaped spout. Once again this work refers to notions about vessels and containment. For Marer the piece was "a conventional pot, well decorated"[13] that he purchased after the close of Cornelius's 1976 show.

Scripps-trained ceramist Jun Kaneko exploited his Japanese heritage and painting education to create his reductive forms. Often decorated with vivid and sparse patterns, the works successfully meld traditional Japanese designs and bold "pop art" splashes of color. The two early works in the Marer Collection, both dated 1971 and both entitled *Plate* (cat. 52 and 53), sport loosely rendered calligraphic and gestural decorations (a bird shape and the artist's hand, respectively) that are both confident and spirited. They rely on an organization of surface (and are successful because of it) that is usually associated with traditional Japanese decorative design.

Jun Kaneko is a personal friend of Marer. During his first visit to the United States in 1963, Kaneko was introduced to Marer by Jerry Rothman. Marer was about to depart on a summer trip to Europe and invited Kaneko to housesit in his absence. Kaneko recalled that the Marer house on Kenmore Street was "full of ceramics." In 1969 Kaneko returned to Los Angeles to begin his graduate studies in ceramics at Scripps College under Paul Soldner. This was a difficult time for Kaneko, as his Japanese education and not-yet-perfected English did not prepare him for the graduate-level work required. But the two plates in the Marer Collection illustrate clearly the talent that Soldner recognized. As he had done with other ceramics students, Marer aided Kaneko by buying the wine for the opening of his Master's show at Scripps and also by covering some of the installation expenses.[14] At the same time Marer purchased *Sanbon Ashi*, 1971 (cat. 51), from the show to express his support and provide money for Kaneko to continue his work. Marer later visited and stayed with Kaneko during a trip to Japan in 1978.

After leaving Scripps Kaneko moved away from these semiliteral representations to geometric decorations, often brightly colored. His vocabulary of forms came to include ovoid wall platters and totemic "stones." The mass of these latter works pushes the limits of clay technology, much as Mason's geometric works of the 1960s did. His current work is also large scale and incorporates black lines balanced by colorful decorative patterns.

Another later Scripps artist who caught Marer's eye was Anne Scott Plummer. Known for her later figurative work, often with mythological themes,[15] she is a talented Scripps graduate. *Peter Hunt's Africa*, 1988 (cat. 61), displays her figurative bent on a vessel form. Marer so enjoys her work that he retained one of her small figurative pieces, withdrawing it from his bequest to Scripps, and displays it prominently in his living room.

LATER TRAVEL AND COLLECTING

After retiring from his various teaching jobs, Marer was able to travel internationally. His collecting continued but now was marked less by ties of friendship and time and more by chance meetings with artists and artworks. In England he visited the Royal College of Art and picked up pieces by ceramists working there. On his 1978 trip to Japan, Marer did not seek out the famous potters but rather bought works from artists who crossed his path. However, this chance approach did not cut down on the volume of works he collected. When he returned to California, he sent home a cargo container of works he had acquired.

One of the artists whose work he acquired in this manner was Ryoji Koie, whom Marer first met when he worked in Jun Kaneko's studio. Koie was raised in the pottery-making town of Tokoname[16] on the Bay of Ise in Japan. First trained as a factory tile maker, Koie was soon drawn to what he saw as the interplay of earth and fire and its artistic potential. The sparse but complete quality of Koie's work comes from years of focused study. While known mostly as a maker of teabowls, his *Sculpture (Chernobyl Series)*, 1990 (cat. 54), shows a political interest. He was a small child when atomic bombs were dropped on Hiroshima and

Ryoji Koie (at right) giving workshop in class of Nobuho Nagasawa (at left) at Scripps College, Claremont, 1994

Nagasaki and grew to believe that many things done by man are wrong because they violate the relationship between earth and man. His *Sculpture (Chernobyl Series)* is his statement against the potential destruction posed by nuclear accidents. For Marer the graphically decorated square tile had beauty of form and meaning.

MARER AND OTHER COLLECTORS

During the 1980s the medium of clay was accepted by the larger art world. By shifting subject matter from the utilitarian vessel to the content-driven sculpture, clay artists achieved parity with artists in other media. Now seen as capable of communicating ideas, clay became a collectible art medium. This shift was confirmed when clay began to be shown alongside paintings and sculpture in mainstream art galleries and thus could demand gallery prices. For Marer this movement into the larger art world was a loss to the ceramics world. Like many who were drawn to handmade ceramics, Marer felt that the imposition of galleries, and the art-world hype they promulgated, damaged the work produced by the artists.

While artists (many of them represented in the Marer Collection) benefited from the increased esteem of art in clay, this change in attitude also made acquisitions more difficult for the collector whose love of ceramics exceeded a limited budget. But Marer's example shows that it is still possible—if one takes the time to talk to artists, look at their work, and develop a keen eye—to identify emerging talents. The Marer Collection, which began forty years ago and is still growing, is a testament to Marer's continuing engagement in contemporary ceramics. In his ninth decade, Marer is still eagerly looking for work that offers fresh ways of seeing the world. His visual acumen and deep belief in the power of clay to convey ideas allowed Marer to recognize the "revolution in clay"; Marer's ongoing appreciation for genuinely new work helps us see that collecting contemporary ceramics is still an exciting enterprise.

NOTES

1. Fred Marer, interview with the author, 8 April 1994, Los Angeles.

2. Ibid.

3. Michael Frimkess, conversation with the author, 22 April 1994, Venice, California.

4. In the mid 1960s Michael Frimkess travelled to The Metropolitan Museum of Art in New York, where he studied this extensive collection of classical Greek vases for throwing technique and decorative devices.

5. Michael Frimkess, conversation with the author, 22 April 1994.

6. Later works by Michael Frimkess feature the fine drawing ability of his wife, Magdalena Frimkess.

7. This work has been difficult to display over the years because of its ill-fitting large stopper. It was recently modified to allow for safe display.

8. Traces are further defined in this quotation from Maryilyn Levine's interview with Nancy Fotte: "An acquaintance of mine, Marc Treib, described pretty neatly the two types of impact man has on the world, 'intent' and 'trace,' as he called them. He defined 'intent' as the results of man's acting consciously. This would include design, building, and other purposeful action. 'Trace' on the other hand is the accumulation of the marks left by the realization of man's intent, such as trampled grass, grease spots, and dirt. In trace, he says, we find richness, a humanity often omitted in intent. Trace always tells a story. My work is involved with the story told by trace." "The Photo-Realists: Twelve Interviews," *Art In America* 60, no. 6 (November/December 1972), 84.

9. A *bricoleur* collects everyday items and then assembles them into a new whole.

10. The mouselike form is typical of the potentially sinister images often favored by Frey.

11. Fred Marer, interview with the author, 8 April 1994.

12. Garth Clark, *American Potters: The Works of Twenty Modern Masters* (New York: Watson Guptil, 1981), 36.

13. Fred Marer, interview with the author, 8 April 1994.

14. Ibid.

15. See Martha Drexler Lynn, *Anne Scott Plummer: Myth in Clay Forms* (Los Angeles: A.R.T. Press, William S. Bartman Foundation, 1989).

16. Tokoname pottery dates to the late eleventh century and is known for tea-ceremony wares and other utensils.

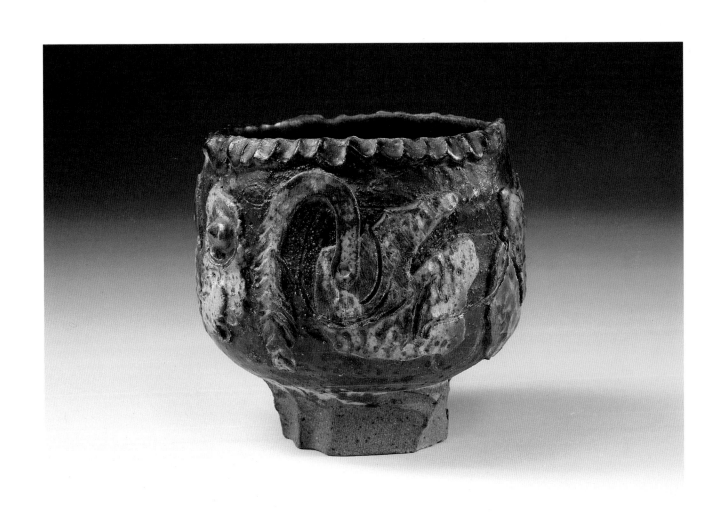

46
ROBERT ARNESON

Footed Bowl, 1955
Stoneware, glazed
6¾ x 7 x 7
(81.8.2)

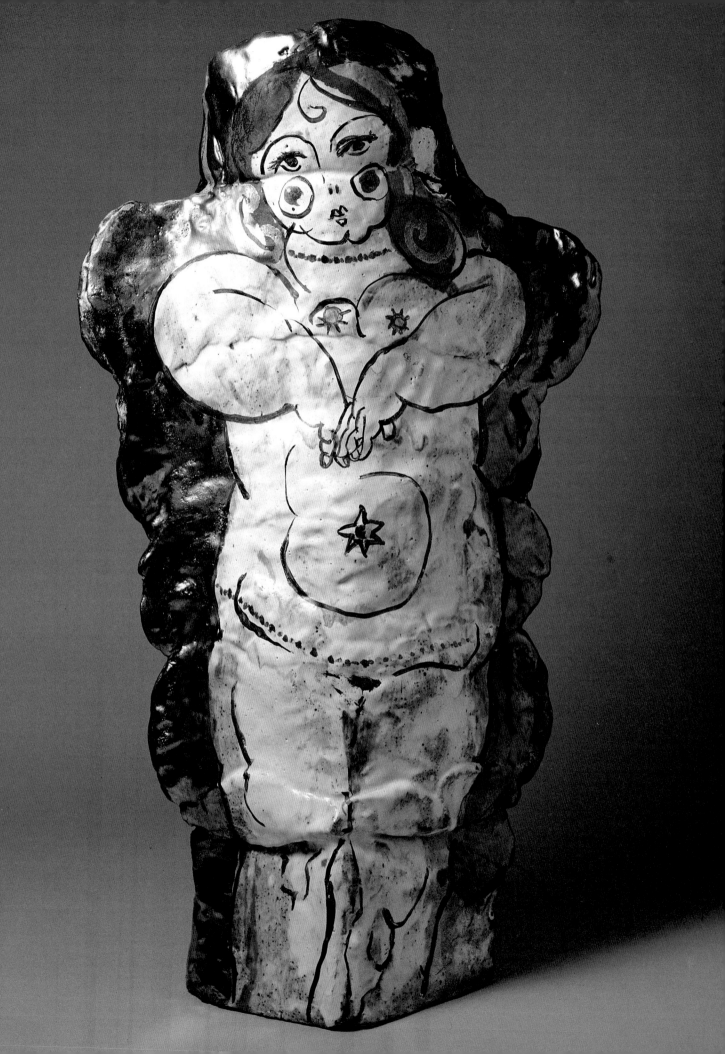

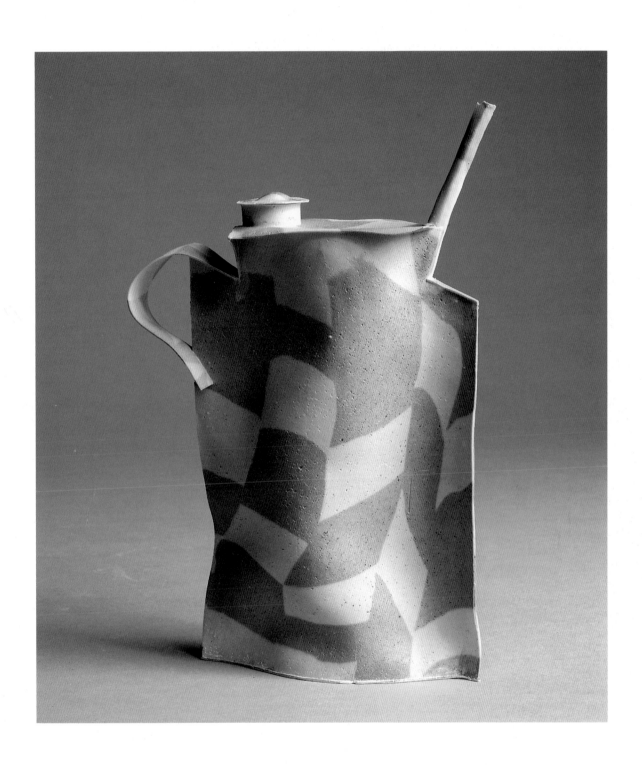

47
RUDY AUTIO

Doll Vase, 1968
Stoneware, low-fire lustre overglaze
40 x 23 x 12
(L78.1.216)

48
PHILIP CORNELIUS

Enterprise, 1976
Porcelain, glazed
11⅝ x 7½ x 2⅛
(L89.1.4)

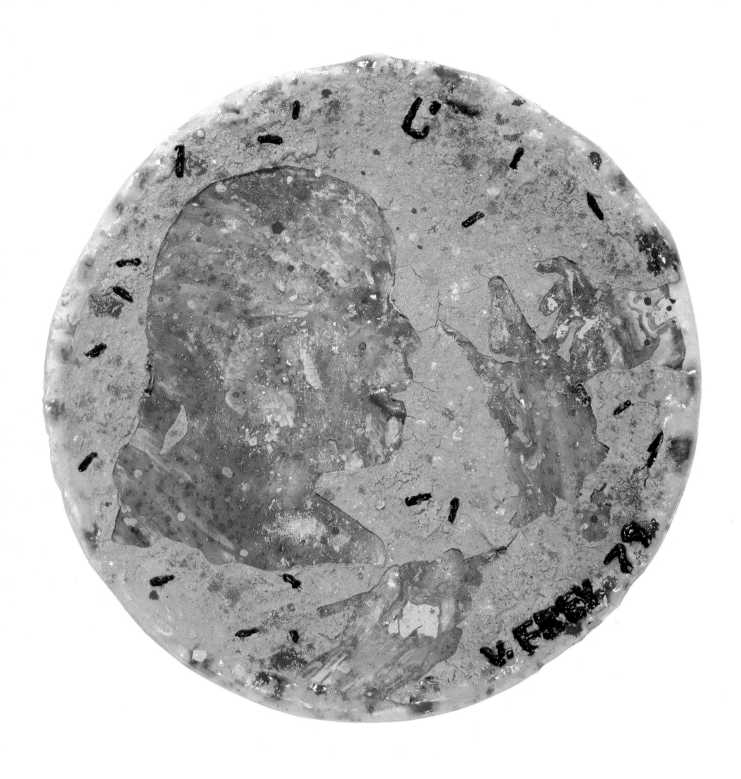

49
VIOLA FREY

Plate, 1979
Porcelain, glazed
3 x 20½ x 20½
(85.4.1)

50
MICHAEL FRIMKESS

Jumpin' at the Moon, 1968
Stoneware, low-fire lustre overglaze
28¼ x 16 x 16
(92.1.3a,b)

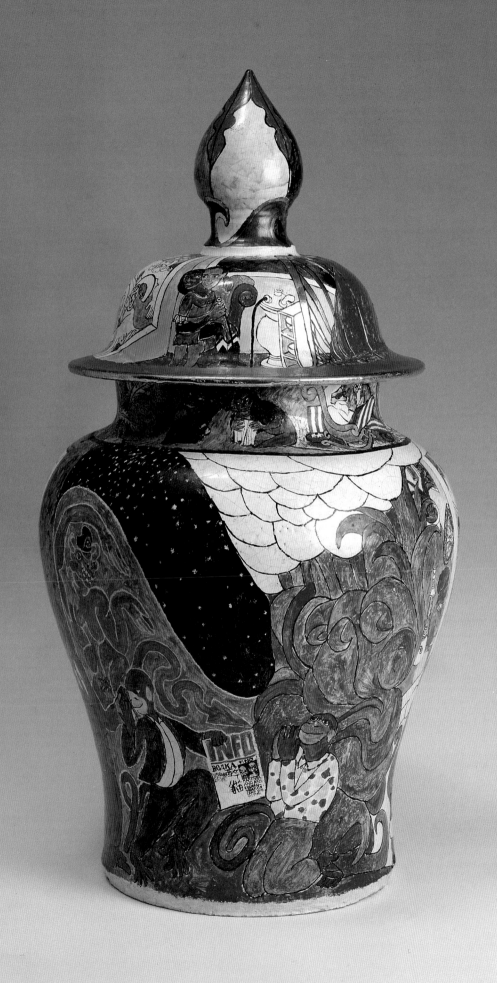

51
JUN KANEKO

Sanbon Ashi, 1971
Stoneware, glazed
30 x 35 x 20
(L78.1.618, 619,620,621)

52
JUN KANEKO
Plate, 1971
Stoneware, raku fired, partially glazed
2 x 12½ x 12½
(84.9.5)

53

JUN KANEKO

Plate, 1971
Stoneware, raku fired, partially glazed
2 x 12½ x 13
(86.1.6)

54
RYOJI KOIE
Sculpture (Chernobyl Series), 1990
Stoneware, partially glazed
23 x 23
(L94.1.1)

55
MARILYN LEVINE

F.M. Case, 1981
Stoneware and mixed media, partially glazed
4¾ x 9⅜ x 7
(L85.1.8)

56
JOHN MASON

Sculpture, 1961
Stoneware, glazed
42 x 13½ x 11
(79.8.9)

57

JOHN MASON

Vase, 1964

Stoneware, glazed

12 x 6 x 6

(92.1.49)

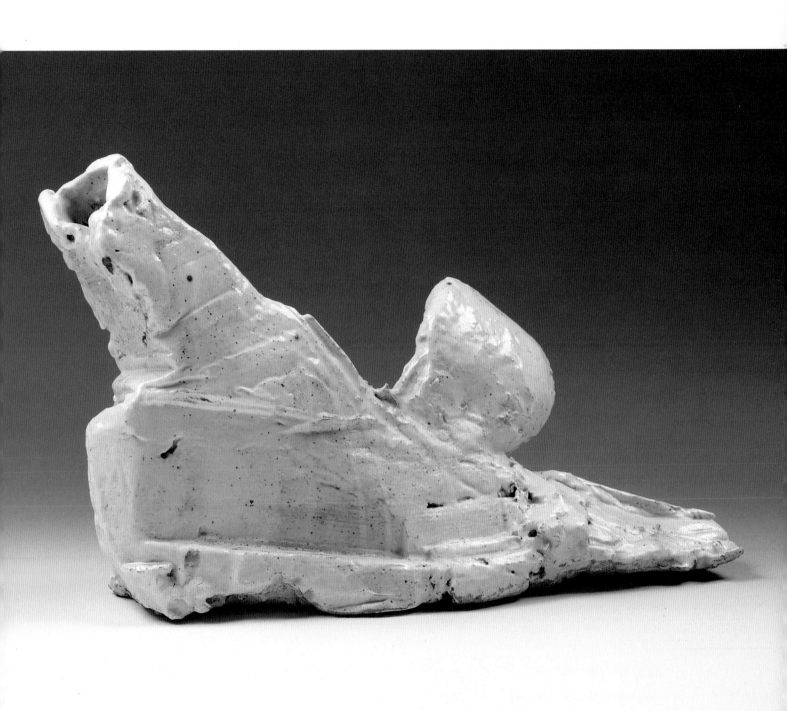

58
JAMES MELCHERT
Container, 1960
Stoneware, glazed
13 x 20 x 6
(L78.1.683)

59
MINEO MIZUNO

Sculpture (Screw), 1973
Stoneware, glazed
13 x 13 x 37
(83.2.15)

60
RON NAGLE

Perfume Bottle (Bottle with Stopper), 1960
Stoneware, light-fire and low-fire glazed
24½ x 22 x 5
(92.1.61a,b)

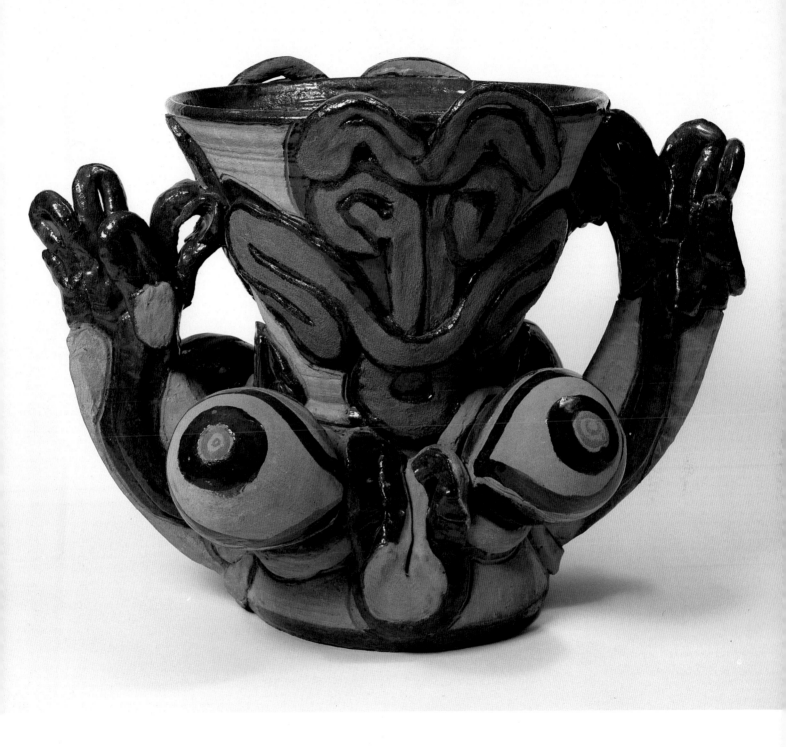

61

ANNE SCOTT PLUMMER

Peter Hunt's Africa, 1988

Low-fire ceramic, glazed

28 x 17½ x 17

(L89.1.2)

62

JERRY ROTHMAN

Drink Me, 1961

Stoneware, glazed

26 x 35 x 22½

(92.1.84)

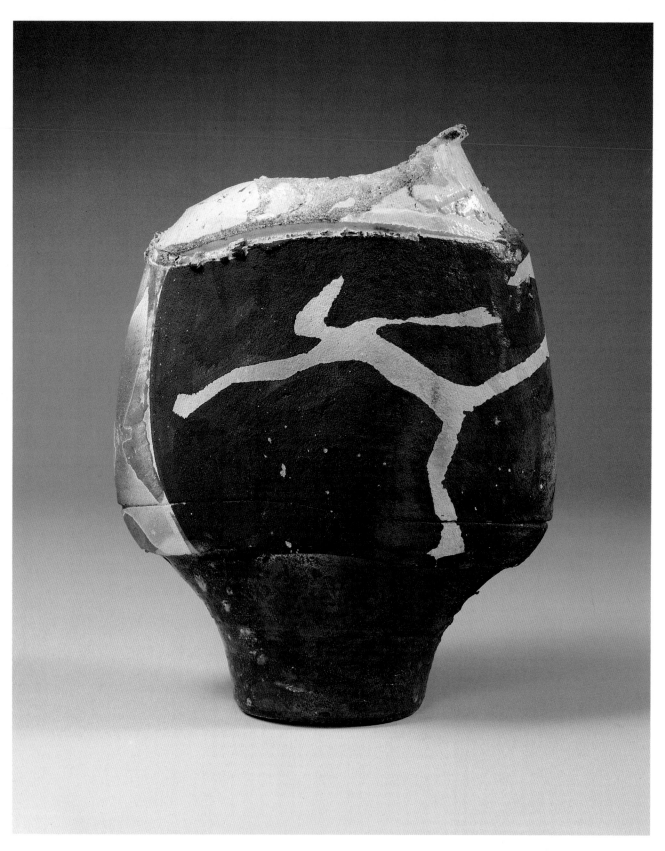

63
PAUL SOLDNER
Vessel, 1966
Stoneware, partially glazed, raku fired
13¼ x 10¼ x 6¾
(92.1.89)

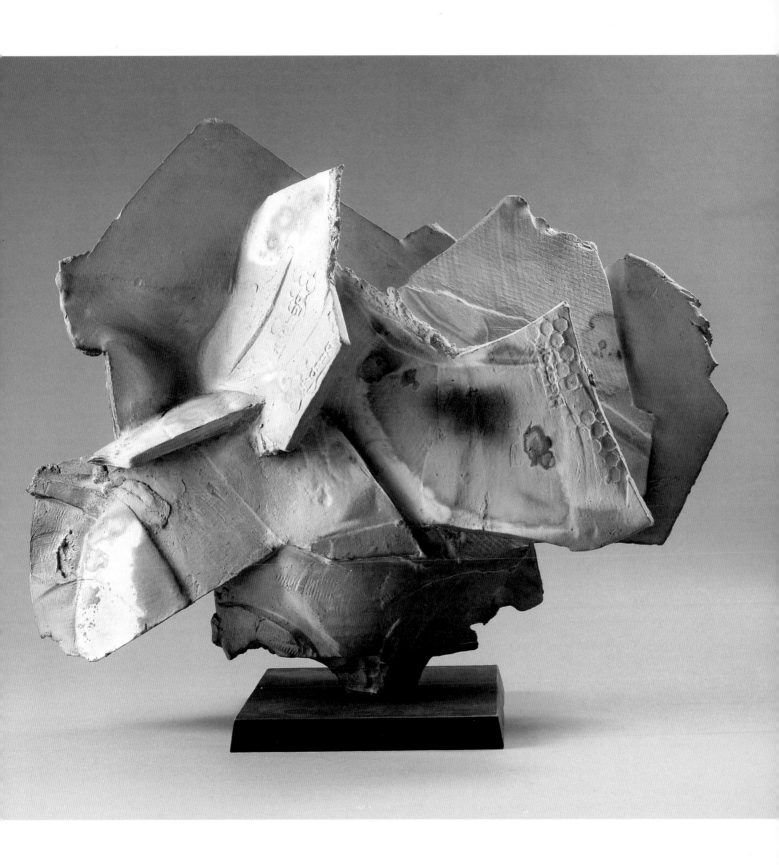

64
PAUL SOLDNER
Pedestal Piece (907), 1990
Raku clay, glazed terra sigillata,
low temperature, salt-vapor fired
27 x 30 x 11
(92.1.154)

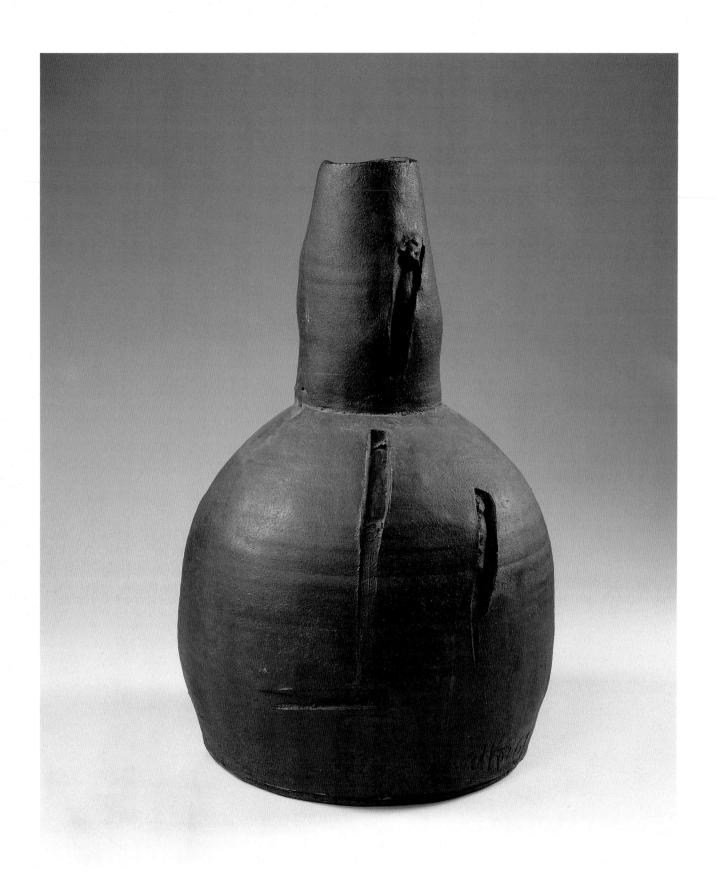

65
PETER VOULKOS

Large Vessel, 1967
Stoneware, glazed
28 x 15¼ x 15¼
(92.1.121)

66
PETER VOULKOS

Vase, 1975
Stoneware, porcelain inlays, glazed
39 x 10½ x 10½
(79.8.29)

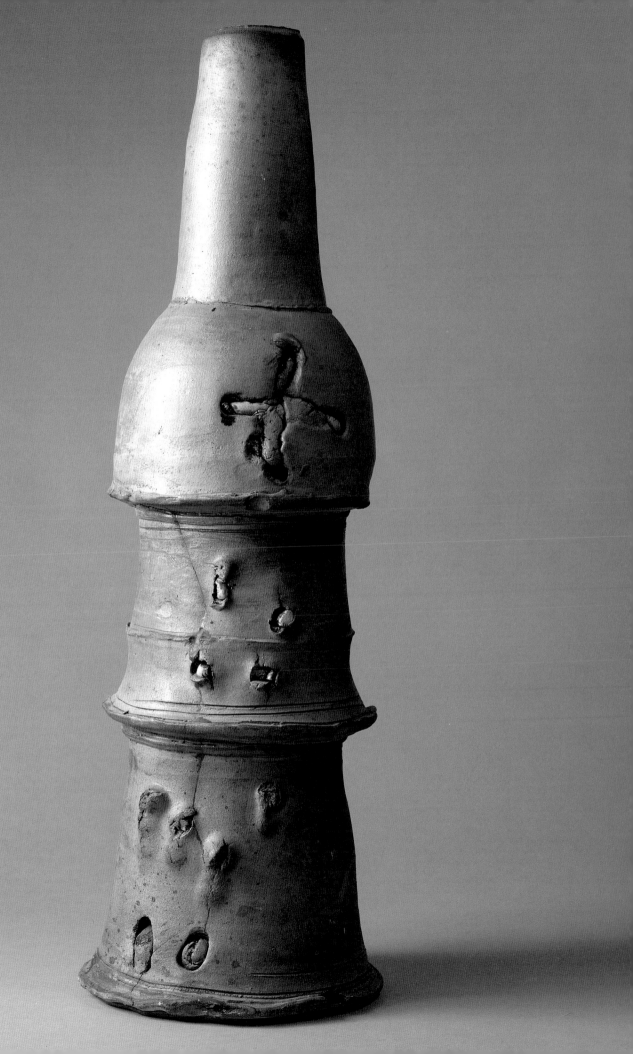

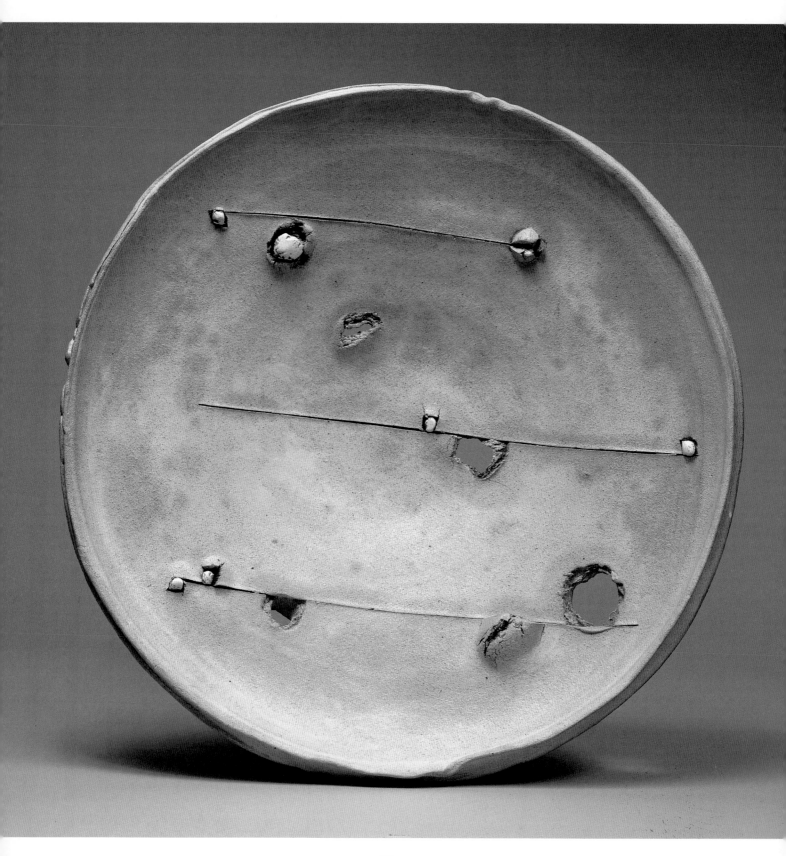

67
PETER VOULKOS
Plate, 1975
Stoneware, porcelain inlays, glazed
4½ x 20½ x 20½
(92.1.117)

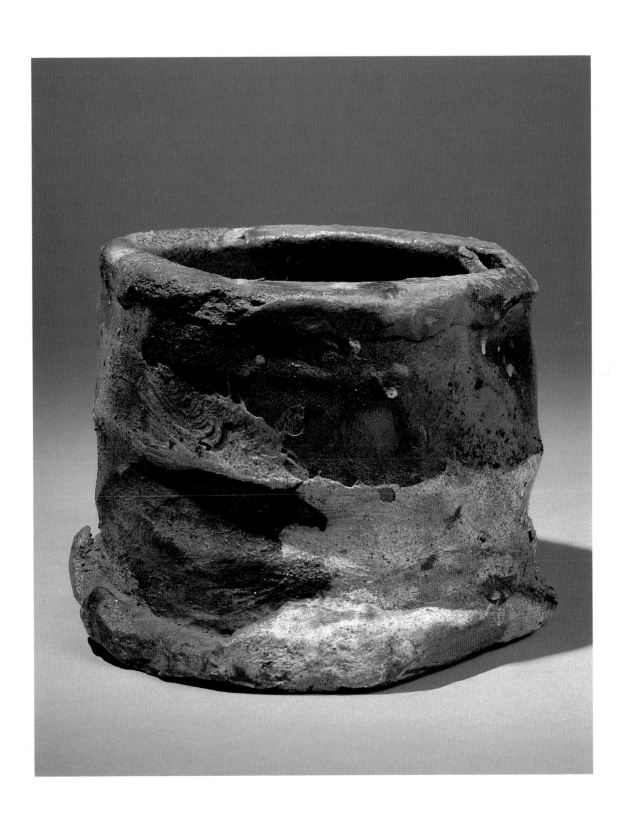

68
PETER VOULKOS
Vessel (Ice Bucket), 1982
Earthenware, glazed
7⅛ x 9½ x 9½
(92.1.142)

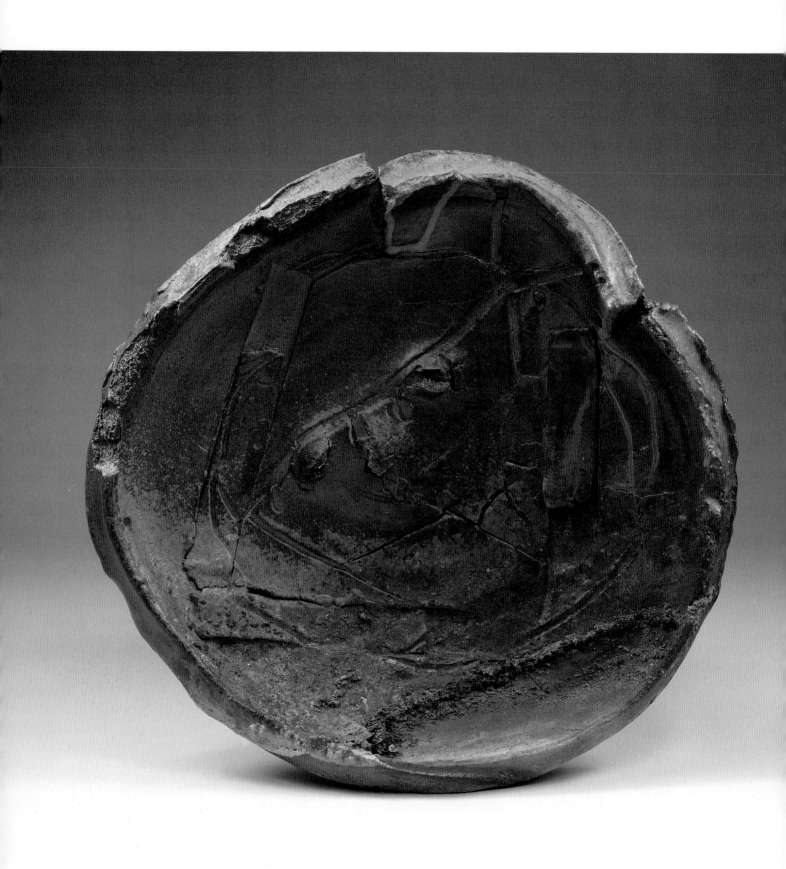

69
PETER VOULKOS
Plate, 1990
Stoneware, glazed
4¼ x 21½ x 21⅛
(92.1.155)

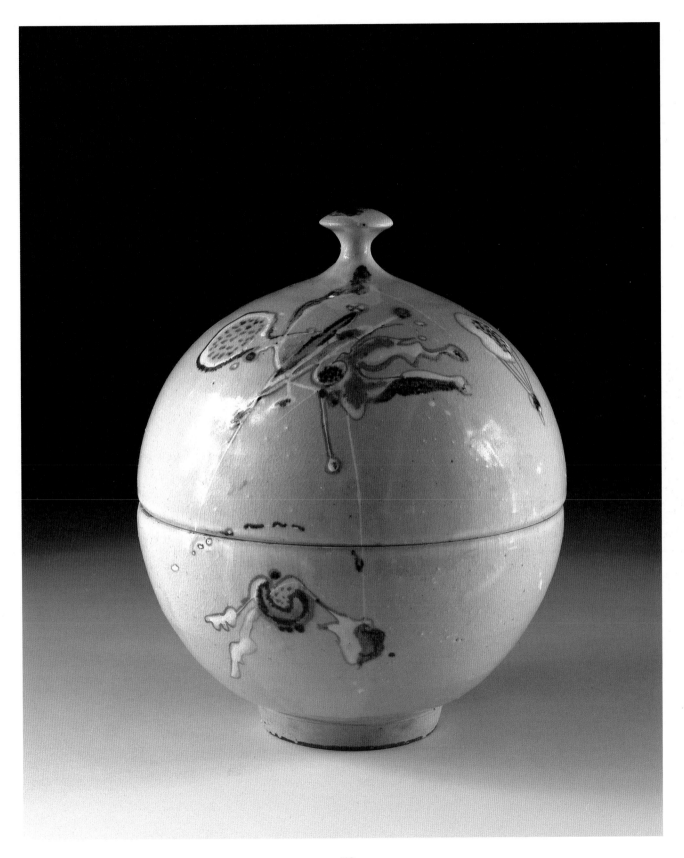

70
PATTY WARASHINA
Covered Jar, 1968
Porcelain, glazed
12¾ x 10 x 19
(L78.1.230a,b)

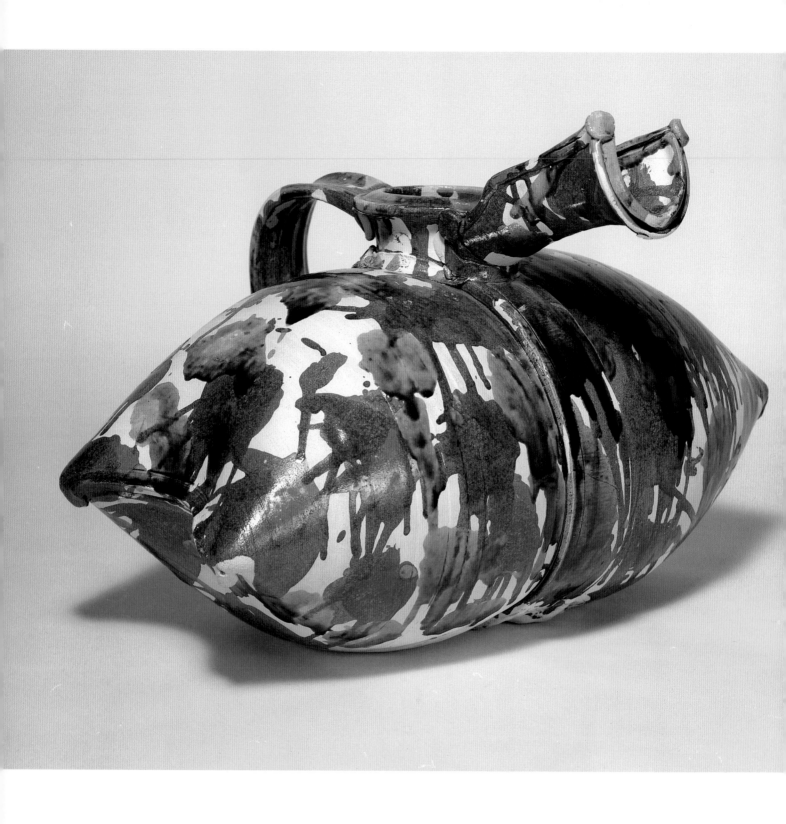

71
BETTY WOODMAN
Pitcher, 1978
Earthenware, low-fire glazed
15 x 22 x 15 ¼
(80.8.33)

Glossary of Terms

Compiled by Cynthia Lewis

Art pottery
Pottery made to be used as art objects rather than functional objects.

Ash
The remains of burnt grass, leaves, straw, etc., which are used in certain high-fire glazes.

Bisque
Ware that has been fired at a low temperature that prepares the surface for glazing and refiring.

Clay body
The composition of clay and other elements.

Cone
A triangular or cone-shaped support for an object being fired. The cone is used to determine when firing is complete. When the predetermined temperature is reached, the tip of the cone collapses. Also known as pyrometric cones.

Cones 022–15:	605° to 1435° C.
Cone 07:	990° C. (low-fire earthenware matures)
Cone 02:	1125° C. (earthenware matures)
Cone 9:	1285° C. (stoneware matures)
Cone 13:	1350° C. (porcelain matures)

(All temperatures are approximate. Source: John B. Kenny, ed., *The Complete Book of Pottery Making* (Radnor, PA: Chilton Book Company, 1976).

Crackle glaze
A technique of deliberately creating a glaze surface covered with minute cracks for a decorative effect.

Earthenware
A body of clay fired at a low heat (normally 1125° C.). Earthenware is porous and opaque, usually red/brown in color, and unable to hold water unless glazed.

Engobe
A prepared slip applied over a clay body, often used to provide a smooth surface for glaze decoration (may consist of clay, flint, feld spar, flux, and/or colorants).

Glaze
A coating of finely ground minerals that is applied to bisque-fired ceramic ware and fired, fusing the ingredients to create a nonporous covering of glass. The appearances of glazes vary, depending on the temperature at which the piece is fired.

Japonisme
A term coined in 1872 by Philippe Burty, a French art collector and critic, to describe the western preoccupation with and influence by things Japanese. In American ceramics, the influence of the Japanese design aesthetic first appeared in Rookwood Pottery in the 1880s.

Kiln
A furnace developed specifically for the use of firing ceramic materials. There are several types of kilns, each designed for different purposes and to produce different results.

Low fire
Usually referring to earthenware, a clay form which is fired at a temperature lower than 2000° F.

Lustre
Metallic decoration consisting of metallic salt, resin, and bismuth nitrate. This mixture is applied to a glazed piece, which is then reduction-fired at a low temperature.

> **On-glaze lustres**
> Matte glazes with decorated surfaces.
> **In-glaze lustres**
> Lustres applied to the glazed but unfired surface of ware. During firing, the oxides in the pigment sink into the glaze.

Matte glaze
A glaze that is non-glossy, with a granular surface rather than a shiny appearance

Mingei
Japanese movement which sought to restore prestige to folk crafts and objects created by anonymous artisans. Mingei ceramics were mainly created for mass consumption.

Oxide
Metal oxides used for coloring fired clay:

chromium oxide	gray-green
cobalt oxide	blue
copper oxide	green to black
iron oxide	brown
manganese dioxide	brown
rutile	yellow

Porcelain
A white, translucent clay body that is vitrified and usually fired at 1,300°C.

Post-firing
The process by which ceramic pieces are cooled following raku firing.

Raku
Originally a Japanese technique, raku became popular in the United States in the mid 1960s. In this process pots are bisque fired, glazed, and placed into a kiln for 15-30 minutes until the glaze matures. The pot is then removed from the kiln with tongs and cools quickly. It may then be placed on combustible material such as grass, saw-dust, or straw, or dunked into water. Translated as "happiness," raku is associated with the Zen Buddhist-inspired tea ceremony.

Raku clay
An open porous clay created to endure the thermal shock of fast firing and fast cooling that the raku process entails.

Reduction firing
A firing technique in which oxygen is limited, causing color changes in both the clay body and glazes. Reduction firing facilitates the integration of clay body and glaze in high-fired porcelain and stoneware.

Salt glaze
A hard, glassy glaze created by throwing salt into the kiln during firing. The salt vaporizes and combines with the silica in the clay body to produce sodium silicate.

Sgraffito
Scratching through the colored slip or glaze to reveal the color underneath, creating a decorative design.

Slip
Clay, combined with water, that forms a thin liquid. This liquid can be applied to parts of the vessel or over the whole piece. It can be applied as decoration or to change the color of the body.

Stoneware
Pottery, normally brown, tan, or gray in color, which is fired at temperatures of 1,200° C. and above, creating a hard, vitreous body that can hold water without being glazed.

Throwing
The process of making a symmetrical, circular object on a rotating wheel. The potter's hands, along with the centrifugal force of the wheel, control the clay's shape.

Checklist of the Exhibition

Compiled by Ella Howard and
Cynthia Lewis

Checklist is arranged chronologically in
three sections, then alphabetically by artist.
All measurements are given in inches.
Collection accession numbers are indicated
by parentheses.

PART I. THE STUDIO POTTERY
TRADITION, 1940–1970

LAURA ANDRESON (b. 1902)
1. *Teapot*, 1944
Earthenware, glazed
5 x 6½ x 9½
(L78.1.387)

2. *Bowl*, 1954
Stoneware, glazed
4¼ x 9 x 9
(78.1.166)

MICHAEL CARDEW (1900–1983)
3. *Plate*, c. 1970
Stoneware, glazed
2 x 11¼ x 11¼
(L78.1.783)

4. *Handled Jar*, c. 1970
Earthenware, glazed
12¼ x 8½ x 8½
(L78.1.543)

HANS COPER (1920–1981)
5. *Vase*, c. 1970
Stoneware, glazed
9½ x 6½ x 6½
(L78.1.576)

SHOJI HAMADA (1894–1978)
6. *Bottle*, n.d.
Stoneware, glazed
9¼ x 7 x 5¾
(L78.1.417)

VIVIKA AND OTTO HEINO
(Vivika b. 1909; Otto b. 1915)
7. *Lidded Container*, c. 1960
Stoneware, glazed
7½ x 5 x 5
(83.2.6 a,b)

TOYO KANESHIGE (1894–1978)
8. *Bottle*, 1956
Stoneware, salt glazed
8 ¼ x 4½ x 4½
(L78.1.260)

KANJIRO KAWAI (1890–1966)
9. *Bottle*, c. 1950
Stoneware, glazed
8½ x 7½ x 3½
(L78.1.92)

10. *Vase*, c. 1960
Stoneware, glazed
8¾ x 6¾ x 6
(L78.1.533)

BERNARD LEACH (1887–1979)
11. *Bottle*, 1956
Stoneware, glazed
8 x 5 x 3⅜
(L78.1.264)

WILLIAM STAITE MURRAY
(1881–1961)
12. *Vase*, 1939
Stoneware, glazed
12½ x 7 x 7
(81.8.9)

ANTONIO PRIETO (1912–1967)
13. *Bottle*, 1959–60
Stoneware, glazed
8½ x 8¼ x 8¼
(81.8.10)

LUCIE RIE (b. 1902)
14. *Bowl*, 1960
Porcelain, glazed
3 x 7¼ x 7¼
(L78.1.263)

MARGUERITE WILDENHAIN
(1896–1985)
15. *Bowl*, 1954
Stoneware, glazed
3½ x 15¼ x 15¼
(L78.1.299)

16. *Vase*, 1954
Stoneware, glazed
6 x 5 x 5
(L78.1.136)

BEATRICE WOOD (b. 1893)
17. *Vase*, 1955
Earthenware, glazed
6½ x 6½ x 6½
(L78.1.442)

ANONYMOUS
18. Japanese Shigaraki ware
Lidded Container, 20th c.
Stoneware, glazed
8⅜ x 7¾ x 6¾
(L78.1.22a,b)

19. Japanese Bizen ware
Vase, 20th c.
Stoneware, glazed
10½ x 5¼ x 5
(78.1.23)

PART II. INNOVATIONS IN
CLAY: THE OTIS ERA, 1954–1960

BILLY AL BENGSTON (b. 1934)
20. *Flower Pickers*, 1956
Stoneware, glazed
13½ x 6 x 6
(87.1.3)

21. *Moontan*, 1957
Stoneware, glazed
13 x 13 x 1¾
(87.1.4)

MICHAEL FRIMKESS (b. 1937)
22. *Plate*, 1960
Stoneware, glazed
19 x 19 x 3
(92.1.2)

JOHN MASON (b. 1927)
23. *Vase*, 1958
Stoneware, low-fire glazed
24 x 8 x 6½
(92.1.51)

24. *Container ("X")*, 1958-60
Stoneware, low-fire glazed
12 x 11½ x 10
(92.1.47)

MAC McCLAIN (b. 1933)
25. *Vase*, 1957
Stoneware, glazed
14⅝ x 8½ x 5½
(92.1.43)

KENNETH PRICE (b. 1935)
26. *Vase*, 1956
Stoneware, glazed
17½ x 5 x 5
(84.9.7)

27. *Vase*, c. 1958
Stoneware, glazed
20 x 6 x 6
(92.1.62)

JANICE ROOSEVELT (b. 1935)
28. *Candelabra*, 1959
Stoneware, glazed
10½ x 6½ x 3½
(81.8.11)

JERRY ROTHMAN (b. 1933)
29. *Shallow Bowl: Self-Portrait with
Karen Neubert*, 1958
Stoneware, glazed
16¼ x 16¼ x 3¼
(92.1.70)

30. *Sky Pot*, 1960
Stoneware, unglazed
28½ x 25 x 9
(92.1.82)

PAUL SOLDNER (b. 1921)
31. *Bottle with Face (Sophia Loren)*,
c. 1958–59
Stoneware, glazed
17 x 12 x 8
(92.1.94)

32. *Vase*, 1961
Stoneware, glazed
18 x 11 x 9
(92.1.90)

HENRY TAKEMOTO (b. 1930)
33. *First Kumu*, 1959
Stoneware, glazed
21¾ x 22 x 22
(92.1.113)

34. *Flag*, 1960
Stoneware, glazed
36¾ x 26 x 7¼
(92.1.109)

35. *Plate*, 1960
Stoneware, glazed
2½ x 16 x 16
(83.2.18)

PETER VOULKOS (b. 1924)
36. *Vase*, 1955
Stoneware, glazed
26¾ x 9½ x 9½
(92.1.149)

37. *Vase*, 1955
Stoneware, glazed
12¾ x 7½ x 7½
(92.1.135)

38. *Covered Jar*, 1956
Stoneware, glazed
26½ x 18 x 18
(91.4.1)

39. *Vessel*, 1956
Stoneware, low-fire overglaze
3¾ x 5 x 4¾
(92.1.129)

40. *Sculpture (Walking Man)*, 1957
Stoneware, low-fire overglaze
17 x 12 x 8
(92.1.136)

41. *Plate (Bullfight)*, 1957
Stoneware, glazed, painted
3 x 17 x 17
(92.1.153)

42. *Plate*, 1957
Stoneware, glazed
2 x 12 x 12
(92.1.122)

43. *Sculpture*, 1957
Stoneware, thin colemanite glaze
35 x 21 x 21
(82.2.1)

44. *Bird Vase*, 1958
Stoneware, glazed
9 x 15 x 15
(91.4.2)

45. *Bottle*, 1961
Stoneware, glazed
17 x 8 x 8
(92.1.138)

PART III. CONTEMPORARY
CERAMICS IN THE MARER
COLLECTION, 1960–1990

ROBERT ARNESON (1930–1992)
46. *Footed Bowl*, 1955
Stoneware, glazed
6¾ x 7 x 7
(81.8.2)

RUDY AUTIO (b. 1926)
47. *Doll Vase*, 1968
Stoneware, low-fire lustre overglaze
40 x 23 x 12
(L78.1.216)

PHILIP CORNELIUS (b. 1934)
48. *Enterprise*, 1976
Porcelain, glazed
11⅝ x 7½ x 2⅛
(L89.1.4)

VIOLA FREY (b. 1933)
49. *Plate*, 1979
Porcelain, glazed
3 x 20½ x 20½
(85.4.1)

MICHAEL FRIMKESS (b. 1937)
50. *Jumpin' at the Moon*, 1968
Stoneware, low-fire lustre overglaze
28¼ x 16 x 16
(92.1.3a,b)

JUN KANEKO (b. 1942)
51. *Sanbon Ashi*, 1971
Stoneware, glazed
30 x 35 x 20
(L78.1.618, 619,620,621)

52. *Plate*, 1971
Stoneware, raku fired, partially glazed
2 x 12½ x 12½
(84.9.5)

53. *Plate*, 1971
Stoneware, raku fired, partially glazed
2 x 12½ x 13
(86.1.6)

RYOJI KOIE (b. 1938)
54. *Sculpture (Chernobyl Series)*, 1990
Stoneware, partially glazed
23 x 23
(L94.1.1)

MARILYN LEVINE (b. 1935)
55. *F.M. Case*, 1981
Stoneware and mixed media, partially
glazed
4¾ x 9⅜ x 7
(L85.1.8)

JOHN MASON (b. 1927)
56. *Sculpture*, 1961
Stoneware, glazed
42 x 13½ x 11
(79.8.9)

57. *Vase*, 1964
Stoneware, glazed
12 x 6 x 6
(92.1.49)

JAMES MELCHERT (b. 1930)
58. *Container*, 1960
Stoneware, glazed
13 x 20 x 6
(L78.1.683)

MINEO MIZUNO (b. 1944)
59. *Sculpture (Screw)*, 1973
Stoneware, glazed
13 x 13 x 37
(83.2.15)

RON NAGLE (b. 1939)
60. *Perfume Bottle (Bottle with Stopper)*,
1960
Stoneware, light-fire and low-fire glazed
24½ x 22 x 5
(92.1.61a,b)

ANNE SCOTT PLUMMER (b. 1951)
61. *Peter Hunt's Africa*, 1988
Low-fire ceramic, glazed
28 x 17½ x 17
(L89.1.2)

JERRY ROTHMAN (b. 1933)
62. *Drink Me*, 1961
Stoneware, glazed
26 x 35 x 22½
(92.1.84)

PAUL SOLDNER (b. 1921)
63. *Vessel*, 1966
Stoneware, partially glazed, raku fired
13¼ x 10¼ x 6¾
(92.1.89)

64. *Pedestal Piece (907)*, 1990
Raku clay, glazed terra sigillata,
low temperature, salt-vapor fired
27 x 30 x 11
(92.1.154)

PETER VOULKOS (b. 1924)
65. *Large Vessel*, 1967
Stoneware, glazed
28 x 15¼ x 15¼
(92.1.121)

66. *Vase*, 1975
Stoneware, porcelain inlays, glazed
39 x 10½ x 10½
(79.8.29)

67. *Plate*, 1975
Stoneware, porcelain inlays, glazed
4½ x 20½ x 20½
(92.1.117)

68. *Vessel (Ice Bucket)*, 1982
Earthenware, glazed
7⅛ x 9½ x 9½
(92.1.142)

69. *Plate*, 1990
Stoneware, glazed
4¼ x 21½ x 21⅛
(92.1.155)

PATTY WARASHINA (b. 1939)
70. *Covered Jar*, 1968
Porcelain, glazed
12¾ x 10 x 19
(L78.1.230a,b)

BETTY WOODMAN (b. 1930)
71. *Pitcher*, 1978
Earthenware, low-fire glazed
15 x 22 x 15¼
(80.8.33)

Checklist of the Collection

Compiled by Ella Howard

Checklist is arranged alphabetically by artist.
Asterisks indicate works included in current exhibition.
All measurements are given in inches.
Collection accession numbers are enclosed in parentheses.
+ Indicates only partial name available. We would appreciate information to help us complete our records.

I. ARTISTS

ANN ADAIR

1. *Cup*, 1973
 Porcelain, glazed
 2½ x 4½ x 3¼
 (L78.1.725)

2. *Plaque-plate*, 1973
 Porcelain, glazed
 13 x 13 x 2½
 (L78.1.301)

3. *Bottle*, n.d.
 Stoneware, glazed
 7½ x 4½ x 4¼
 (L78.1.84)

4. *Plate*, n.d.
 Porcelain, glazed
 1 x 12¾ x 12¾
 (L78.1.357)

5. *Plate*, 1980
 Porcelain, glazed
 1½ x 13½ x 8¼
 (L78.1.716)

6. *Vase*, n.d.
 White stoneware, glazed
 8¾ x 4½ x 4½
 (L78.1.82)

R. AMONOTE

7. *Plate*, n.d
 Stoneware, glazed
 11½ x 11½ x 1
 (L85.1.10)

TERENCE ANDERSON

8. *Low-bowl*, 1974
 Stoneware, glazed
 2¼ x 14½ x 14½
 (79.8.1)

LAURA ANDRESON

9. *Shallow bowl*, 1944
 Earthenware, glazed
 2 x 8¾ x 8¾
 (81.8.1)

*10. *Teapot*, 1944
 Earthenware, glazed
 5 x 6½ x 9½
 (L78.1.387)

*11. *Bowl*, 1954
 Stoneware, glazed
 4¼ x 9 x 9
 (78.1.166)

ROBERT ARNESON

12. *Footed bowl*, 1955
 Stoneware, glazed
 4⅝ x 6½ x 5¾
 (86.1.1)

13. *Footed bowl*, 1955
 Stoneware, glazed
 6¾ x 7 x 7
 (81.8.2)

14. *Plate*, c. 1960
 Stoneware, glazed
 1½ x 7½ x 6½
 (L78.1.396)

RUDY AUTIO

15. *Vase*, 1958
 Earthenware, glazed
 18 x 7½ x 8
 (L78.1.568)

16. *Container*, 1959
 Stoneware, glazed
 10 x 6 x 5
 (81.8.3)

17. *Vase*, 1963
 Stoneware, glazed
 14½ x 11 x 8
 (84.9.1)

18. *Figurine*, 1964
 Stoneware, glazed
 10¾ x 5 x 2½
 (L78.1.93)

19. *Figurine*, 1964
 Stoneware, glazed
 13 x 5½ x 4
 (87.1.1)

*20. *Doll-Vase*, 1968
 Stoneware, low-fire lustre overglaze
 40 x 23 x 12
 (L78.1.216)

21. *Sculpture*, n.d.
 Stoneware, unglazed
 4¼ x 2¾ x 2½
 (L78.1.402)

22. *Sculpture*, n.d.
 Stoneware, unglazed
 3½ x 3⅜ x 2½
 (L78.1.403)

23. *Vase*, n.d.
 Stoneware, glazed
 6 x 5½ x 4
 (78.1.105)

D. BAILEY

24. *Bowl*, n.d.
 Earthenware, glazed
 3H x 11K x 10K
 (L83.1.2)

MARIO BARTELS

25. *Cup*, 1956
 Stoneware, salt fire
 4 x 3¼ x 2¾
 (L78.1.77)

BILLY AL BENGSTON

*26. *Flower Pickers*, 1956
 Stoneware, glazed
 13½ x 6 x 6
 (87.1.3)

27. *Plate*, 1956
 Stoneware, glazed
 2 x 11 x 11
 (84.9.2)

*28. *Moontan*, 1957
 Stoneware, glazed
 13 x 13 x 1¾
 (87.1.4)

29. *Moontan*, n.d.
 Earthenware
 9 x 5 x 6
 (91.1.1)

RICHARD BENNETT

30. *Bottle*, n.d.
 Porcelain, crystalline glaze
 11 x 4 x 4
 (L78.1.709)

KATHERINE (TAFFY) BESLEY

31. *Plate*, 1979
 Porcelain, glazed
 18½ x 18½ x 2¼
 (L78.1.704)

32. *Sculpture*, n.d.
 Stoneware, low-fire salt
 15 x 18¾ x 4
 (L78.1.287)

33. *Sculpture*, n.d.
 White stoneware, glazed
 23¾ x 15 x 20½
 (93.3.6L)

34. *Square bowl with feet*, n.d.
 Raku porcelain
 4½ x 12½ x 12
 (L78.1.308)

35. *Serving Dish*, n.d.
 Raku porcelain
 3⅜ x 12 x 12
 (L78.1.306)

KRISTIN BONKEMEYER

36. *Hanging Sculpture*, 1977
 Paper, low-fire salt ribbon
 11 x 10½ x 11
 (L78.1.664)

37. *Sculpture*, n.d.
 Stoneware, glazed
 26 x 16 x 5
 (L78.1.666)

JOHN BOWER

38. *RO Series VIII*, 1978
 Stoneware, glazed
 5¼ x 7¾ x 4
 (L87.1.12)

CHARLES CAMPBELL

39. *Platter*, 1977
 Stoneware, glazed
 19 x 19 x 2½
 (L78.1.698)

40. *Sculpture*, n.d.
 Earthenware, low-fire, and painted
 decoration
 15 x 15 x 10
 (L78.1.266)

ARA CARDEW

41. *Plate*, n.d.
 Stoneware, glazed
 2¼ x 14½ x 10¾
 (L84.1.17)

MICHAEL CARDEW

42. *Bowl*, 1980
 Stoneware, glazed
 8¼ x 12 x 12
 (L78.1.743)

*43. *Plate*, c. 1970.
 Stoneware, glazed
 2 x 11¼ x 11¼
 (L78.1.783)

*44. *Handled Jar*, c. 1970
 Earthenware, glazed
 12¼ x 8½ x 8½
 (L78.1.543)

SETH CARDEW

45. *Covered jar*, n.d.
 Stoneware, glazed
 24¼ x 12 x 12
 (L84.1.13a,b)

46. *Plate*, n.d.
 Stoneware, glazed
 2 x 10¾ x 10¾
 (L78.1.784)

NINO CARUSO

47. *Platter, sculpture*, 1981
 Earthenware, glazed
 22 x 22 x 3½
 (L78.1.706)

CHATTERTON

48. *Shallow bowl*
 Earthenware, glazed
 3¼ x 19 x 19
 (L78.1.788)

ANN CHRISTENSON

49. *Teapot*, n.d.
 Porcelain, glazed
 13½ x 15 x 7
 (L78.1.734a,b)

ERIK CLARK

50. *Flower Vase*, 1970
 Stoneware, glazed
 6 x 3½ x 3½
 (L78.1.368)

THOM COLLINS

51. *Covered jar*, 1973
 Stoneware, glazed
 19¼ x 12¾ x 12¾
 (79.8.2a,b)

52. *Bottle*, 1985
 Stoneware, glazed, raku fired
 11⅜ x 4½ x ¾
 (L86.1.20)

ROBERT COOPER

53. *Plaque*, 1982
 Porcelain, low-fire clay, wood
 20⅝ x 16 x 1½
 (L84.1.1)

54. *Covered pot*, 1985
 Stoneware, glazed
 14½ x 8½ x 8½
 (L87.1.11a,b)

55. *Lidded vessel*, 1985
 Stoneware, glazed
 16 x 12 x 12
 (L87.1.21)

56. *Lidded vessel*, 1986
 Stoneware, glazed
 13 x 11¾ x 7
 (L87.1.22)

57. *Lidded vessel*, 1988
Stoneware, glazed
18½ x 10½
(L88.1.3a,b)

58. *Vessel with three legs*, 1988
Stoneware, glazed
17 x 11¼ x 9½
(L88.1.6a,b)

59. *Pitcher*, n.d.
Stoneware, glazed
15⅛ x 6½ x 5½
(L92.2.1)

60. *Plaque*, n.d
Stoneware, glazed, raku fired
22 x 15 x 1½
(L85.1.7)

61. *Plaque*, n.d.
Stoneware, glazed
20¼ x 16¼ x 1⅝
(L84.1.3)

62. *Triangular sculpture*, n.d.
Stoneware, painted
24 x 18½ x 4½
(L89.1.3)

HANS COPER
*63. *Vase*, c.1970
Stoneware, glazed
9½ x 6½
(L78.1.576)

PHILIP CORNELIUS
64. *Covered jar*, 1971
Stoneware, glazed
19 x 15 x 15
(80.8.3a,b)

65. *Cup*, 1971
Porcelain, glazed
4 x 3½ x 3
(80.8.2a)

66. *Cup*, 1971
Porcelain, glazed
4 x 3½ x 3
(80.8.2b)

67. *Cup*, 1971
Porcelain, glazed
4 x 3½ x 3
(80.8.2c)

68. *Covered jar*, 1973
Stoneware, glazed
24 x 16 x 19
(79.8.3a,b)

*69. *Enterprise*, 1976
Porcelain, glazed
11⅝ x 7½ x 2⅛
(L89.1.4)

70. *Samian*, 1984
Porcelain, glazed
9¾ x 7½ x 2½
(L87.1.26)

71. *Use It or Lose It*, 1984
Porcelain, glazed
7¾ x 6 x 4
(L87.1.27)

72. *Sound*, 1989
Porcelain
7¼ x 18 x 3
(L89.1.5)

73. *Bottle*, n.d.
Raku clay
7 x 6 x 6
(L78.1.175)

74. *Plate*, n.d.
White stoneware
20 x 20 x 3
(79.8.4)

75. *Three Small Clouds*, n.d.
Porcelain, glazed
12¾ x 14¼ x ¾
(L85.1.11)

JULIAN CURRY
76. *Sugar bowl*, n.d.
Stoneware, glazed
4¼ x 4 x 2½
(L86.1.19a,b)

JIM DANISCH
77. *Bowl*, n.d.
Porcelain, glazed
6½ x 8 x 8
(L78.1.750)

ROBIN DAVIS
78. *Container*, n.d.
Earthenware, glazed
13¾ x 7¾ x 7¾
(L78.1.508)

DORA DELARIOS
79. *Vessel*, n.d.
Stoneware, glazed
7½ x 7 x 7
(L78.1.443)

RON DITTMER
80. *Saucer*, n.d.
Stoneware, glazed
1½ x 5 x 5
(78.1.248)

81. *Saucer*, n.d.
Stoneware, glazed
1¼ x 4¼ x 4¼
(78.1.251)

EDDIE DOMINGUEZ
82. *Cups as Totem Pole*, 1984
Earthenware, glazed
15 x 3½ x 8¼
(L86.1.2a-d)

RUTH DUCKWORTH
83. *Bowl*, n.d.
Stoneware, glazed
4 x 8 x 7¾
(81.8.4)

STAN EDMONSON
84. *Tombstone*, 1986
Earthenware, glazed
21 x 24 x 4
(L87.1.2)

JOEL EDWARDS
85. *Lidded container*, 1956
Earthenware, glazed
11½ x 6½ x 6½
(L78.1.544a,b)

HIROAKI ENDO
86. *Covered jar*, 1974
Porcelain, glazed
9 x 7 x 7
(L78.1.451a,b)

87. *Covered jar*, 1974
Porcelain, glazed
20½ x 10½ x 10½
(L78.1.479a,b)

88. *Vase*, 1974
Stoneware, glazed
21½ x 15 x 15
(L78.1.674)

89. *Mustache cup*, n.d.
Stoneware, salt glazed
3½ x 3¾ x 5
(L78.1.381)

90. *Teapot with eight cups*, n.d.
Porcelain, glazed
Teapot: 6½ x 9 x 6
Cups: 2½ x 4 x 3
(L78.1.450a-i)

91. *Cup*, n.d.
Stoneware, glazed
5½ x 5 x 4
(L78.1.159)

92. *Vase*, n.d.
Stoneware, glazed
19 x 5 x 5
(L78.1.565)

93. *Vase*, n.d.
Stoneware, glazed
10⅝ x 5¾ x 5¾
(L78.1.466)

94. *Vase*, n.d.
Stoneware, glazed
10 x 11 x 11
(L78.1.385)

95. *Vase*, n.d.
Stoneware, glazed
18 x 4 x 4
(L78.1.514)

CHRISTINE FEDERIGHI
96. *Carved Horse House Rider*, n.d.
White stoneware, glazed
26½ x 9 x 12
(L85.1.4a,b)

CHARLENE FELOS
97. *Sculpture*, 1976
Raku clay, fiber, sticks
8 x 11½ x 11½
(L78.1.407)

ELLIE FERNALD
98. *Plate*, 1971
Porcelain, low-fire, glazed
1 x 13 x 13
(83.2.1)

99. *Plate*, 1971
Porcelain, low-fire, glazed
¾ x 10½ x 10½
(80.8.1)

DOUGLAS FEY
100. *Coffee/Tea Set*, 1980
Stoneware, glazed
pitcher: 10 x 8½ x 5
cup: 4 x 4½ x 3½
(L88.1.7a-k)

101. *Platter*, n.d.
Stoneware, glazed
3 x 19 x 19
(L78.1.768)

102. *Plate*, n.d.
White stoneware, glazed
2 x 14 x 14
(L89.1.9)

103. *Plate*, n.d.
Porcelain, glazed
1½ x 13½ x 13½
(93.3.2L)

ANGELA FINA
104. *Bowl*, n.d.
Porcelain, glazed
3¼ x 9 x 9
(L78.1.749)

105. *Vase*, n.d.
Porcelain, glazed
8 x 6½ x 6½
(L78.1.746)

JAMES FOSTER
106. *Sculpture*, 1971
Stoneware
19 x 13½ x 13½
(80.8.4)

107. *Vessel*, 1975
Stoneware, salt-fire glazed
20½ x 12 x 12
(80.8.5)

108. *Sculpture*, n.d.
White stoneware, glazed
9½ x 8 x 8
(L78.1.294)

109. *Teapot*, n.d.
Earthenware, glazed
11½ x 8½ x 7
(L78.1.711)

SESHU FOSTER
110. *Sculpture*, n.d.
Stoneware, glazed
11½ x 6 x 7¼
(L78.1.689)

VIOLA FREY
*111. *Plate*, 1979
Porcelain, glazed
3 x 20½ x 20½
(85.4.1)

FRIBERG-GUSTAVBERG STUDIO
112. *Bottle*, n.d.
Porcelain, glazed
7½ x 6¾ x 6¾
(L78.1.81)

MAGDALENA FRIMKESS
113. *Bottle*, 1974
Stoneware, glazed
10½ x 5 x 5
(L78.1.119)

114. *Bowl*, n.d.
Stoneware, glazed
3 x 4¾ x 4¾
(L78.1.76)

115. *Cup*, n.d.
Stoneware, glazed
4¼ x 3¾ x 4
(L88.1.9)

116. *Cup*, n.d.
Stoneware, glazed
2⅞ x 5 x 4½
(L88.1.10)

117. *Figurine*, n.d.
Stoneware, glazed
8½ x 4½ x 8½
(L78.1.116)

118. *Goblet*, n.d.
Porcelain, glazed
4¼ x 3¼ x 3¼
(L78.1.161)

119. *Goblet*, n.d.
Porcelain, glazed
4 x 3 x 3
(L78.1.153)

MICHAEL FRIMKESS
120. *Plate*, 1958
Earthenware, glazed
1½ x 11½ x 11½
(92.1.33)

121. *Platter*, 1958
Earthenware, glazed
1½ x 11 x 11
(92.1.36)

122. *Plate*, 1960
Stoneware, glazed
1½ x 10 x 10
(92.1.31)

123. *Plate*, 1960
Stoneware, glazed
1½ x 10½ x 10¼
(92.1.35)

*124. *Platter*, 1960
Stoneware, glazed
3 x 19 x 19
(92.1.2)

125. *Platter*, 1962
Stoneware, glazed
2¼ x 18¾ x 18¾
(92.1.34)

*126. *Jumpin' at the Moon*, 1968
Stoneware, low-fire lustre overglaze
28¼ x 16 x 16
(92.1.3a,b)

127. *Lidded Container*, 1968
Porcelain, low-fire overglaze
14½ x 12 x 12
(92.1.30a,b)

128. *Lidded container*, 1970
Stoneware, glazed
3½ x 4½ x 3½
(92.1.23)

129. *Bottle*, 1972
Stoneware, glazed
8½ x 4 x 4
(92.1.40)

130. *Teapot with camel lid*, 1974
Stoneware, glazed
19¼ x 5 x 9¾
(92.1.29a,b)

131. *Vase*, 1974
Stoneware, glazed
9 x 5 x 5
(92.1.4)

132. *Bowl*, n.d.
Earthenware, glazed
7 x 9½ x 5
(92.1.24)

133. *Bowl*, n.d.
Stoneware, glazed
2¾ x 6½ x 6½
(92.1.20)

134. *Bowl*, n.d.
Earthenware, glazed
5 x 19 x 19
(92.1.13)

135. *Bowl*, n.d.
Porcelain, glazed
3 x 7¼ x 7¼
(92.1.17)

136. *Bowl*, n.d.
Stoneware, glazed
3½ x 5 x 5
(92.1.37)

137. *Shallow bowl*, n.d.
Stoneware, glazed
1⅝ x 10⅛ x 9¾
(92.1.22)

138. *Lidded container*, n.d
Earthenware, glazed
9½ x 5½ x 5½
(92.1.32)

139. *Lidded jar*, n.d.
Stoneware, glazed
4¼ x 4¼ x 4¼
(92.1.16)

140. *Lidded jar*, n.d.
Stoneware, glazed
6 x 4½ x 4½
(83.2.3a,b)

141. *Plate*, n.d.
Stoneware, glazed
1 x 9½ x 9½
(92.1.12)

142. *Vase*, n.d.
Stoneware, glazed
10¾ x 6¾ x 6¾
(92.1.39)

143. *Vase*, n.d.
Stoneware, glazed
8½ x 7½ x 7½
(92.1.14)

144. *Vase*, n.d.
Stoneware, glazed
8 x 5½ x 5½
(92.1.18)

145. *Vessel*, n.d.
Stoneware, glazed
4 x 5½ x 5½
(92.1.15)

MICHAEL AND MAGDALENA FRIMKESS
146. *Platter*, 1968
Stoneware, glazed
2½ x 21¼ x 21¼
(92.1.28)

147. *Vase*, 1968
Stoneware, glazed
23 x 8½ x 8½
(83.2.4)

148. *Bowl*, 1970
Stoneware, glazed
2 x 12⅜ x 12⅜
(L78.1.314)

149. *Deep-dish plate*, 1972
Porcelain, glazed
2 x 11¾ x 11¾
(83.2.2)

150. *Vase*, 1972
Earthenware, glazed
19¼ x 11 x 11
(92.1.29)

151. *Willow Vase*, 1972
Stoneware, glazed
22¾ x 8½ x 8¼
(92.1.27)

152. *Bowl*, 1973
Stoneware, glazed
2 x 7½ x 7½
(92.1.10)

153. *Covered jar*, 1973
Stoneware, glazed
7¾ x 7 x 7
(L78.1.408a,b)

154. *Vase*, 1974
Earthenware, glazed
11¾ x 5¼
(92.1.21)

155. *Bowl*, n.d.
Stoneware, glazed
1¼ x 8 x 8
(92.1.11)

156. *Shallow bowl*, n.d.
Stoneware, glazed
1¾ x 8 x 8
(92.1.41)

157. *Shallow bowl*, n.d.
Stoneware, glazed
2 x 10¼ x 10¼
(92.1.5)

158. *Jar*, n.d.
Stoneware, glazed
5½ x 7½ x 7½
(92.1.9)

159. *Lidded container*, 1967
Porcelain, glazed
15 x 12 x 12
(92.1.25a,b)

160. *Lidded container*, n.d.
Stoneware, glazed
7 x 5¼
(92.1.7a,b)

161. *Lidded container*, n.d.
Stoneware, glazed
7 x 5½ x 5½
(92.1.6a,b)

162. *Vase*, n.d.
Stoneware, glazed
12¾ x 6¾ x 6¾
(L78.1.453)

163. *Vase*, n.d.
Stoneware, glazed
29½ x 11 x 29½
(86.1.3)

164. *Vase*, n.d.
Stoneware, glazed
8 x 4
(92.1.38)

165. *Vase*, n.d.
Stoneware, glazed
25¾ x 10 x 10
(85.4.2)

166. *Vase*, n.d.
Stoneware, glazed
7 x 5 x 5
(92.1.8)

AKIKO FUJITA

167. *Sculpture*, n.d.
Stoneware, glazed
9½ x 4¼ x 3
(L78.1.715)

DAVID FURMAN

168. *Bottle*, n.d.
Porcelain, glazed
2¼ x 2¾ x ¾
(78.1.194)

WLADISLAW GARNIK

169. *Chess set, 34 pieces*, 1978
Porcelain, glazed
Each piece approx. 4½ x 2 x 2
(L78.1.668a-hh)

170. *Sculpture*, n.d.
Porcelain, lustre glaze
13 x 11 x 8
(L78.1.668)

171. *Vessel*, n.d.
Earthenware, glazed
10½ x 12 x 3½
(L78.1.54)

RICHARD GERRISH

172. *Lidded teapot*, 1976
Earthenware, glazed
10 x 4 x 8
(L86.1.3a,b)

173. *Man-da-la* (Sculptural wall relief), 1985
Earthenware, glazed
20 x 20½ x 5
(L86.1.22)

+FRAN GIER

174. *Mug*, 1974
Stoneware, glazed
5 x 4 x 5
(L78.1.370)

175. *Cup*, 1975
Earthenware, glazed
5⅝ x 5¼ x 4¼
(L78.1.56)

ANDREA GILL

176. *Bowl*, 1976
Earthenware, glazed
7½ x 8 x 18
(83.2.5)

CRISPIN GONZALES

177. *Sculpture*, 1967
Stoneware, high-fired, glazed
23½ x 11 x 11
(79.8.5)

178. *Sculpture*, 1967
Stoneware, glazed
29 x 17 x 15
(79.8.6)

DURAN GONZALO

179. *Platter*, 1973
Porcelain, glazed
1¼ x 13½ x 13½
(L78.1.599)

JEAN GRIFFITH

180. *Container*, 1963
Raku clay, glazed
18½ x 8 x 6½
(80.8.6)

SHOJI HAMADA

181. *Bottle*, n.d.
Stoneware, glazed
9¼ x 7 x 5¾
(L78.1.417)

+HANNA

182. *Bottle*, 1959
Stoneware, glazed
8¾ x 3¼ x 3¼
(L78.1.326)

SHARON HARE

183. *Sculpture*, 1973
Stoneware, low-fire, plywood base
11¾ x 26 x 17
(L78.1.808)

ROBERT W. HARRISON

184. *T'ang meets Yuan*, 1991
Porcelain and earthenware, plaster, wood
30 x 25 x 3
(92.2.4L)

VIVIKA AND OTTO HEINO

185. *Vase*, 1960
Stoneware, glazed
9½ x 6½ x 3½
(83.2.7)

*186. *Lidded Container*, c. 1960
Stoneware, glazed
7½ x 5 x 5
(83.2.6a,b)

KEN HENDRY

187. *Plate*, n.d.
Stoneware, glazed
4 x 14 x 13½
(L78.1.268)

SAM HERMAN

188. *Vase*, 1970
Glass
15½ x 7 x 5½
(L87.1.35)

WAYNE HIGBY

189. *Shallow bowl*, 1970
Raku clay, glazed
2½ x 10¼ x 10¼
(80.8.7)

ROBERT HIRSH

190. *Three-legged vessel*, 1980
Stoneware, unglazed
10⅜ x 8¾ x 7¼
(L78.1.755)

ANNE HOLIAN

191. *Cup*, n.d.
Porcelain, glazed
3¾ x 3 x 3
(L78.1.773)

192. *Cup*, n.d.
Porcelain, glazed
3 x 3
(L78.1.774)

193. *Teacup*, n.d.
Porcelain, glazed
1½ x 2⅛ x 1¾
(L78.1.775)

COILLE HOOVEN
194. *Cup*, n.d.
Porcelain, glazed
2¾ x 6 x 3¾
(L78.1.708)

STEVE HORN
195. *Plate*, 1973
Stoneware, glazed
1¾ x 12½ x 10
(L78.1.303)

196. *Plate*, 1974
Stoneware, glazed
1½ x 14 x 14
(78.1.257)

197. *Platter*, 1974
Stoneware, glazed
2 x 18¼ x 16¼
(L78.1.458)

198. *Car Crucifixion*, 1975
Earthenware, glazed
28½ x 29 x 3½
(83.2.8)

199. *Sculptural vessel form*, 1990
Stoneware, glazed
8½ x 11 x 4¼
(L91.1.4)

200. *Vase with two handles*, 1990
Stoneware, glazed
15¼ x 10½ x 6
(L91.1.3)

201. *Vase*, 1990
Stoneware, glazed
6¾ x 5½ x 5½
(L91.1.2)

202. *Vase*, 1990
Stoneware, glazed
9⅛ x 5⅛ x 5⅛
(L91.1.5)

203. *Platter*, 1991
Porcelain, glazed
1¼ x 13⅝ x 13⅝
(93.3.3L)

204. *Bowl*, n.d.
Stoneware, glazed
4¾ x 10 x 11¾
(L78.1.680)

205. *Coffee Server with lid*, n.d.
Stoneware, gunmetal
11 x 9½ x 6
(L78.1.95a,b)

206. *Coffee Server with lid*, n.d.
Stoneware, gunmetal
12½ x 8 x 5½
(L78.1.96a,b)

207. *Cup*, n.d.
Porcelain, salt glazed
6¾ x 6¾ x 3¼
(L78.1.182)

208. *Cup*, n.d.
Stoneware, salt glazed
4 x 8 x 3
(L78.1.210)

209. *Platter*, n.d.
Earthenware, glazed
3¼ x 24 x 24
(L78.1.670)

210. *Plaque*, n.d.
Stoneware, glazed, steel frame
23½ x 21⅝ x 2¼
(L91.1.6)

211. *Vessel*, n.d.
Stoneware, glazed
12¼ x 8¼ x 5
(L78.1.293)

212. *Sculpture*, n.d.
Stoneware
32 x 30½ x 1¼
(L78.1.647)

213. *Vessel*, n.d.
Stoneware
4½ x 3½ x 1¼
(L78.1.69)

214. *Vessel with two legs*, n.d.
Stoneware, glazed
15½ x 10½ x 5
(L78.1.291)

DOUG HUMBLE
215. *Rocking Chair*, 1970
Stoneware, glazed
19 x 22½ x 13
(L88.1.1)

216. *Sculpture*, 1974
Stoneware, unglazed
17½ x 24 x 6
(L78.1.617)

GLENN R. HUSTED
217. *Laughing Man*, 1993
Stoneware, terra sigillata
37 x 22½ x 11½
(93.3.1L)

DAIKA JAKATA
218. *Sake Bottle with box*, n.d.
Stoneware, glazed
5¾ x 4⅜ x 4⅜
(L78.1.289a-c)

+JANAVS
219. *Container*, 1965
Stoneware, glazed
11 x 7½ x 6¼
(L78.1.445)

KAGE-GUSTAVSBERG STUDIO
220. *Cylindrical vase*, n.d.
Earthenware, glazed
4¾ x 4¼ x 4¼
(L78.1.436)

FUMI KANEKO
221. *Sculpture*, 1964
Stoneware, glazed
10¾ x 8¼ x 10½
(L78.1.471)

JUN KANEKO
222. *Sculpture*, 1963
Stoneware, glazed
37¾ x 10 x 5½
(L78.1.628)

223. *Bowl*, 1965
Earthenware, glazed
4¾ x 12¼ x 15¾
(L78.1.497)

224. *Bowl*, 1965
Raku clay, glazed
3⅝ x 6½ x 6½
(L78.1.499)

225. *Platter*, 1965
Stoneware, glazed
1½ x 21 x 20½
(L78.1.344)

226. *Vase*, c. 1965
Stoneware, Raku clay, glazed
8¼ x 6¾ x 5
(L91.1.8)

227. *Vase*, 1965
Stoneware, glazed
11 x 6½ x 6½
(L78.1.420)

228. *Vase*, 1965
Stoneware, glazed
22 x 14 x 5
(L78.1.577)

229. *Vase*, 1965
Stoneware, glazed
10 x 9½ x 9½
(L78.1.233)

230. *Vessel*, 1965
Stoneware, glazed
36 x 20 x 20
(L91.1.9)

231. *Bottle*, 1966
Stoneware, glazed
10¾ x 14½ x 14
(L78.1.516)

232. *Bowl*, 1966
Earthenware, glazed
4 x 12¼ x 14¼
(L78.1.498)

233. *Container*, 1966
Stoneware, glazed
8¾ x 15 x 15
(L78.1.438)

234. *Platter*, 1966
Stoneware, glazed
1¾ x 22 x 21½
(L78.1.460)

235. *Vase*, 1966
Earthenware, glazed
13½ x 7½ x 7
(L78.1.518)

236. *Container*, 1967
Stoneware, glazed
20½ x 6 x 6
(L78.1.432)

237. *Vase*, 1967
Earthenware, glazed
35½ x 9 x 5
(L78.1.630)

238. *Vase*, 1967
Stoneware, glazed
6½ x 5 x 3½
(L78.1.280)

239. *Container-sculpture*, 1966
Earthenware, glazed
17 x 13½ x 6½
(86.1.8)

240. *Goblet*, 1968
Earthenware, glazed
6¼ x 3¾
(L78.1.320)

241. *Mug*, 1968
Earthenware, glazed
6 x 4 x 6
(L78.1.398)

242. *Vase*, c.1968
Stoneware, glazed
12½ x 9 x 6½
(84.9.4)

243. *Plate*, 1969
Stoneware, glazed
2¼ x 12½ x 11¼
(86.1.4)

244. *Vase*, 1969
Stoneware, glazed
9¾ x 8½ x 4¾
(L78.1.596)

245. *Plate*, 1970
Stoneware, raku-fired, glazed
2 x 12½ x 13
(86.1.5)

246. *Container,* 1971
Stoneware, raku-fired, glazed
12 x 10½ x 9½
(L78.1.354)

*247. *Plate*, 1971
Stoneware, raku-fired, partially glazed
2 x 12½ x 12½
(84.9.5)

*248. *Plate*, 1971
Stoneware, raku-fired, partially glazed
2 x 12½ x 13
(86.1.6)

*249. *Sanbon Ashi* (Sculpture), 1971
Stoneware, glazed
30 x 35 x 20
(L78.1.618,619,620,621)

250. *Sculpture with three legs*, 1971
Stoneware, glazed
29 x 38½ x 16
(L78.1.811)

251. *Sculpture*, 1971
Stoneware, glazed
19 x 35½ x 17
(83.2.9)

252. *Sculpture*, 1971
Stoneware, glazed
3¾ x 44½ x 6¼
(L78.1.63)

253. *Lidded Container*, 1973
Stoneware, glazed
19¼ x 15 x 15
(84.9.6)

254. *Platter*, 1973
Stoneware, low-fire overglazed
2½ x 20 x 20
(83.2.10)

255. *Platter*, 1974
Stoneware, low-fire overglazed
3¼ x 19½ x 19½
(86.1.7)

256. *Goblet*, 1975
Stoneware, glazed
8 x 5⅝ x 5
L78.1.523

257. *Goblet*, 1975
Stoneware, salt glazed
8 x 7 x 4½
.(L78.1.270)

258. *Platter*, 1975
Earthenware, glazed
2½ x 20 x 20
(85.4.3)

259. *Bowl*, n.d.
Earthenware, glazed
3¾ x 5¼ x 5¼
(L78.1.126)

260. *Bowl*, n.d.
Stoneware, raku-fired, glazed
4⅜ x 4½ x 4½
(L78.1.397)

261. *Cup*, n.d.
Stoneware, salted
4½ x 4½ x 2½
(L78.1.278)

262. *Cup*, n.d.
Stoneware, salted
4½ x 4½ x 2½
(L78.1.277)

263. *Cups* (set of 2), n.d.
Stoneware, glazed
4¾ x 3¼ x 3¼
(L78.1.724a,b)

264. *Goblet with handle*, n.d.
Stoneware, salt glazed
7¼ x 6 x 5½
(L78.1.114)

265. *Lidded container*, n.d.
Stoneware, glazed
24 x 12 x 12
(L78.1.610a,b)

266. *Lidded container*, n.d.
Stoneware, glazed
11 x 11 x 11
(L78.1.529a,b)

267. *Lidded container*, n.d.
Earthenware, glazed
27 x 12 x 12
(L78.1.624a,b)

268. *Lidded container*, n.d
Earthenware, glazed
22 x 13 x 13
(L78.1.609a,b)

269. *Plate*, n.d.
Stoneware, glazed
1¾ x 6¼ x 6¼
(L78.1.190)

270. *Sculpture*, n.d.
Stoneware, raku-fired, glazed
10½ x 8 x 5
(L78.1.423)

271. *Sculpture*, n.d.
Stoneware, partially glazed
47 x 38 x 5
(L78.1.649)

272. *Sculpture with two legs*, n.d.
Stoneware, glazed
35 x 19 x 8
(L78.1.656)

273. *Vase*, n.d.
Earthenware, glazed
24 x 13 x 7½
(L78.1.578)

274. *Vase*, n.d.
Stoneware, glazed
12 x 12 x 13
(L78.1.575)

TOYO KANESHIGE
*275. *Bottle*, 1956
Stoneware, salt glazed
8¼ x 4½ x 4½
(L78.1.260)

BEN KATZ
276. *Platter*, 1976
Stoneware, glazed
2½ x 21½ x 21½
(80.8.8)

277. *Tile*, 1983
Porcelain, glazed
14½ x 13¼ x ¼
(L85.1.12)

278. *Lidded container*, n.d.
Stoneware, glazed
13⅜ x 6½ x 5¾
(L78.1.60a,b)

279. *Lidded container*, n.d.
Stoneware, sand glazed
7½ x 8½ x 6
(L78.1.688a,b)

KANJIRO KAWAI
*280. *Bottle*, c. 1950
Stoneware, glazed
8½ x 7½ x 3½
(L78.1.92)

*281. *Vase*, c. 1960
Stoneware, glazed
8¾ x 6¾ x 6
(L78.1.533)

RIKIZO KAWAKAMI
282. *Sculpture*, c. 1970
Stoneware, glazed
11¼ x 12¾ x 9⅝
(78.1.33)

CHITARU KAWASAKI
283. *Cups* (set of 3), n.d.
Stoneware, glazed
6½ x 7¾ x 3¾
(L78.1.687a-c)

284. *Sculpture*, n.d.
Stoneware, glazed
26¼ x 18 x 6
(L78.1.35)

K. (HARA) KAWASHIMA
285. *Vessel with three legs*, 1965
Stoneware, glazed
9¼ x 6¼ x 8
(L78.1.389)

MARGARET KEELEN
286. *Sculpture*, n.d.
Porcelain, glazed
34 x 11 x 12
(L78.1.786)

STEVEN AND SUSAN KEMENYFFY
287. *Platter*, 1977
Raku clay, lustre glaze
3 x 25¼ x 23½
(L78.1.58)

SUSIE KETCHUM
288. *Plate*, 1992
Porcelain, glazed
1¼ x 13½ x 13½
(93.3.4L)

JOHN KIDD
289. *Plaque*, n.d
Stoneware
27½ x 21¼ x 3¼
(L78.1.782)

290. *Sculpture*, n.d.
Stoneware, glazed
1½ x 12½ x 12½
(L78.1.737)

ERNIE KIM
291. *Bottle*, n.d.
Stoneware, glazed
19½ x 7¾ x 7¾
(78.1.244)

SUZANNE KLOTZ-REILLY
292. *Odessa*, 1973
Stoneware, acrylics, wood, cloth, glazed
27 x 17¼ x 4¼
(L78.1.363)

293. *Figurine*, c.1975
Clay, low-fire, earthenware painted, with bird feather
5½ x 8¼ x 7¼
(L78.1.142)

JAMES KOBAYASHI
294. *Covered jar*, n.d.
White stoneware, glazed
9½ x 6¾ x 6¾
(L84.1.18a,b)

RYOJI KOIE
295. *Plate, sculpture*, 1969
Porcelain, glazed
3 x 11¾ x 11¾
(L78.1.297)

296. *Yo (Four Heads)*, 1969
Stoneware, unglazed
13½ x 5 x 6¾
(L78.1.810a-d)

297. *Cups* (set of 2), 1976
Porcelain, clear glaze
3½ x 6 x 3½
2¾ x 3¼ x 5
(L78.1.728a,b)

298. *Cylindrical pot with boot*, n.d.
Raku clay, glazed
11⅝ x 5½ x 3½
(L87.1.25)

299. *Plate*, n.d.
Porcelain, glazed
4½ x 12 x 12
(L78.1.249)

*300. *Sculpture (Chernobyl Series)* 1990
Stoneware, partially glazed
23 x 23
(L94.1.1)

ROGER KUNTZ
301. *Bowl*, 1961
Earthenware, glazed
7½ x 11 x 11
(L78.1.511)

KAZUHIRO KURIRIO
302. *Plate*, n.d.
Stoneware, glazed
1G x 6½ x 6½
(L78.1.778)

ANNETTE LAPORTE
303. *Bowl*, n.d.
Raku clay, glazed
11 x 6 x 5
(79.8.7)

DOUG LAWRIE
304. *Vase*, c. 1961
Stoneware, glazed
10 x 8 x 4½
(L78.1.579)

305. *Lidded jar*, 1960
Stoneware, glazed
8¼ x 7 x 4¼
(L78.1.99a,b)

306. *Vase*, n.d.
Stoneware, oxides
18¾ x 12 x 4½
(L87.1.19)

307. *Vase Form,* 1989
Earthenware, oxides, arcylic
12 x 8 x 4½
(89. 1.3)

BERNARD LEACH
*308. *Bottle*, 1956
Stoneware, glazed
8 x 5 x 3⅜
(L78.1.264)

309. *Shallow bowl*, 1956
Porcelain, glazed
2⅝ x 10 x 10
(81.8.5)

JENIFER LEE
310. *Vessel*, n.d.
Stoneware, glazed
6½ x 6¼ x 5¾
(L83.1.3)

MYUNG-GYU LEE
311. *Vase*, n.d.
Stoneware, glazed
13½ x 8 x 8
(L78.1.732)

MATTHEW LEEDS
312. *Vase*, 1975
Stoneware, glazed
28 x 12 x 12
(92.2.11L)

313. *Vase*, 1975
Stoneware, glazed
28 x 12 x 12
(92.2.10L)

314. *Vessel*, 1982
Earthenware, glazed
11 x 11 x 9
(L86.1.6)

315. *Bowl*, 1983
Porcelain, glazed
3½ x 19 x 19
(L86.1.4)

316. *Bowl*, 1983
Earthenware, glazed
3¾ x 17½ x 17½
(L86.1.5)

317. *Vase*, 1983
Porcelain, glazed
19⅛ x 15½ x 15½
(L84.1.19)

318. *Vase*, 1983–84
Porcelain, glazed
18¼ x 16 x 16
(L84.1.15)

319. *Black and White Self-Portrait,* 1984
Earthenware, glazed, oxides
2 x 21 x 21
(92.2.3L)

320. *Platter*, 1984
Porcelain, glazed
2¾ x 18 x 18
(92.2.13L)

321. *Platter*, 1984
Porcelain, glazed
3¾ x 17¾ x 17¾
(92.2.8L)

322. *Vessel*, 1985
Stoneware, glazed
29 x 19 x 19
(L88.1.5)

323. *Platter*, 1987
Earthenware, glazed
24¼ x 10 x 8
(L90.1.2)

324. *Platter*, 1990
Earthenware, glazed
3 x 16 x 16
(92.2.7L)

325. *Platter*, 1992
Stoneware, glazed
2¾ x 16 x 16
(92.2.6L)

326. *Vessel*, 1993
Stoneware, lustre glazed
52 x 34½ x 34½
(93.3.7L)

327. *Calabash*, n.d.
Stoneware, glazed
24½ x 13 x 13
(L87.1.10)

328. *Vase*, n.d.
Stoneware, glazed
36 x 16½ x 16½
(L87.1.23)

329. *Vase*, n.d.
Earthenware, glazed
26 x 22 x 10
(L86.1.7)

330. *Vase*, n.d.
Stoneware, glazed
31 x 17½ x 17½
(L83.1.1)

331. *Vase*, n.d.
Earthenware, glazed
23 x 18½ x 18½
(85.4.4)

MARILYN LEVINE
332. *F.M. Case*, 1981
Stoneware and mixed media,
partially glazed
4¾ x 9⅜ x 7
(L85.1.8)

JOHN LEWIS
333. *Vase*, n.d.
Glass
7¼ x 7 x 7
(L87.1.32)

JENNY (MASTERSON) LIND

334. *Leda and the Swan*, 1973
Porcelain, glazed
19½ x 5½ x 5½
(80.8.12)

MARVIN LIPOFSKY

335. *Vessel*, n.d.
Glass
11¼ x 7⅜ x 6
(81.8.6)

HARRISON MacINTOSH

336. *Utamaro's "Abalone Divers,"* 1986
Stoneware, glazed
13½ x 7½ x 7½
(L87.1.14)

WARREN MacKENZIE

337. *Covered jar*, n.d.
Stoneware, glazed
7½ x 8¼ x 8¼
(L84.1.7a,b)

338. *Lidded container*, n.d.
Earthenware, glazed
7½ x 6 x 6
(L78.1.723a,b)

339. *Teapot*, n.d.
Stoneware, glazed
9 x 9½ x 6½
(78.1.712a,b)

340. *Vase*, n.d.
Earthenware, glazed
8½ x 4 x 4
(L78.1.753)

BEVERLY MAGENNIS

341. *Sculpture*, 1966
Raku clay, glazed
7 x 8 x 6
(80.8.9)

342. *Sculpture*, 1966
Stoneware, glazed
12¾ x 8¼ x 4½
(80.8.10)

343. *Teapot*, 1974
Porcelain, low-fire overglaze
25 x 11½ x 16½
(80.8.11a-c)

344. *Sculpture*, n.d.
Stoneware, glazed, painted
68 x 17 x 7
(L89.1.8)

RICHARD MARQUIS

345. *Teapot*, 1980
Glass
10½ x 7½ x 7½
(L87.1.34)

RUDY MARTINEZ

346. *Plaque*, 1973
Earthenware, glazed with luster
4 x 15½ x 15
(79.8.8)

347. *A Juanderful Piece*, 1976
Earthenware, glazed, painted
23 x 18¼ x 4¼
(86.1.9)

JOHN MASON

348. *Bowl*, 1955
Stoneware, glazed
14½ x 17 x 17
(92.1.60)

349. *Figurine*, 1955
Stoneware, glazed
13 x 4 x 4
(92.1.59)

350. *Bowl*, 1955–56
Porcelain, glazed
5 x 7 x 7
(87.1.6)

351. *Bowl*, 1956
Earthenware, glazed
4½ x 12½ x 11¾
(92.1.54)

352. *Sculpture (Triptych)*, 1956
Stoneware, glazed
14½ x 44 x 3
(92.1.44a-c)

353. *Bowl*, c. 1957
Stoneware, glazed
13½ x 16 x 13½
(92.1.53)

354. *Container*, 1957
Stoneware, glazed
17½ x 9½ x 8
(92.1.52)

355. *Sculpture, candle-holder, vase*, 1957
Stoneware, glazed
8 x 12 x 4
(92.1.55)

356. *Vase*, 1957
Stoneware, glazed
10½ x 8 x 5
(92.1.48)

357. *Plate*, 1958
Earthenware, glazed
3½ x 20 x 15
(92.1.57)

*358. *Vase*, 1958
Stoneware, low-fire glazed
24 x 8 x 6½
(92.1.51)

*359. *Container ("X")*, 1958–60
Stoneware, low-fire glazed
12 x 11½ x 10
(92.1.47)

360. *Container*, 1960
Stoneware, glazed
19 x 15 x 9
(92.1.58)

361. *Platter*, 1960
Stoneware, glazed
3½ x 25½ x 20½
(92.1.46)

362. *Vase*, 1961
Earthenware, glazed
11¼ x 15 x 5½
(80.8.38)

*363. *Sculpture*, 1961
Stoneware, glazed
42 x 13½ x 11
(79.8.9)

*364. *Vase*, 1964
Stoneware, glazed
12 x 6 x 6
(92.1.49)

365. *Container*, 1965
Stoneware, glazed
14 x 6 x 7
(80.8.39)

366. *Plaque*, 1969
Stoneware, glazed
15½ x 13½ x 3¾
(85.4.5)

367. *Bowl*, n.d.
Stoneware, glazed
5¾ x 12 x 12
(92.1.45)

368. *Platter*, n.d.
Stoneware, high-fire glazed
2½ x 16 x 17
(92.1.56)

369. *Vase*, n.d.
Stoneware, glazed
11½ x 6½ x 6
(92.1.50)

370. *Vase*, n.d.
Porcelain, glazed
7½ x 7 x 5½
(87.1.5)

BERRY MATHEWS
371. *Plaque*, 1976
Porcelain, low-temperature salt glazed
1½ x 15½ x 15½
(79.8.10)

KAZUKO MATTHEWS
372. *Bottle*, n.d.
Porcelain, glazed
9 x 6½ x 6½
(93.3.5L)

373. *Plaque*, n.d.
Raku clay, wood, glazed
15 x 17½ x 1½
(L78.1.758)

374. *Vase*, n.d.
Porcelain, glazed
14¼ x 11 x 5
(L78.1.731)

MAC McCLAIN
*375. *Vase*, 1957
Stoneware, glazed
14⅝ x 8½ x 5½
(92.1.43)

376. *Bang Bottle*, n.d.
Stoneware, glazed
14¼ x 6¼ x 6¼
(92.1.42)

JOHN TOBY McCUISTON
377. *Covered jar*, 1973
Stoneware, low-fire, lustre glaze
18½ x 12
(80.8.16a,b)

JIM McKINNELL
378. *Bowl*, n.d.
Stoneware, glazed
5½ x 6¼ x 6½
(L78.1.722)

379. *Bowl*, n.d.
Stoneware, glazed
9⅞ x 16¼ x 15
(L84.1.8)

380. *Bowl*, n.d.
Stoneware, glazed
2¼ x 11 x 11
(L84.1.9)

381. *Urn*, n.d.
Porcelain, glazed
8¾ x 6½ x 6½
(L78.1.733)

NAN McKINNELL
382. *Urn*, n.d.
Porcelain, glazed
6½ x 4½ x 4½
(L78.1.747)

383. *Vessel*, n.d.
Stoneware, glazed
16¼ x 13½ x 13½
(L78.1.767)

DAN MEHLMAN
384. *Teapot*, 1973
Stoneware, partially glazed
8¾ x 7¼ x 4
(79.8.11 a,b)

385. *Sculpture*, 1974
Earthenware, partially glazed
9½ x 13½ x 7½
(80.8.13)

386. *Urn*, 1975
Stoneware, partially glazed
34¼ x 19 x 17½
(80.8.14)

387. *Lidded Jar*, n.d.
Stoneware, glazed
18 x 10 x 10
(L78.1.41a,b)

JAMES MELCHERT
388. *Sculpture*, 1958
Stoneware, glazed
25¼ x 8 x 8
(L78.1.631)

*389. *Container*, 1960
Stoneware, glazed
13 x 20 x 6
(L78.1.683)

390. *Cup*, 1973
Porcelain, glazed
3¾ x 3¾ x 2½
(87.1.8)

391. *Railroad Spike*, 1973
Porcelain, glazed
3¼ x 3½ x 2½
(87.1.7)

392. *Plate*, n.d.
Stoneware, glazed
2¼ x 12 x 12
(L78.1.203)

SALVATORE MELI
393. *Pitcher*, 1952
Earthenware, glazed
17¾ x 11 x 16
(83.2.11)

394. *Urn*, 1953
Earthenware, glazed
14¾ x 18½ x 11½
(83.2.12)

395. *Vase*, 1953
Earthenware, glazed
16 x 13 x 13
(83.2.13)

396. *Roma*, 1978
Stoneware, glazed
18¼ x 4¾ x 2½
(L88.1.4)

PETE MELOY
397. *Plate*, 1959
Stoneware, glazed
1¼ x 14¼ x 14¼
(L78.1.261)

398. *Plate*, 1959
Stoneware, glazed
1¼ x 12 x 12
(L78.1.347)

HAROLD MEYERS
399. *Vessel*, 1960
Stoneware, glazed
12¼ x 9¾ x 11
(80.8.15)

RON MEYERS
400. *Platter*, 1990
Stoneware, glazed
2½ x 19 x 19
(L91.1.7)

RACHEL MILLER
401. *Sculpture*, 1969
Earthenware, glazed
24¼ x 20 x 9½
(79.8.12)

FUNAKI MICHITADA
402. *Platter*, n.d.
Stoneware, glazed
3 x 17 x 12½
(L78.1.296)

RYOSAKU MIWA

403. *Sculpture*, 1969
Stoneware, glazed
15 x 12 x 13
(L78.1.509)

404. *Sculpture*, n.d.
Stoneware, glazed
10½ x 17½ x 16
(L78.1.795)

RIKICHI MIYONAGA

405. *Sculpture*, 1967
Porcelain, glazed
19 x 10½ x 3½
(L78.1.503)

MINEO MIZUNO

406. *Platter*, 1969
Porcelain, glazed
20½ x 20½ x 2½
(L78.1.424)

407. *Platter*, 1969
Porcelain, glazed
3½ x 30 x 30
(L78.1.62)

408. *Plate*, 1971
Porcelain, glazed
1¾ x 17 x 17
(81.8.7)

409. *Platter*, 1971
Porcelain, glazed
1¾ x 18¾ x 18¾
(83.2.14)

410. *Cups* (set of 2), 1973
Porcelain, glazed
3 x 2¾ x 6¾
2½ x 2¾ x 7
(81.8.8a,b)

*411. *Sculpture (Screw)*, 1973
Stoneware, glazed
37 x 13 x 13
(83.2.15)

412. *Cup*, 1978
Porcelain, glazed
2½ x 5 x 3¼
(L78.1.726)

413. *Plate*, 1980
Porcelain, glazed
1 x 12 x 12
(86.1.10a)

414. *Platter*, 1980
Porcelain, glazed
3 x 20¼ x 20¼
(L89.1.7)

415. *Cup and Saucer*, 1981
Porcelain, glazed
3 x 6¼ x 6¼
(L78.1.713a,b)

416. *Cup and Saucer*, 1981
Porcelain, glazed
3 x 6¼ x 6¼
(L78.1.714a,b)

417. *Plate*, 1983
Porcelain, glazed
1¾ x 19½ x 19½
(L83.1.6)

418. *Plate*, n.d.
Porcelain, glazed
1 x 12 x 12
(86.1.10b)

KYOKO MORIYAMA

419. *Hat Sculpture*, 1975
Porcelain, low-fire, lustre, decals
3½ x 11½ x 11½
(79.8.15)

420. *Sculpture*, n.d.
Porcelain, glazed
9 x 7 x 4½
(79.8.13)

WILLIAM STAITE MURRAY

*421. *Vase*, 1939
Stoneware, glazed
12½ x 7 x 7
(81.8.9)

422. *Vase*, 1960
Stoneware, glazed
8½ x 8 x 8
(L78.1.566)

MILES MUSHLIN

423. *Container*, 1974
Stoneware, oxide design painted
10 x 6 x 6
(L78.1.419)

PATRICIA NAGAI

424. *Pitcher*, 1978
Earthenware, glazed
8½ x 5½ x 5½
(L78.1.739)

425. *Vessel*, 1978
Stoneware, partially glazed
7 x 6½ x 6½
(L78.1.740)

426. *Bowl*, 1981
Earthenware, glazed
1¾ x 8½ x 8½
(L85.1.1)

427. *Plate*, 1982
Earthenware, low-fire overglaze
1⅜ x 12 x 8½
(L84.1.10)

428. *Teapot*, n.d.
Earthenware, unglazed
4½ x 7½ x 3
(L86.1.21a,b)

429. *Teapot*, n.d.
Earthenware, unglazed
8½ x 5¾ x 4½
(L84.1.20a,b)

RON NAGLE

*430. *Perfume Bottle (Bottle with Stopper)*,
1960
Stoneware, light fire and low-fire
glazed
24½ x 22 x 5
(92.1.61a,b)

YOKO NAKAMURA

431. *Sculpture*, n.d.
Earthenware, glazed
10 x 11 x 1
(L78.1.717)

KIMPEI NAKEMURA

432. *Vase*, 1970
Stoneware, glazed
22 x 20 x 8
(L78.1.641)

433. *Vase*, 1970
Stoneware, glazed
20 x 20 x 11
(L78.1.645)

434. *Teapot*, n.d.
Earthenware, glazed
3¾ x 2¾ x 5⅞
(L86.1.18)

435. *Vessel*, n.d.
Stoneware, glazed
5 x 7¼ x 5½
(L87.1.20)

RICICHI NAKEMURA

436. *Vase*, 1973
Earthenware, glazed
26 x 11 x 12
(L78.1.633)

BILLY O'BRIEN

437. *Vessel*, 1982
Stoneware, glazed
9¾ x 18½ x 8¼
(L86.1.8)

438. *"What me worry?,"* 1985
Porcelain, glazed
11⅜ x 11⅜ x ½
(L86.1.9)

439. *Vessel*, 1985
Earthenware, glazed
10 x 6¾ x 1¾
(L85.1.13)

ROSILIND O'CONNOR

440. *Sculpture*, 1979
Stoneware, unglazed
6½ x 7 x 7
(L78.1.690a,b)

CHRISTINE O'LAUGHLIN

441. *Sculpture*, c. 1970
Stoneware, lustre glaze
17¾ x 21 x 13
(L78.1.40)

KAZ OTA

442. *Platter-sculpture*, c. 1972
Stoneware, partially glazed
2½ x 23 x 23
(80.8.17)

MIKE PAYNE

443. *Platter*, 1973
Earthenware, glazed
2¼ x 18 x 16
(79.8.17)

444. *Platter*, 1973
Stoneware, glazed
4 x 18 x 18
(79.8.16)

445. *Platter*, 1974
Stoneware, glazed
1¾ x 16¾ x 17½
(79.8.18)

TIMOTHY PERSONS

446. *Vase*, 1983
Porcelain, glazed
21⅜ x 10 x 9
(L84.1.21)

447. *Lidded Container*, n.d.
Stoneware, glazed
15 x 13 x 13
(L78.1.792a,b)

ANNE SCOTT PLUMMER

448. *Volcano*, 1980
Clay, low-fire glazed
32¼ x 19⅜ x 4¼
(L78.1.781)

449. *Sculpture*, 1982
Porcelain, low-fire overglaze
11¾ x 9¼ x 6
(L85.1.2)

450. *Sculpture*, 1985
Stoneware, glazed, painted
15¼ x 11¾ x 4¼
(L88.1.2)

451. *Global Man*, 1988
Stoneware, glazed
26 x 15½ x 12
(L88.1.13)

452. *Les A...*, 1988
Stoneware, glazed
39 x 20 x 12
(L89.1.1)

453. *Figure*, 1989
Porcelain, glazed
24 x 15½ x 14
(92.2.12L)

454. *Pitcher*, n.d.
Stoneware, low-fire overglazed
29 x 16¼ x 12½
(L78.1.43)

455. *Sculpture*, n.d.
Colored glazes
21 x 18½ x 11¼
(86.1.11)

456. *Sculpture*, n.d.
Earthenware, glazed
22 x 16 x 16
(L85.1.9)

457. *Sculpture*, n.d.
Porcelain, glazed
10 x 10¼ x 10¼
(86.1.12)

458. *Sculpture*, n.d.
Stoneware, glazed
25¼ x 12¼ x 16
(L78.1.759)

459. *Sculpture*, n.d.
Stoneware, acrylic
24¼ x 24½ x 19
(L78.1.798)

460. *Sculpture*, n.d.
Stoneware, glazed
18 x 18 x 12
(L78.1.766)

*461. *Peter Hunt's Africa*, 1988
Low-fire ceramic, glazed
38 x 17½ x 17
(L89.1.2)

KENNETH PRICE

*462. *Vase*, 1956
Stoneware, glazed
17½ x 5 x 5
(84.9.7)

463. *Bowl*, 1957
Stoneware, glazed
3¾ x 11 x 11
(92.1.66)

464. *Plate*, 1957
Stoneware, glazed
2½ x 11½ x 11½
(92.1.63)

465. *Urn*, 1957
Stoneware, glazed
5½ x 5½ x 5½
(92.1.64)

*466. *Vase*, c. 1958
Stoneware, glazed
20 x 6 x 6
(92.1.62)

467. *Cup*, 1960
White stoneware, low fire
4 x 3½ x 3
(86.1.14)

468. *Platter*, 1960
Earthenware, glazed
1½ x 11½ x 12
(92.1.67)

469. *Sculpture*, n.d.
Stoneware, glazed
11¼ x 5½ x 4
(92.1.65)

ANTONIO PRIETO

*470. *Bottle*, 1959–60
Stoneware, glazed
8½ x 8¼ x 8¼
(81.8.10)

GAYLE PRUMHUBER

471. *Platter*, 1979
Porcelain, glazed
2 x 24 x 13
(L84.1.11)

472. *Teapot*, 1979
Earthenware, refined
10½ x 7½ x 6
(L78.1.741)

473. *Sculpture*, n.d.
Clay, low-fire, painted
34 x 33 x 6¼
(L78.1.797)

MAX R. READ III
474. *Sculpture*, 1973
Earthenware, glazed
21 x 15¾ x 10
(79.8.20)

475. *Sculpture*, 1973
Earthenware, acrylic, low-fire
overglaze
28½ x 24 x 19
(79.8.19a,b)

476. *Sculpture*, 1973
Earthenware, low-fire glazes, acrylic
19¾ x 40 x 14
(L78.1.657)

477. *Sculpture*, 1973
Earthenware, low-fire glazes, acrylic
22 x 30 x 11
(L78.1.623)

478. *Plaque*, n.d.
Earthenware, low-fire acrylic paint
16¾ x 17½ x½
(L83.1.8)

STEVE REYNOLDS
479. *Sculpture*, 1975
Stoneware, glazed
15 x 21 x 18½
(79.8.22)

480. *Sculpture*, 1975
Stoneware, glazed
16½ x 19 x 18
(79.8.21)

LUCIE RIE
*481. *Bowl*, 1960
Porcelain, glazed
3 x 7¼ x 7¼
(L78.1.263)

JAMES ROMBERG
482. *Sculpture*, 1970
Raku clay, glazed
10¾ x 20½ x 8¼
(79.8.24)

483. *Platter*, 1989
Stoneware, glazed
1¼ x 18 x 21½
(L90.1.1)

484. *Bottle with Stopper*, n.d.
Stoneware, salt glaze
11 x 6 x 4
(79.8.23)

JANICE ROOSEVELT
*485. *Candelabra*, 1959
Stoneware, glazed
10½ x 6½ x 3½
(81.8.11)

LINDA ROSENUS
486. *Plate*, 1976
Stoneware, glazed
2 x 19½ x 19½
(79.8.25)

487. *Sculpture*, 1976
Raku, glazed
22 x 23 x 11
(80.8.18)

488. *Bowl*, n.d.
Porcelain, glazed
2 x 5¾ x 5¾
(L78.1.187)

JERRY ROTHMAN
489. *Vase*, 1956–57
Stoneware, glazed
18 x 7½ x 3¾
(92.1.72)

*490. *Shallow Bowl: Self-Portrait with Karen
Neubert*, 1958
Stoneware, glazed
3¼ x 16¼ x 16¼
(92.1.70)

491. *Round Platter: Self-Portrait with Karen
Neubert*, 1958
Stoneware, high-fire, glazed
2 x 15 x 15
(92.1.71)

492. *Plaque*, 1959
Stoneware, glazed
3 x 17 x 17½
(92.1.83)

493. *Bowl*, 1960
Stoneware, glazed
7¼ x 6 x 8
(92.1.80)

494. *Plate*, 1960
Porcelain, glazed
1 x 10½ x 10½
(81.8.13)

*495. *Sky Pot*, 1960
Stoneware, unglazed
28½ x 25 x 9
(92.1.82)

496. *Teapot*, 1960
Stoneware, glazed
10 x 10 x 5
(92.1.81)

*497. *Drink Me*, 1961
Stoneware, glazed
26 x 35 x 22½
(92.1.84)

498. *Platter*, 1961
Stoneware, glazed
3 x 16 x 17
(92.1.78)

499. *Container*, 1963
Stoneware, glazed
15½ x 9 x 9
(81.8.12a,b)

500. *Teapot*, 1966
Stoneware, glazed
10 x 8 x 5½
(92.1.79)

501. *Square plate*, c. 1969
Stoneware, glazed
1½ x 9¼ x 9
(92.1.76)

502. *Plaque*, 1970
Stoneware, underglazed, overglazed
1 x 14 x 13½
(92.1.75)

503. *Baroque Series*, 1966
Stoneware, glazed
29 x 17 x 17
(80.8.19)

504. *Platter*, 1970
Stoneware, glazed
2 x 13¾ x 14¼
(92.1.74)

505. *Cup*, 1972
Porcelain, soda salt glaze
5¼ x 5½ x 4¼
(92.1.68)

506. *Lidded container*, 1975
Porcelain, glazed
13¾ x 12¼ x 9¾
(80.8.20a,b)

507. *Cup*, n.d.
White stoneware, glazed
5 x 7 x 3
(92.1.69)

508. *Cup*, n.d.
Porcelain, glazed
4 x 5½ x 3
(92.1.77)

509. *Plate*, n.d.
Stoneware, glazed
2³⁄₁₆ x 14 x 14
(92.1.73)

510. *Teapot*, n.d.
Porcelain, glazed
16½ x 14½ x 9
(85.4.6)

JANETTE ROTHWOMAN
511. *Plate*, 1972
Porcelain, glazed
1¼ x 11 x 11
(79.8.26)

512. *Plate*, 1973
Porcelain, glazed
1½ x 11 x 11
(L79.8.27)

513. *Plate*, 1978
Porcelain, glazed
2¼ x 14 x 14
(86.1.15)

DALE RUFF
514. *Vase*, 1982
Raku clay, glazed
11 x 12 x 12
(85.4.7)

JAY RUMMEL
515. *Vase*, 1962
Stoneware, glazed
12¼ x 8¾ x 8¾
(81.8.14)

516. *Platter*, n.d.
Stoneware, glazed
2½ x 20 x 20
(L78.1.348)

DAIKA SAKATA
517. *Sake bottle with box*, n.d.
Stoneware, glazed
5¾ x 4⅜ x 4⅜
(L78.1.289a-c)

TADAYASU SASAYAMA
518. *Sculpture*, c. 1970
Stoneware, glazed
4 x 26 x 15
(78.1.32)

SATOSHI SATO
519. *Sculpture*, c. 1970
Stoneware, glazed
6⅜ x 5¼ x 5¼
(78.1.36)

520. *Sculpture*, c. 1970
Stoneware, glazed
11½ x 20½ x 6
(78.1.37a,b)

521. *Sculpture*, c. 1970
Earthenware, white slip with glaze
22¼ x 2½ x 14
(78.1.38a,b)

522. *Sculpture*, 1977
Stoneware, glazed
23⅝ x 6¼ x 4¼
(78.1.41)

EDWIN AND MARY SCHEIER
523. *Bowl*, 1955
Earthenware, glazed
12¾ x 15 x 14¾
(L78.1.679)

KURT SCHMINKE
524. *Bowl*, 1974
Stoneware, glazed
3⅝ x 15½ x 15½
(L78.1.496)

NORMAN SCHULMAN
525. *Vase*, 1974
Porcelain, glazed
13½ x 6 x 6
(81.8.17)

SCOTT
526. *Cup*, n.d.
Stoneware, gold lustre
3½ x 4½ x 3
(L78.1.155)

527. *Goblet*, n.d.
Stoneware, glazed
5½ x 3 x 3
(L78.1.151)

HIROSHI SETO
528. *Sculpture*, n.d.
Stoneware, glazed
15½ x 16½ x 9
(78.1.28)

DAVID SHANER
529. *Slab platter*, n.d.
Stoneware, glazed
2 x 13½ x 14
(80.8.21)

MASAAKI SHIBATA
530. *Sculpture*, 1969
Raku clay, glazed
14 x 14½ x 13½
(84.9.8)

531. *Sculpture*, 1969
Earthenware, raku-fired, slip
11½ x 12 x 7
(84.9.9)

532. *Hammers* (set of 3), 1970
Porcelain, salt glazed
5¼ x 2¼ x 11¾
(L78.1.351a-c)

533. *Sculpture*, 1970
Stoneware, salt glazed
7¾ x 5¾ x 5
(L78.1.353)

534. *Sculpture*, 1970
Stoneware, salt glazed, stain, slip
13½ x 5¾ x 3½
(L78.1.345)

535. *Sculpture*, 1970
Stoneware, salt glazed, slip
11 x 4½ x 5
(L78.1.422)

536. *Basket-type container*, 1972
Raku clay, glazed
15½ x 9¼ x 6½
(L78.1.355)

537. *Vase-sculpture*, 1972
Stoneware, raku-fired, glazed
14½ x 11½ x 6½
(L78.1.582)

538. *Bottle*, 1973
Raku clay, glazed
10½ x 14 x 6½
(78.1.25)

539. *Sculpture*, 1973
Raku clay, glazed
17 x 11 x 9
(84.9.11)

540. *Sculpture*, 1973
Raku clay, glazed
10 x 13½ x 9¾
(84.9.10)

541. *Sculpture*, n.d.
Stoneware, raku-fired, glazed
11 x 11 x 11
(L78.1.607)

542. *Dish*, n.d.
Raku clay, glazed
5 x 8 x 4
(L78.1.178)

NORIO SHIBATA

543. *Sculpture*, 1977
Stoneware, glazed
11½ x 9½ x 8
(78.1.26)

PATRICK SILER

544. *Vessel with three legs*, 1981
Stoneware, glazed
12 x 10½ x 10½
(L83.1.9)

545. *Bowl*, n.d.
White earthenware, underfired
porcelain
3½ x 13½ x 12
(L78.1.206)

546. *Lidded container*, n.d.
Stoneware, glazed
11 x 5¼ x 7¼
(L78.1.335a,b)

547. *Lidded container*, n.d.
Stoneware, glazed
8½ x 7 x 7
(L78.1.530a,b)

548. *Lidded container*, n.d.
Stoneware, glazed
3¾ x 4½ x 4½
(L78.1.456a,b)

549. *Lidded container*, n.d.
Stoneware, glazed
6¾ x 7 x 7¼
(L78.1.337a,b)

550. *Mug*, n.d.
White stoneware, glazed
4⅜ x 3¾ x 5½
(L78.1.446)

551. *Teapot*, 1967
Stoneware, glazed
12½ x 13 x 7
(L78.1.571a,b)

BOBBY SILVERMAN

552. *Spiral Ewer*, 1991
Porcelain, glazed
28 x 13 x 7
(92.2.5L)

AMY SMITH

553. *Sculpture*, n.d.
Porcelain, glazed
16½ x 10½ x 10½
(L78.1.692)

PETER SMITH

554. *Plaque*, n.d.
Stoneware, partially glazed
13 x 13 x 1½
(L78.1.785)

KIT-YIN SNYDER

555. *Teapot*, 1971
Porcelain, glazed
10 x 6 x 6
(80.8.22a,b)

PAUL SOLDNER

*556. *Bottle with Face (Sophia Loren)*,
c. 1958–59
Stoneware, glazed
17 x 12 x 8
(92.1.94)

557. *Vase*, c. 1958–59
Stoneware, glazed
11½ x 12 x 11½
(92.1.91)

*558. *Vase*, 1961
Stoneware, glazed
18 x 11 x 9
(92.1.90)

559. *Vase*, c. 1961
Raku clay, unglazed
11 x 10½ x 10½
(92.1.92)

560. *Vase*, 1965
Raku clay, unglazed, oxides
16½ x 14½ x 14½
(92.1.93)

561. *Platter*, c. 1965–69
Stoneware, glazed
2 x 10½ x 12½
(92.1.85)

562. *Vase*, c. 1966
Raku clay, unglazed
11 x 10½ x 10½
(92.1.92)

*563. *Vessel*, 1966
Stoneware, partially glazed, raku fired
13¼ x 10¼ x 6¾
(92.1.89)

564. *John Lennon and Playboy*, 1969
Raku clay, partially glazed
25¼ x 18½ x 3¼
(92.1.86)

565. *Container-Vase*, 1974
Raku clay, low-salt
15 x 9 x 7½
(81.8.15)

566. *Plaque*, 1974
Raku clay, glazed
21½ x 23 x 4½
(85.4.9)

567. *Vessel*, c. 1975
Raku clay, unglazed
16 x 15 x 18
(92.1.88)

568. *Vessel*, c. 1975
Raku clay, unglazed
16 x 15 x 18
(92.1.88)

569. *Wall Piece*, 1976
Raku clay, unglazed, slips
17¾ x 21¼ x 4
(86.1.16)

570. *Eve*, 1979
Raku clay, partially glazed, slips
24⅜ x 13 x 3
(85.4.10)

571. *Pedestal Piece*, 1985
Raku clay, slip, low temperature, salt
vapor fired
32 x 36 x 10½
(92.1.87)

*572. *Pedestal Piece (907)*, 1990
Raku clay, glazed terra sigillata, low
temperature, salt vapor fired
27 x 30 x 11
(92.1.154)

573. *Vase*, 1992
Sculpture clay, low salt, oxide
21½ x 5¾ x 5¾
(92.2.2L)

THURMAN STATOM

574. *Sculpture*, n.d.
Plate glass, mixed media
16½ x 10 x 7½
(L78.1.817)

SCOTT STEVENS

575. *Relief plaque*, 1976
Stoneware, glazed
26¼ x 14⅝ x 2¾
(79.8.28)

JON STOKESBARY

576. *Urn-slab and thrown construction*, 1964
Stoneware, glazed
13¾ x 14 x 10
(L78.1.492)

VINCENT SUEZ

577. *Self-Portrait*, 1966
Stoneware, glazed
6 x 16½ x 12
(L78.1.181)

578. *Pitcher*, 1967
Stoneware, glazed
27½ x 16 x 9½
(L78.1.643)

579. *Bowl*, 1968
Earthenware, glazed
4 x 17 x 17
(L78.1.557)

580. *Urn*, 1968
Earthenware, glazed
39 x 20 x 17¾
(L78.1.44)

581. *Vase*, 1968
Stoneware, glazed
26 x 13½ x 13½
(83.2.16)

582. *Vase*, 1968
Earthenware, glazed
27 x 15 x 15
(L78.1.626)

583. *Admiral's Pony*, 1970
Stoneware, glazed
22 x 10½ x 10½
(L78.1.815)

584. *Vase with three handles*, n.d.
Stoneware, glazed
43 x 13 x 9¼
(L87.1.9)

585. *Vase*, n.d.
Earthenware, painted
14 x 11½ x 11½
(L78.1.429)

LEO SUGANO

586. *Platter*, 1976
Stoneware, glazed
2½ x 21 x 21
(L78.1.421)

587. *Cup*, n.d.
Porcelain, glazed
3 x 5½ x 3
(L78.1.89)

588. *Cup*, n.d.
Porcelain, glazed
3 x 5½ x 3½
(L78.1.152)

PATTY SULLIVAN

589. *Lidded jar*, 1974
Raku clay, glazed
9 x 5 x 4
(L78.1.269a,b)

KAZUYE SUYEMATSU

590. *Vase*, 1965
Stoneware, glazed
13 x 9½ x 6¾
(L78.1.464)

591. *Cabinet*, 1967
Stoneware, wood, iron
27 x 13 x 10
(L78.1.634)

592. *Bowl with Turtle Foot*, 1968
White stoneware, glazed
2¾ x 5½ x 5½
(L78.1.131)

593. *Plate*, 1970
Porcelain, glazed
2 x 12¾ x 12¾
(86.1.18)

594. *Plate with Yellow Roses*, 1970
Porcelain, glazed
1¾ x 10 x 10
(86.1.17)

595. *Cup*, 1971
Porcelain, glazed
3¾ x 6¼ x 3½
(L78.1.245)

596. *Lidded box*, 1972
Earthenware, glazed
3¾ x 3¼ x 3¼
(L78.1.284a,b)

597. *Cup*, 1972
Porcelain, glazed
3 x 5¼ x 2¾
(L88.1.12)

598. *Plate*, 1973
Earthenware, glazed
1½ x 11¼ x 10½
(L78.1.52)

599. *Plate*, 1973
Earthenware, glazed
1½ x 11¼ x 10½
(L78.1.52)

600. *Cup*, 1978
Porcelain, glazed
2¾ x 3 x 4¾
(L86.1.14)

601. *Tray*, 1979
Porcelain, glazed
7/8 x 7½ x 4¾
(L86.1.15)

602. *Cup*, 1986
Porcelain, glazed
3 x 4¼ x 3½
(L88.1.11)

603. *Bottle*, n.d.
Stoneware, glazed
12 x 8 x 8
(L78.1.115)

604. *Container*, n.d.
Stoneware, glazed
14 x 9 x 9½
(L78.1.573)

605. *Creamer*, n.d.
Porcelain, glazed
Height: 3¼
(86.1.19)

606. *Cup*, n.d.
Stoneware, glazed
3¼ x 4¾ x 3½
(L78.1.727)

607. *Lidded container*, n.d.
Porcelain, glazed
2 x 2¾ x 2¼
(L78.1.325a,b)

608. *Plate*, n.d.
Earthenware, glazed
1¼ x 6½ x 5½
(L78.1.170)

609. *Plate*, n.d.
White stoneware
1¼ x 10 x 10
(L78.1.174)

610. *Vase*, n.d.
Stoneware, glazed
12 x 12 x 12
(L78.1.567)

611. *Vase*, n.d.
Earthenware, glazed
5 x 5½ x 5½
(L78.1.751)

612. *Vessel*, n.d.
Stoneware, glazed
7½ x 8½ x 8
(L84.1.23)

GORO SUZUKI

613. *Bird Plate*, 1969
Stoneware, glazed
3½ x 9¼ x 6
(L78.1.180)

614. *Bowl*, 1969
Stoneware, glazed
9 x 13½ x 12½
(L78.1.317

615. *Bowl*, 1969
Stoneware, salt glazed, slip
9 x 13½ x 12½
(L78.1.317)

616. *Cup*, 1969
Stoneware, glazed
5½ x 4 x 3½
(L78.1.160)

617. *Lidded container*, 1969
Stoneware, partially glazed
8 x 8 x 8
(L78.1.241a,b)

618. *Bottle*, 1970
Stoneware, glazed
15 x 8 x 9
(L78.1.265)

619. *Bottle*, 1970
Stoneware, glazed
8½ x 7 x 5
(L78.1.98)

620. *Cup*, 1970
Porcelain, glazed
5 x 4 x 3⅛
(L78.1.67)

621. *Cup*, 1970
Stoneware, glazed
6 x 4¼ x 3½
(L78.1.64)

622. *Lidded box with sculptured hand*, 1970
Porcelain and stoneware, glazed
9¾ x 6¾ x 6¼
(L78.1.338a,b)

623. *Mug with feet*, 1970
Stoneware, glazed
3½ x 3¾ x 4½
(L78.1.395)

624. *Pitcher*, 1970
Porcelain, glazed
8¾ x 9 x 4½
(L78.1.572)

625. *Sculpture*, 1970
Stoneware and porcelain, glazed
6¼ x 2¾ x 3⅛
(L78.1.465)

626. *Sculpture*, 1970
Stoneware, glazed
14 x 10 x 5½
(L78.1.521)

627. *Sculpture*, 1970
Porcelain, glazed
40 x 23¾ x 22½
(L78.1.612)

628. *Shallow bowl*, 1970
Stoneware, glazed
2¼ x 15½ x 15½
(L78.1.310)

629. *Sculpture*, 1973
Porcelain, glazed
15½ x 21½ x 21½
(L78.1.613)

630. *Container*, 1975
Stoneware, glazed
10 x 5 x 5
(L78.1.103)

631. *Urn/vase*, 1982
Stoneware, partially glazed
12½ x 7½ x 7½
(L78.1.770)

632. *Cup with three legs*, n.d.
Porcelain, glazed
5 x 5½ x 4
(L78.1.158)

633. *Goblet*, n.d.
Porcelain, glazed
7 x 3 x 3
(L78.1.678)

634. *Plate*, n.d.
Porcelain, glazed
½ x 12¾ x 12¾
(L78.1.735)

635. *Porcelain rose*, n.d.
Porcelain, glazed
1⅞ x 1¾ x 1¾
(L78.1.382)

636. *Sculpture*, n.d.
Stoneware, glazed
8½ x 3½ x 8
(L78.1.386)

637. *Vase*, n.d.
Stoneware, glazed
12 x 5 x 5
(L87.1.24)

638. *Vessel*, n.d.
Stoneware, glazed
5 x 6¼ x 4¼
(L78.1.124)

FUMIO TAGASUGI

639. *Lidded container*, 1979
Stoneware, glazed
7½ x 7¾ x 7⅝
(L84.1.4a,b)

640. *In a Damm (sic) Hot Day*, 1979
Stoneware, glazed
20 x 20 x 3
(L78.1.695)

641. *Platter*, 1979
Earthenware, glazed
2 x 22⅜ x 22⅜
(L87.1.3)

642. *Vase*, 1979
Earthenware, glazed
11¾ x 14 x 6
(L87.1.6)

643. *Platter*, 1981
Earthenware, glazed
2⅜ x 15 x 27½
(l87.1.4)

644. *Bottle*, n.d.
Stoneware, glazed
19 x 20½ x 12
(L78.1.45)

645. *Plate*, n.d.
Stoneware, glazed
1 x 7¼ x 7¼
(L78.1.721)

646. *Sculpture*, n.d.
Earthenware, glazed
36 x 10½ x 10½
(L78.1.648)

647. *Urn*, n.d.
Stoneware, unglazed
45 x 23 x 20
(L87.1.7)

648. *Vase*, n.d.
Stoneware, glazed
20 x 15 x 11
(L78.1.637)

649. *Vessel*, n.d.
Stoneware, glazed
29½ x 20¼ x 19¾
(L78.1.694)

TOSHIKU TAKAEZU

650. *Bowl*, n.d.
Porcelain, glazed
3 x 4¾ x 4¾
(L78.1.745)

TAKASHIMA

651. *Lidded container*, n.d.
Earthenware, glazed
11½ x 7½ x 7½
(L78.1.742a,b)

HENRY TAKEMOTO

652. *Plate*, 1958
Stoneware, glazed
3 x 16¼ x 16¼
(92.1.108)

653. *Sculpture*, 1958
Earthenware, glazed
18 x 9 x 6
(92.1.96)

*654. *First Kumu*, 1959
Stoneware, glazed
21¾ x 22 x 22
(92.1.113)

655. *Jar*, 1959
Stoneware, glazed
6½ x 6 x 6
(92.1.101)

656. *Plate*, c. 1959
Stoneware, glazed
1¼ x 12 x 8¾
(92.1.102)

657. *Plate*, 1959
Stoneware, glazed
1 x 6½ x 6½
(92.1.106)

658. *Plate*, 1959
Stoneware, glazed
1 x 12¼ x 10½
(92.1.97)

659. *Plate*, 1959
Stoneware, glazed
2¼ x 17 x 17
(83.2.17)

660. *Plate*, 1959
Earthenware, glazed
1 x 6½ x 6½
(92.1.104)

661. *Platter*, 1959
Stoneware, glazed
2 x 16 x 16
(92.1.114)

662. *Platter*, 1959
Earthenware, glazed
2½ x 16½ x 16½
(92.1.107)

663. *Sculpture*, 1959
Stoneware, glazed
23 x 6 x 5
(92.1.112)

664. *Vessel*, 1959
Stoneware, glazed
36 x 28 x 28
(L78.1.818)

*665. *Flag*, 1960
Stoneware, glazed
36¾ x 26 x 7¼
(92.1.109)

666. *Plate*, c. 1960
Stoneware, glazed
¾ x 7 x 8¼
(92.1.98)

667. *Platter*, 1960
Stoneware, glazed
3 x 15¾ x 15½
(81.8.18)

668. *Platter*, 1960
Stoneware, glazed
2¾ x 17¼ x 17
(81.8.19)

*669. *Plate*, 1960
Stoneware, glazed
2½ x 16 x 16
(83.2.18)

670. *Platter*, 1961
Stoneware, glazed
16½ x 16½ x 2½
(92.1.115)

671. *Platter*, 1961
Stoneware, glazed
2 x 14 x 14
(92.1.116)

672. *Vessel-sculpture*, 1986
Stoneware, glazed
26 x 25 x 9½
(92.1.95)

673. *Plate*, n.d.
Stoneware, glazed
1¼ x 8 x 8
(92.1.105)

674. *Platter*, n.d.
Stoneware, glazed
2 x 15 x 15
(92.1.103)

675. *Platter*, n.d.
Stoneware, glazed
1½ x 14 x 13
(85.4.12)

676. *Platter*, n.d.
Earthenware, glazed
2½ x 13½ x 11½
(85.4.11)

677. *Sculpture*, n.d.
Stoneware, unglazed
18 x 7½ x 6½
(92.1.100)

678. *Sculpture-vase*, n.d.
Earthenware, glazed
40 x 19 x 14
(92.1.110)

679. *Vase*, n.d.
Earthenware, glazed
8 x 17½ x 17½
(92.1.111)

680. *Vase*, n.d.
Stoneware, glazed
11 x 10 x 10
(92.1.99)

CHRIS TEDESCO

681. *Sculpture*, 1973
Earthenware, glazed
19 x 11 x 5
(L78.1.548)

682. *Sculpture*, 1976
Clay, low-fire, lustre glaze
30 x 19 x 16
(80.8.23a,b)

683. *Sculpture*, n.d.
Stoneware, glazed
12 x 23 x 2
(L78.1.515)

THEA TENNENBAUM
684. *Lidded teapot*, n.d.
Earthenware, refired
9 x 9½ x 7½
(L78.1.760a-c)

TAMARA THORNTON
685. *Come Home Tane*, 1974
Stoneware, glazed
9 x 9 x 1
(80.8.24)

ED TRAYNOR
686. *Lidded container*, n.d.
Earthenware, glazed
11 x 9½ x 5¼
(L78.1.591)

ASUKA TSUBOI
687. *Kyoto Diary*, 1976
Stoneware, glazed
7½ x 22½ x 18½
(78.1.39)

KENJI UEDA
688. *Sculpture*, 1975
Stoneware, glazed
9½ x 10 x 10¾
(78.1.31)

689. *Sculpture*, 1977
Stoneware, glazed, stained, painted
20 x 14 x 15
(78.1.34)

CYNTHIA UPCHURCH
690. *Ladle*, 1971
Porcelain, low-fire overglaze
12 x 3½ x 3¼
(80.8.35)

VAEA
691. *Plate*, 1964
Stoneware, glazed
2¾ x 15¼ x 15
(80.8.26)

692. *Sculpture*, 1965
Stoneware, glazed
20¾ x 12½ x 9½
(80.8.28)

693. *Les Deux*, 1972
Stoneware, glazed
3¾ x 9 x 9
(80.8.27)

694. *Plate*, 1975
Stoneware, glazed
2½ x 13 x 12¾
(80.8.25)

695. *Plate*, n.d.
Stoneware, glazed
2¼ x 12½ x 12½
(L78.1.806)

696. *Plate*, n.d.
Stoneware, glazed
2 x 12⅜ x 12⅜
(L87.1.1)

PAMELA BOWREN VANDIVER
697. *Jar*, n.d.
Stoneware, glazed
6 x 6½ x 6½
(L78.1.448)

MARK VILLAGRAN
698. *Dish*, 1960
Stoneware, glazed
4 x 16 x 12
(L78.1.494)

DENNIS VOSS
699. *Sculpture*, n.d.
Earthenware, "silly-putty," glazed
17 x 19 x 8
(L84.1.24)

PETER VOULKOS
700. *Plate*, c. 1950–55
Stoneware, glazed
2 x 8¾ x 8¾
(92.1.137)

701. *Lidded container*, 1952
Stoneware, glazed
20½ x 5¾ x 5¾
(92.1.151a,b)

702. *Vase*, 1952
Stoneware, glazed
13¾ x 7¼ x 7¼
(92.1.148)

*703. *Vase*, 1955
Stoneware, glazed
26¾ x 9½ x 9½
(92.1.149)

704. *Container*, 1955
Stoneware, glazed
12 x 10 x 6½
(92.1.134)

*705. *Covered jar*, 1956
Stoneware, glazed
26½ x 18 x 18
(91.4.1)

706. *Jar*, 1955
Stoneware, glazed
5 x 5¾ x 5¾
(92.1.133)

707. *Plate*, 1955
Stoneware, glazed
1½ x 8 x 8
(92.1.152)

708. *Platter*, 1955
Stoneware, glazed
1½ x 9¾ x 10
(92.1.131)

709. *Vase*, 1955
Stoneware, glazed
29½ x 9 x 8¼
(80.8.29)

*710. *Vase*, 1955
Stoneware, glazed
12¾ x 7½ x 7¼
(92.1.135)

711. *Vessel*, 1955
Stoneware, glazed
6½ x 7 x 7
(92.1.125)

*712. *Vessel*, 1956
Stoneware, low-fire overglaze
3¾ x 5 x 4¾
(92.1.129)

*713. *Sculpture (Walking Man)*, 1956
Stoneware, low-fire overglaze
17 x 12 x 8
(92.1.136)

714. *Bowl*, 1957
Stoneware, glazed
6¾ x 12½ x 12½
(92.1.150)

*715. *Plate (Bullfight)*, 1957
Stoneware, glazed, painted
3 x 17 x 17
(92.1.153)

716. *Covered jar*, 1957
Stoneware, glazed
12 x 6½ x 6½
(92.1.140a,b)

717. *Plate*, 1957
Stoneware, glazed, painted
2½ x 16 x 16
(92.1.139)

718. *Plate*, 1957
Stoneware, sand slip, brushed glaze
4 x 17 x 16¾
(92.1.132)

719. *Platter*, 1957
Stoneware, glazed
3 x 17½ x 18
(92.1.146)

*720. *Platter*, 1957
Stoneware, glazed
2 x 12 x 12
(92.1.122)

*721. *Sculpture*, 1957
Stoneware, thin colemanite glaze
35 x 21 x 21
(82.2.1)

*722. *Bird Vase*, 1958
Stoneware, glazed
9 x 15 x 15
(91.4.2)

723. *Vase*, 1958
Stoneware, glazed
18 x 11 x 4
(92.1.141)

724. *Vase*, 1959
Stoneware, glazed, painted
21 x 11 x 9
(L78.1.555)

*725. *Bottle*, 1961
Stoneware, glazed
17 x 8 x 8
(92.1.138)

726. *Plate*, 1963
Stoneware, grey, white, blue glaze
4¾ x 16 x 12¾
(92.1.130)

*727. *Vase*, 1967
Stoneware, glazed
28 x 15¼ x 15¼
(92.1.121)

728. *Plate*, 1973
Stoneware, porcelain inlays
2½ x 18½ x 18½
((92.1.120)

729. *Plate*, 1973
Stoneware, glazed
3 x 18¼ x 18¼
(79.8.30)

730. *Plate*, 1973
Stoneware, porcelain inlays with
colbalt glazed
2¾ x 18¼ x 18¼
(79.8.30)

731. *Plate*, 1973
Stoneware, glazed
5⅝ x 18½ x 18½
(80.8.36)

732. *Plate*, 1973
Stoneware, glazed
3⅝ x 18¼ x 18¼
(80.8.37)

733. *Platter*, 1973
Stoneware, glazed
3½ x 19 x 19
(92.1.118)

734. *Vase*, 1973
Stoneware, glazed
10 x 7 x 7
(87.1.9)

735. *Plate*, 1974
Stoneware, porcelain inlays
1½ x 14½ x 15
(L78.1.300)

*736. *Plate*, 1975
Stoneware, porcelain inlays, glazed
4½ x 20½ x 20½
(92.1.117)

*737. *Vase*, 1975
Stoneware, porcelain inlays, glazed
39 x 10½ x 10½
(79.8.29)

738. *Platter*, 1980
Stoneware, glazed
4 x 21 x 21
(92.1.119)

*739. *Vessel (Ice Bucket)*, 1982
Earthenware, glazed
7⅛ x 9½ x 9½
(92.1.142)

740. *Platter*, 1983
Stoneware, wood-fired, glazed
6½ x 23 x 21½
(92.1.126)

*741. *Plate*, 1990
Stoneware, glazed
21½ x 21⅛ x 4¼
(92.1.155)

742. *Cup*, n.d.
Stoneware, porcelain inlay
3½ x 4¼ x 4¼
(92.1.143)

743. *Cup*, n.d.
Stoneware, wood-fired, glazed
3½ x 5½ x 4½
(92.1.144)

744. *Cup*, n.d.
Raku
3½ x 5 x 5
(92.1.145)

745. *Plate*, n.d.
Stoneware, glazed
2 x 16½ x 16¾
(92.1.156)

746. *Sculpture*, n.d.
Stoneware, glazed
20 x 14 x 3
(92.1.128)

747. *Vase*, n.d.
Stoneware, glazed
5½ x 4 x 4
(92.1.147)

748. *Vase*, n.d.
Stoneware, glazed
9 x 7¼ x 7¼
(92.1.127)

749. *Vase*, n.d.
Stoneware, glazed
7¾ x 9½ x 9½
(85.4.13)

750. *Vessel*, n.d.
Stoneware, glazed
9 x 7½ x 7½
(92.1.123)

751. *Vessel*, n.d.
Stoneware, glazed
12¼ x 8½ x 6
(92.1.124)

JANE WALLER
752. *Bowl*, 1985
Clay, marbled
9 x 5 x 8
(L86.1.12)

753. *Bowl*, n.d.
Stoneware, glazed
3½ x 11½ x 11½
(L78.1.748)

PATTY WARASHINA
*754. *Covered Jar*, 1968
Porcelain, glazed
12¾ x 10 x 19
(L78.1.230a,b)

STAN WELSH
755. *Platter*, 1980
Earthenware, glazed
2 x 23¾ x 23¾
(L78.1.764)

756. *Platter*, 1981
Stoneware, glazed
2¼ x 23¼ x 23¼
(L78.1.776)

757. *In The Jungle*, 1990
Stoneware, glazed
26½ x 23 x 6
(L91.1.1)

758. *Cup*, n.d.
Earthenware, low-fire glaze
4⅜ x 3¼ x 3¼
(L84.1.25)

759. *Platter*, n.d.
Raku clay, stained
23 x 23¾ x 3¾
(L78.1.485)

760. *Sculpture*, n.d.
Raku clay, glazed
36 x 13¼ x 7
(L78.1.42)

761. *Sculpture*, n.d.
Raku clay, stain, glaze, inserts
24¼ x 18½ x 6¾
(L78.1.46)

MARGUERITE WILDENHAIN
762. *Bowl*, 1954
Stoneware
1½ x 6½ x 6½
(L78.1.205)

*763. *Vase*, 1954
Stoneware
6 x 5 x 5
(L78.1.136)

*764. *Bowl*, 1956
Stoneware, glazed
3½ x 15¼ x 15¼
(L78.1.299)

765. *Vase*, n.d.
Stoneware
4½ x 3¾ x 3¾
(L78.1.133)

LIZ WILLIAMS
766. *Bowl with three legs*, n.d.
Stoneware
5⅝ x 11½ x 10½
(L78.1.807)

767. *Covered jar*, n.d.
Porcelain, low fire
14⅝ x 6½ x 5½
(L85.1.5a,b)

768. *Lidded container*, n.d.
Porcelain
12½ x 6 x 5½
(L78.1.796a,b)

+WITKOP
769. *Vase*, n.d.
Porcelain, wood fired
4¼ x 4 x 4
(L78.1.371)

BARBARA WITTENBURGS
770. *Bowl*, 1963
Porcelain, celadon glaze
2⅛ x 10 x 10
(L78.1.388)

BEATRICE WOOD
771. *Bottle*, 1955
Stoneware, lustre
5½ x 3½ x 3½
(81.8.21)

772. *Plate*, c. 1960s
Stoneware, sand glaze
2 x 16¾ x 16¾
(81.8.20)

773. *Platter*, c. 1960s
Earthenware
1¼ x 12¾ x 12¾
(L78.1.502)

*774. *Vase*, 1955
Earthenware, glazed
6½ x 6½ x 6½
(L78.1.442)

BETTY WOODMAN
775. *Vase*, 1964
Stoneware, glazed
12½ x 8 x 8
(80.8.30)

776. *Container*, 1973
Porcelain, glazed
15½ x 22½ x 8½
(80.8.31)

777. *Container*, 1978
Earthenware, low-fire, terra slip glaze
19½ x 10¼ x 7
(80.8.34)

*778. *Pitcher*, 1978
Earthenware, low-fire, glazed
15 x 22 x 15¼
(80.8.33)

779. *Vessel*, 1978
Clay, low-fire, glazed
5½ x 32½ x 9½
(80.8.32)

780. *Cup*, n.d.
Stoneware, glazed
3⅛ x 5⅞ x 4⅞
(L78.1.660b)

781. *Plate*, n.d.
Stoneware, glazed
1¾ x 6¾ x 6¾
(L78.1.660a)

782. *Plate*, n.d.
Stoneware, glazed
2 x 27 x 9
(L78.1.729)

783. *Tray*, n.d.
Porcelain, low-fire, glazed
7½ x 17 x 10
(L85.1.6)

784. *Vessel with three legs*, n.d.
Earthenware, glazed
7 x 7 x 7
(L78.1.331)

KAZUO YAGI
785. *Sculpture*, 1969
Stoneware, glazed
7 x 13½ x 12½
(L78.1.490)

HIKARU YAMADA
786. *Sculpture*, 1970
Stoneware, glazed
14½ x 10½ x 2¼
(78.1.30)

MUTSUO YANAGIHARA
787. *Lidded jar*, 1973
Stoneware, lustre glaze
3 x 4¾ x 4¾
(L78.1.273a,b)

788. *Sculpture*, 1973
Stoneware, low-fire, lustre glazed
20 x 13½ x 11½
(83.2.19)

789. *Vase*, n.d
Stoneware, lustre glazed
7 x 5 x 4
(L87.1.31)

ANGELA YAPOR
790. *Cup with Faucet Handle*, n.d.
Porcelain, low-fire pencil decoration
3 x 5½ x 5½
(L78.1.157)

CARLO ZAULLI
791. *Sculpture*, 1978
Stoneware, glazed
21 x 20½ x 8
(L86.1.11)

II. ANONYMOUS

CHINA
792. *Bowl*, 19th c.
Stoneware, glazed
1¾ x 4 x 4
(78.1.5)

793. *Vase*, 20th c.
Porcelain, glazed
10 x 4¼ x 4¼
(78.1.6)

794. *Vase*, 19th c.
Porcelain, glazed
10 x 4½ x 4½
(78.1.7)

795. *Bowl with three bands*, 20th c.
Porcelain, glazed
2¼ x 3 x 3
(78.1.8)

796. *Cup*, 19th c.
Porcelain, glazed
2½ x 3¼ x 3¼
(78.1.9)

797. *Plate*, Famille rose export ware, late
19th c.
Porcelain, glazed
½ x 8⅛ x 8⅛
(78.1.10)

798. *Plate*, Famille rose export ware, late
19th c.
Porcelain, glazed
¾ x 10⅜ x 10⅜
(78.1.11)

799. *Platter/bowl*, Famille rose export ware,
late 19th c.
Porcelain, glazed
2⅜ x 7⅜ x 10⅜
(78.1.14)

800. *Lidded Container*, 1900
Porcelain, glazed
3 x 5 x 5
(78.1.16a,b)

801. *Vase*, 1900
Porcelain, glazed
18 x 8¼ x 8¼
(L78.1.790)

802. *Covered Jar*, n.d.
Stoneware, glazed
11⅞ x 8¼ x 8⅛
(L83.1.4a,b)

803. *Vase*, 19th c.
Porcelain, glazed
8 x 4¾ x 4¾
(L84.1.2)

804. *Bowl*, n.d.
Stoneware, glazed
3⅜ x 7 x 7
(L84.1.5)

805. *Covered Jar*, n.d.
Earthenware, glazed
8¾ x 9⅛ x 9⅛
(L84.1.6a,b)

806. *Large Platter*, Ming Dynasty 16th c.
Earthenware, glazed
25⅝ x 13
(L87.1.15)

JAPAN
807. *Bowl*, 19th c.
Kutani ware
3 x 15 x 15
(78.1.1)

808. *Vase*, 20th c.
Arita ware
4½ x 2½ x 2½
(78.1.2)

809. *Urn*, 19th c.
Stoneware, glazed
9¾ x 7¾ x 7¾
(78.1.3)

810. *Bowl*, 19th c.
Oribe ware
Stoneware, glazed
2 x 5½ x 5½
(78.1.4)

811. *Bowl*, 19th c.
Oribe ware
2 x 8¼ x 8¼
(78.1.12)

812. *Bowl*, 19th c.
Arita ware
2¼ x 10 x 10
(78.1.13)

813. *Vase*, 20th c.
Satsuma ware
6¼ x 3½ x 3½
(78.1.15)

814. *Vase*, 20th c.
Satsuma ware
8½ x 4¾ x 4¾
(78.1.17)

815. *Vase*, 20th c.
Porcelain, glazed
15 x 8 x 8
(78.1.19)

816. *Vase*, 20th c.
Earthenware, Bizen
9½ x 5¾ x 5¾
(78.1.20)

817. *Bowl*, 20th c.
Stoneware
3 x 6 x 6
(78.1.21)

818. *Lidded Container*, 20th c.
Shigaraki ware
Stoneware, glazed
8⅜ x 7¾ x 6¾
(78.1.22a,b)

819. *Vase*, 20th c.
Bizen ware
Stoneware, glazed
10½ x 5¼ x 5
(78.1.23)

820. *Vase*, 20th c.
Stoneware, glazed
18 x 8 x 8
(78.1.24)

821. *Cup*, 1970
Porcelain
2⅞ x 2
(L78.1.66)

822. *Plate*, n.d.
Stoneware
1 x 6½ x 6½
(L78.1.191)

823. *Plate*, n.d.
Raku ware
2 x 8 x 8
(L78.1.204)

824. *Vase*, n.d.
Stoneware
10¼ x 6 x 4½
(L78.1.295)

825. *Shallow Bowl*, n.d.
Stoneware, glazed
2½ x 14/½ x 14½
(L78.1.316)

826. *Sculpture*, n.d.
Seated cat in clothing (*maneki nekko*)
Cast porcelain
9½ x 8 x 6
(L78.1.329)

827. *Jar*, n.d.
Stoneware
9 x 8 x 4⅛
(L78.1.332)

828. *Pouring bowl*, n.d.
Seto ware
Stoneware, glazed, unglazed
4¼ x 9 x 9
(L78.1.343)

829. *Cylindrical Vase*, 1964
Stoneware, low fire
13 x 3 x 12
(L78.1.404)

830. *Vase*, 20th c.
Oribe ware
15 x 6¼ x 15
(L78.1.789)

831. *Vase - Monkey Pot*, 19th c.
Pu Ware
15 x 13 x 4
(L78.1.791)

832. *Bowl*, Late 19th c.
Chrysanthemum design
3½ x 11
(L86.1.1)

833. *Teapot, cup and saucer*, 19th c.
Satsuma ware
Teapot: 6½ x 3 x 7½
Cup: 1⅞ x 3½
Saucer:½ x 5⅜
(L86.1.13 a-d)

834. *Platter*, 19th c.
Kutani Ware
Stoneware, glazed
¼ x 18 x 18
(L87.1.16)

835. *Bottle/Vase*, n.d.
Kato
Stoneware, blue glaze
8½ x 5
(L87.1.17)

836. *Celadon Vase*, n.d.
Miyanaga
Porcelain, galzed
9½ x 5
(L87.1.33)

KOREA

837. *Bottle*, Yi Dynasty 14th c.
Stoneware, glazed
11½ x 6½ x 6½
(78.1.18)

MEXICO

838. *Sculpture*, n.d.
Earthenware, glazed
9⅛ x 10 x 4
(L84.1.16)

SWEDEN

839. *Vase*, n.d.
Red clay
7½ x 6¼ x 5¾
(L78.1.110)

UNITED STATES

840. *Goblet*, n.d.
Stoneware
4½ x 3½ x 3½
(L78.1.65)

841. *Cup*, n.d.
Porcelain
3¼ x 4¼ x 2¾
(L78.1.72)

842. *Vase*, n.d.
Stoneware white
8¾ x 4½ x 4½
(L78.1.82)

843. *Bottle*, n.d.
Stoneware
12½ x 7 x7
(L78.1.86)

844. *Bottle*, n.d.
Stoneware
8 x 6 x 6
(78.1.102)

845. *Bottle*, 1956
Herreria
Stoneware
9½ x 5¾ x 5¾
(78.1.104)

846. *Jar with Lid*, n.d.
Stoneware, salt glaze
10½ x 8½ x 8½
(78.1.108)

847. *Head*, n.d.
Stone
7 x 8 x 4
(78.1.109)

848. *Figurine*, n.d.
Earthenware
10½ x 4½ x 4½
(L78.1.113)

849. *Bottle*, n.d.
Stoneware, glazed
12 x 8 x 8
(L78.1.115)

850. *Plate,* n.d.
Stoneware, glazed
1 x 6¾ x 6¾
(L78.1.120)

851. *Plate,* n.d.
Earthenware, glaze
1¼ x 7¼ x 7
(L78.1.123)

852. *Bowl,* n.d.
Stoneware, yellow green glaze
5¼ x 6½ x 5¼
(L78.1.1.30)

853. *Cup,* n.d.
Stoneware
3¼ x 2⅞ x 2⅞
(78.1.132)

854. *Vase,* n.d.
Stoneware
7 x 6½ x 6
(L78.1.135)

855. *Bowl,* n.d.
Stoneware, copper red glaze
3½ x 5 x 5
(78.1.137)

856. *Teapot,* n.d.
Stoneware, green celadon, salt glaze
6¼ x 9½ x 5
(L78.1.138)

857. *Sculpture, Envelopes,* n.d.
Porcelain
4½ x 4½ x¾
(781.149 a,b)

858. *Goblet,* January 30, 1970
Stoneware
5¾ x 3¼
(78.1.150)

859. *Cup,* n.d.
G. Marsha
Stoneware
4½ x 3½ x 3½
(L78.1.154)

860. *Bowl,* n.d.
Native American
Clay, low-fire, pit fired
(78.1.171)

861. *Plate,* n.d.
Stoneware, white
1¼ x 10 x 10
(L78.1.174)

862. *Cup,* n.d.
Porcelain, salt
6¾ x 6¾ x 3¼
(78.1.182)

863. *Bowl,* n.d.
Porcelain
3 x 7¼ x 7¼
(78.1.183)

864. *Bottle,* n.d.
Stoneware, low-fire color
12½ x 7 x 7
(78.1.86)

865. *Bowl,* 1974
Bisque ware
2½ x 7¾ x 7¾
(L78.1.188)

866. *Bowl,* n.d.
Earthenware, pit fired
1¾ x 5½ x 5½
(78.1.189)

867. *Sculpture,*
Porcelain
2¼ x 1½ x 1½
(78.1.192)

868. *Scuplture,* n.d.
Porcelain
2¼ x 1½ x 1½
(78.1.193)

869. *Plate,* n.d.
Stoneware
2¼ x 12 x 12
(78.1.203)

870. *Square Plate,* n.d.
Stoneware, lustre glaze
(78.1.208)

871. *Plaque,* n.d.
Stoneware
1 x 10 x 8
(78.1.209)

872. *Cup,* n.d.
Stoneware, salt
4 x 8 x 3
(78.1.210)

873. *Vase,* n.d.
Stoneware
4½ x 3¼ x 3¼
(78.1.213)

874. *Plate,* n.d.
Stoneware, glazed
3½ x 18¼x 17½
(L78.1.247)

875. *Plate,* n.d.
Copper, enamel
¾ x 5¾ x 5¾
(78.1.250)

876. *Plate,* n.d.
Stoneware, glazed
1¼ x 14¼ x 14¼
(78.1.261)

877. *Vase,* n.d.
Smudge ware
Clay, low fire
9½ x 5¾ x 5¾
(78.1.267)

878. *Goblet,* n.d.
Porcelain, low-fire, glazed
5 x 3 x 3
(L78.1.272)

879. *Vase,* n.d.
Vivian
Earthenware, glazed
4 x 2¾ x 2¾
(L78.1.276)

880. *Cup on Platform,* n.d.
Stoneware, salt glaze
6½ x 6½ x 4½
(78.1.279)

881. *Plaque-Sculpture,* n.d.
Stoneware, raku, glazed
14¾ x 15¾ x 1½
(L78.1.309)

882. *Vase,* n.d.
Earthenware, glazed
5¼ x 3 x 2½
(L78.1.321)

883. *Small Flower Vase,* n.d.
Porcelain, clear-salt glaze
4¼ x 2¾ x 2
(L78.1.322)

884. *Teapot,* n.d.
Stoneware, high-salt glazed
8⅜ x 6 x 7
(L78.1.330)

885. *Mug,* n.d.
Stoneware, matte glaze
4½ x 3½ x 5
(L78.1.365)

886. *Stout Vase,* n.d.
Earthenware
3¾ x 4 x 4
(L78.1.367)

887. *Small Bowl*, n.d.
Stoneware
2¼ x 3 x 2¾
(L78.1.372)

888. *Mug*, n.d.
Stoneware
3 x 2¾ x 4
(L78.1.373)

889. *Mug*, n.d.
Porcelain
3½ x 3 x 4
(L78.1.375)

890. *Goblet*, n.d.
Porcelain
4⅜ x 3¼ x 4½
(L78.1.376)

891. *Cup*, n.d.
Stoneware
3¾ x 3⅜ x 3¼
(L78.1.379)

892. *Goblet*, n.d.
Porcelain
7 x 2½ x 3
(L78.1.380)

893. *Mug*, n.d.
Stoneware
7½ x 5 x 7½
(L78.1.384)

894. *Sculputure*, n.d.
Stoneware
4 x 6 x 7
(L78.1.392)

895. *Goblet*, n.d.
Stoneware
6½ x 3 x 3
(L78.1.399)

896. *Lidded Container*, n.d.
Stoneware, glazed
8¾ x 9 x 9
(L78.1.409)

897. *Teapot*, n.d.
Raku
6¾ x 6½ x 8
(L78.1.410)

898. *Jar*, 1975
Stoneware, glazed
7 x 6
(L78.1.454)

898. *Covered Jar*, n.d.
Stoneware, glazed
5 x 5½
(L78.1.455)

900. *Urn*, n.d.
Glass
10 x 6½ x 6½
(L78.1.467)

901. *Vase*, n.d.
Stoneware, glazed
13½ x 10½
(L78.1.542)

902. *Vase*, n.d.
Anita
12 x 8 x 7½
(L78.1.756)

Selected Bibliography

Compiled by Juliette Heinz and Rachel Latta

DICTIONARIES AND ENCYCLOPEDIAS

Campbell, James Edward. *Pottery and Ceramics: A Guide to Information Sources*. Art and Architecture Information Guide Series, vol. 7. Detroit, MI: Gale Research Co., 1978.

Evans, Paul. *Art Pottery of the United States: An Encyclopedia of Producers and Their Marks*. New York: Charles Scribner's Sons, 1974.

Kovel, Ralph, and Terry Kovel. *Kovel's Collectors Guide to American Art Pottery*. New York: Crown, 1974.

Savage, George, and Harold Newman. *An Illustrated Dictionary of Ceramics*. New York: Van Nostrand Reinhold, 1974.

Strong, Susan. *History of American Ceramics: An Annotated Bibliography*. Metuchen, NJ: Scarecrow Press, 1983.

Weidner, Ruth Irwin. *American Ceramics before 1930: A Bibliography*. Westport, CT: 1982.

Weinrich, Peter H. *Bibliographic Guide to Books on Ceramics*. Toronto: Canadian Craft Council, 1976.

GENERAL HISTORIES

Armstrong, Tom, et al. *200 Years in American Sculpture*. New York: Godine in association with the Whitney Museum of American Art, 1976.

Bray, Hazel. *The Potter's Art in California: 1885-1955*. Oakland, CA: The Oakland Museum, 1980.

Clark, Garth, and Margie Hughto. *A Century of Ceramics in the United States, 1878-1978*. New York: E.P. Dutton in association with the Everson Museum of Art, Syracuse, NY, 1979.

Cox, Warren. *The Book of Pottery and Porcelain*. New York: Crown, 1944.

Doat, Taxile. *History of American Ceramics: Studio Potter*. Dubuque, IA: Kendall/Hunt, 1978.

Denker, Ellen and Bert Denker. *North American Pottery & Porcelain*. Pittstown, NJ: Main Street Press, 1985.

Donhauser, Paul S. *History of American Ceramics*. Dubuque, IA: Kendall/Hunt, 1978.

Keen, Kirsten Hoving. *American Art Pottery 1875-1930*. Wilmington, DE: Delaware Art Museum, 1978.

Levin, Elaine. *The History of American Ceramics: 1607 to the Present*. New York: Harry N. Abrams, 1988.

Museum of Contemporary Crafts, New York. *Craft Forms from the Earth: 1000 Years of Pottery in America*. New York: Museum of Contemporary Crafts, 1961.

Petterson, Richard B. *Ceramic Art in America*. Columbus, OH: Professional Publications, 1969.

Phillips, Lisa, ed. *High Styles: Twentieth Century American Design*. New York: Whitney Museum of American Art, 1985.

Préaud, Tamara, and Serge Gauthier. *Ceramics of the 20th Century*. New York: Rizzoli, 1982.

R. W. Norton Art Gallery. *The American Porcelain Tradition*. Trenton, NJ: New Jersey State Museum, 1972.

Ramsay, John. *American Potters and Pottery*. Boston, MA: Hale, Cushman & Flint, 1939.

Steigleder, Linda. *Checklist of Marks and Supplementary Information: A Century of Ceramics in the United States*. Syracuse, NY: Everson Museum of Art, 1979.

Stiles, Helen. *Pottery in the United States*. New York: E.P. Dutton, 1941.

BOOKS AND EXHIBITION CATALOGUES

Alcauz, Marie de. *Ceci n'est pas le Surrealisme—California Idioms of Surrealism*. Los Angeles, CA: Fisher Gallery, University of Southern California, 1984.

American Ceramics Now: The 27th Ceramic National Exhibition. Syracuse, NY: Everson Museum of Art, 1987.

American Craft Museum. *The Clay Figure*. New York: American Craft Museum, 1981.

_____. *Craft Today: Poetry of the Physical*. Essays by Paul J. Smith and Edward Lucie-Smith. New York: American Craft Museum, 1986.

Anderson, Timothy J., et al. *California Design, 1910*. Pasadena, CA: Pasadena Center, 1974.

Ashton, Dore. *Modern American Sculpture*. New York: Harry N. Abrams, 1967.

_____, et al. *Multiplicity in Clay, Metal & Fiber*. Saratoga Springs, NY: Department of Art, Skidmore College, 1984.

Belloli, Jay, ed. *Contemporary Ceramic Vessels: Two Los Angeles Collections*. Pasadena, CA: Baxter Art Gallery, California Institute of Technology, 1984.

Birks, Tony. *Art of the Modern Potter*. New York: Van Nostrand Reinhold, 1976.

Bismanis, Maija, and Ric Gomez. *The Continental Clay Connection*. Regina, Sask.: MacKenzie Art Gallery, University of Regina, 1980.

Boris, Eileen. *Art and Labor*. Philadelphia, PA: Temple University Press, 1986.

Bray, Hazel. *California Ceramics and Glass 1974*. Oakland, CA: The Oakland Museum, 1974.

Brody, Harvey. *The Book of Low-Fire Ceramics*. New York: Holt, Rinehart and Winston, 1979.

Bormann, Gottfried. *Ceramics of the World in 1984*. Dusseldorf: Kunst & Handwerk Verlag, 1984.

Bruning Levine, Nancy. *Hardcore Crafts.* New York: Watson Guptil, 1976.

Byers, Ian. *The Complete Potter: Raku.* London: B.T. Batsford, 1990.

Campbell, Donald. *Using the Potter's Wheel.* New York: Van Nostrand Reinhold, 1977.

Clay Images. Los Angeles, CA: California State University, 1974.

Ceramics Review. London: Craftsmen Potter's Association of Great Britain, 1977.

Clark, Garth. *American Potters: The Work of the Twenty Modern Masters.* New York: Watson Guptil, 1981.

_____, ed. *Ceramic Art: Comment and Review. 1882-1978.* New York: Dutton Paperbacks, 1978.

_____. *Viewpoint: Ceramics 1979.* El Cajon, CA: Grossmont College, 1979.

_____, ed. *Transactions of the Ceramics Symposium 1979.* Los Angeles, CA: Institute for Ceramic History, 1980.

_____, ed. *Ceramics and Modernism: Response of the Artist, Designer, Craftsman and Architect.* Los Angeles, CA: Institute for Ceramic History, 1982.

_____. *Production Lines: Art/ Craft/ Design.* Philadelphia, PA : Philadelphia College of Art, 1982.

_____, ed. *Ceramic Echoes: Historical References in Contemporary Ceramic Art.* Kansas City, MO: Nelson-Atkins Museum of Art, 1983.

_____, et al. *Who's Afraid of American Pottery?* Hertogenbosch, Netherlands: Dienst voor Beeldende Kunst, 1983.

_____, et al. *Pacific Connections.* Los Angeles, CA: Los Angeles Institute of Contemporary Art, 1985.

Clark, Garth, Gert Staal, et al. *Functional Glamour: Utility in Contemporary American Ceramics.* Hertogenbosch, the Netherlands: Museum het Kruithuis, 1987.

Clark, Garth, and Oliver Watson. *American Potters Today.* London: Victoria and Albert Museum, 1986.

Cochran, Malcolm. *Contemporary Clay: Ten Approaches.* Hanover, NH: Dartmouth College, 1976.

Conrad, John W. *Contemporary Ceramics.* New York: Prentice Daniel, 1978.

Coplans, John. *Abstract Expressionist Ceramics.* Irvine, CA: Art Gallery, University of California, 1966.

Counts, Charles. *Pottery Workshop.* New York: Macmillian, 1972.

Dickerson, John. *Raku Handbook.* New York: Van Nostrand Reinhold, 1972.

Dormer, Peter. *The New Ceramics.* London: Thames and Hudson, 1986.

Drexler Lynn, Martha. *Clay Today:*

Contemporary Ceramicists and Their Work. Los Angeles, CA: Los Angeles County Museum of Art; San Francisco, CA: Chronicle Books, 1990.

Drutt, Helen, and Wayne Higby. *Contemporary Arts: An Expanding View.* Princeton, NJ: The Squibb Gallery, 1986.

Everson Museum of Art. *New Works in Clay by Contemporary Painters and Sculptors.* Text by Margie Hughto. Syracuse, NY: Everson Museum of Art, 1976.

_____. *New Works in Clay III.* Text by Margie Hughto and Brad Benson. Syracuse, NY: Everson Museum of Art, 1981.

Fairbanks, Johnathan, and K.W. Moffett. *Directions in American Ceramics.* Boston, MA: Museum of Fine Arts, 1984.

Freylinghuysen, Alice C., ed. *In Pursuit of Beauty: America and the Aesthetic Movement.* New York: The Metropolitan Museum of Art, 1986.

Hall, Julie. *Tradition and Change: The New American Craftsmen.* New York: E.P. Dutton, 1978.

Hirsch, Rick, and Christopher Tyler. *Raku: Techniques for Contemporary Potters.* New York: Watson Guptil, 1975.

Hopkins, Henry T. *50 West Coast Artists.* San Francisco, CA: Chronicle Books, 1981.

Horn, Richard. *Fifties Styles: Then and Now.* New York: Beech Tree Press, 1985.

Jaffe-Friede and Straus Galleries. *Contemporary Clay: Ten Approaches.* Hanover, NH: Dartmouth College, 1976.

Kaplan, Wendy, ed. *The Art That Is Life.* Boston, MA: Museum of Fine Arts, 1987.

Kleinsmith, Gene. *Clay's The Way.* Victor Valley, CA.: Sono, Nis, 1979.

Kriwanek, Franz F. *Keramos.* Dubuque, IA: Kendall/Hunt, 1970.

Koeninger, Kay, and Douglas Humble, eds. *Earth and Fire: The Marer Collection of Contemporary Ceramics. Catalogue of the Permanent Collection.* Claremont, CA: Galleries of the Claremont Colleges, 1984.

Kohl, Joyce. *Clay Alternatives.* Los Angeles, CA: Fisher Gallery, University of Southern California, 1981.

Lane, Peter. *Studio Ceramics.* Radnor, PA.: Collins Publishers & Chilton Book Company, 1983.

Leach, Bernard. *A Potter's Book.* London: Faber & Faber, 1940.

Lewenstein, Eileen, and Emmanuel Copper. *New Ceramics.* New York: Van Nostrand Reinhold, 1974.

Long Beach Museum of Art. *Ceramic Conjunction 1977.* Long Beach, CA:

Long Beach Museum of Art, 1977.

Los Angeles Institute of Contemporary Art. *Pacific Connections.* Los Angeles, CA: Los Angeles Institute of Contemporary Art, 1985.

Los Angeles Municipal Art Gallery. *Art in Clay: 1950s to 1980s in Southern California.* Exhibition by Betty Warner Sheinbaum. Essays by Susan Peterson, Gerald Nordland, and Eudorah M. Moore. Los Angeles, CA : Los Angeles Municipal Art Gallery, 1984.

Luise, Billy. *Potworks.* New York: Morrow, 1973.

Lyggard, Finn. *Ceramic Manual.* Denmark: N.p., 1972.

McReady, Karen. *Contemporary American Ceramics—Twenty Artists.* Newport Beach, CA: Newport Harbor Art Museum, 1985.

Maines, Penny, ed. *Art in Clay: 1950s to 1980s in Southern California.* Los Angeles Municipal Art Gallery, 1984.

Manhart, Tom, and Marcia Manhart. *The Eloquent Object: The Evolution of American Craft Since 1945.* Tulsa, OK: Philbrook Museum; Seattle: University of Washington Press, 1987.

Maryland Institute, College of Art. *Clay Bodies: Autio—DeStaebler-Frey.* Essay by Ron Lang. Baltimore, MD: Maryland Institute, College of Art, 1982.

Melchert, Jim, and Paul Soldner. *The Fred and Mary Marer Collection.* Claremont, CA: Scripps College, 1974.

Meyer, Fred. *Sculpture in Ceramics.* New York: Watson Guptill, 1971.

Myers, Bernard S. *Understand the Arts.* New York: Holt, Rinehart & Winston, 1974.

Murray, Rona. *The Art of the Earth.* Victoria, British Columbia: N.p., 1979.

Nakamura, Kimpei. *Art and/or Craft: USA & Japan.* Kanazawa, Japan: N. p., 1982.

Nelson, Glen C. *Ceramics.* Rev. ed. New York: Holt, Rinehart & Winston, 1977.

_____. *Ceramics: A Potter's Handbook.* New York: Holt, Rinehart & Winston, 1977.

New Gallery. State University of Iowa. *Clay Today.* Text by James McKinnell and Abner Jonas. Ames, IA: New Gallery, State University of Iowa, 1962.

Nichols, George Ward. *Pottery, How it is Made...: Instructions for Painting on Porcelain and Pottery...* New York: G. P. Putnam's Sons, 1878.

Nigrosh, Leon. *Low Fire: Other Ways to Work in Clay.* Boston, MA: Davis Publishing, 1980.

Nordness, Lee. *Objects, USA.* New York: Viking Press, 1970.

Olmsted, Anna Wetherill. *Contemporary American Ceramics.* Syracuse, NY: Syracuse Museum of Fine Arts, 1937.

Parks, Dennis. *A Potter's Guide to Raw*

Glazing and Oil Firing. New York: Charles Scribner & Sons, 1980.

Pearson, Katherine. *American Crafts: A Source Book for the Home*. New York: Stewart, Tabori & Chang Publishers, 1983.

Perry, Barbara. *American Ceramics: The Collection of the Everson Museum of Art*. Syracuse, NY: Everson Museum of Art; New York: Rizzoli, 1989.

_____, and Ross Anderson. *The Diversions of Keramos: American Clay in Sculpture 1925–1950*. Syracuse, NY: Everson Museum of Art, 1983.

Petterson, Richard B. *Ceramic Art in America*. Columbus, OH: Professional Publications, 1969.

Piepenberg, Robert. *Raku Pottery*. New York: Macmillan, 1971.

Plagens, Peter. *Sunshine Muse: Contemporary Art on the West Coast*. New York: Praeger, 1974.

Poor, Henry Varnum. *A Book of Pottery: From Mud to Immortality*. Englewood Cliffs, NJ: Prentice-Hall, 1958.

Randall, Ruth Hunie. *Ceramic Sculpture*. New York: Watson Guptill, 1948.

Rawson, Philip. *Ceramics: The Appreciation of the Arts*, 2nd ed. Philadelphia, PA: The University of Pennsylvania Press, 1984.

Rhodes, Daniel. *Clay and Glazes for the Potter*. Philadelphia, PA: Chilton, 1957.

_____. *Kilns: Design, Construction and Operation*. Philadelphia, PA: Chilton, 1968.

_____. *Pottery Form*. Radnor, PA: Chilton, 1976.

Riegger, Harold Eaton. *Raku: Art and Technique*. New York: Van Nostrand Reinhold, 1970.

Sanders, Herbert H., and K. Tomimoto. *The World of Japanese Ceramics: Historical and Modern Techniques*. Tokyo: Kodansha International, 1967.

Selz, Peter. *Funk Art*. Berkeley, CA: University Art Museum, University of California, 1967.

Slivka, Rose, Aileen Webb, and Marge Patch. *Crafts of the Modern World*. New York: Horizon Press, 1968.

Slivka, Rose. *The Object As Poet*. Washington, D.C.: Smithsonian Institution Press, 1977.

_____. *West Coast Ceramics*. Amsterdam: Stedelijk Museum, 1979.

Smith, Paul J., and Edward Lucie-Smith. *Craft Today: Poetry of the Physical*. New York: American Craft Museum and Weidenfeld & Nicolson, 1986.

Speight, Charlotte. *Hands in Clay*. Sherman Oaks, CA: Alfred Publishing Company, 1979.

_____. *Images in Clay Sculpture: Historical and Contemporary Techniques*. New York: Harper & Row, 1983.

Triggs, Oscar Lovell. *Chapters in the History of the American Arts and Crafts Movement*. New York: Benjamin Blom, 1971.

Trevor, Harry. *Pottery*. New York: Watson Guptil, 1975.

Tunis, Roslyn. *Ancient Inspirations—Contemporary Interpretations*. Binghamton, NY: Roberson Center for the Arts and Sciences, 1982.

_____. *Clay: The Medium and the Method*. University of California, Santa Barbara. Santa Barbara, CA: University Art Galleries, University of California, 1976.

_____. *Fiber, Metal and Clay*. Ann Arbor, MI: Slusser Gallery, University of Michigan, 1977.

_____. *20 American Studio Potters*. London: Victoria and Albert Museum, 1966.

Wechsler, Susan. *Low Fire Ceramics: A New Direction in American Clay*. New York: Watson Guptil, 1981.

Westphal, Alice. *The Ceramic Vessel As Metaphor*. Evanston, IL: Evanston Art Center, 1977.

Wildenhain, Marguerite. *Pottery: Form and Expression*. New York: American Craftsmen's Council and Reinhold Corp., 1959.

_____. *Invisible Core: A Potter's Life and Thoughts*. Palo Alto, CA: Pacific Books, 1973.

Williams, Gerry, Peter Sabin, and Sarah Bodine. *Studio Potter Book*. New York: Van Nostrand Reinhold, 1978.

Yanagi, Soetsu. *The Unknown Craftsman*. Tokyo: Kodansha International, 1972.

ARTICLES

Ballatore, Sandy. "The California Clay Rush." *Art in America* 64 (July 1976): 84–88.

Bettleheim, Judith. "Pacific Connections." *American Crafts* 46 (April 1986):43–50.

Britton, Allison. "American Ceramics Today." *Ceramics* 1 (May 1986).

Brunner, Astrid. "Edges in Thought, in History, in Clay." *Arts Atlantic* 25 (Spring 1986): 93–94.

Burton, William. "Oriental Influence on 20th-Century Pottery." *The Pottery Gazette* 44 (1985).

Buzio, Lidya. "Line and Rhythm." *Studio Potter* 14 (December 1985): 44.

"California Ceramics." *Art Digest* 12 (March 15, 1938).

"California Crafts and Craftsmen." *Craft Horizons* 16 (September 1956).

Chalke, John. "The Ceramic Identity Scandal of the 70s." *Ceramics Monthly* 28 (December 1980): 25.

Clark, Garth. "Comment." *Ceramics Monthly* 25 (October 1977): 17, 19.

_____. "Ceramic Art: Redefinition." *American Ceramics* 1, no.1 (1982).

_____. "Comment." *Ceramics Monthly* 46 (December 1985).

_____. "The Pictorialization of the Vessel: American Ceramics." *Crafts* 80 (May 1986): 40–47.

Coffelt, Beth. "East Is East and West Is West: The Great Divide." *San Francisco Sunday Chronicle* (April 4, 1982).

Coplans, John. "Sculpture in California: The Clay Movement." *Artforum* 2 (August 1963): 3–6.

_____. "Out of Clay: West Coast Ceramic Sculpture Emerges as Strong Regional Trend." *Art in America* 51 (December 1963).

_____. "Redemption Through Ceramics." *Artnews* 64 (1965): 28-29.

Daley, William. "Celebration of Clay: 100 Years of American Ceramics at the Everson Museum." *American Craft* 39 (August 1979): 2–11.

Evans, Paul F. "Art Pottery in California: An American Era in Microcosm." *Transactions of the Ceramics Symposium 1979*, ed. Garth Clark. Los Angeles, CA: Institute for Ceramic History, 1980.

Falk, Lorne. "Will Ceramics Secede from the Art World?" *Art Examiner* 13 (May 1986): 70-3.

Giambruni, Helen. "Abstract Expressionist Ceramics." *Craft Horizons* 36 (November 1966): 16–25.

Greenberg, Clement. "The Status of Clay." *Transactions of the Ceramics Symposium 1979*, ed. Garth Clark. Los Angeles, CA: Institute for Ceramic History, 1980.

Gronborg, Erik. "The New Generation of Ceramic Artists." *Craft Horizons* 29 (January 1969): 26–29, 50.

Kester, Bernard. "Los Angeles." *Craft Horizons* 36 (December 1976):18–21.

Klemperer, Louise. "Critical Dimensions: How Shall We Judge?" *American Ceramics* 1, no.3 (1982).

Knight, Christopher. "Otis Clay: A Revolution in the Tradition of Pottery." *Los Angeles Herald Examiner* (29 September 1982).

Kramer, Hilton. "Art: Sensual, Serene Sculpture." *The New York Times* (25 January 1975).

_____. "Sculpture: From Boring to Brilliant." *The New York Times* (15 May, 1977).

_____. "Ceramic Sculpture and the Taste of California." *The New York Times* (20 December 1983).

Kuspit, Donald. "Elemental Realities." *Art*

in America 69 (January 1981): 78–87.

Larson, Kay. "California Clay Rush." *New York* (11 January 1982).

Leach, Bernard. "American Impressions." *Craft Horizons* 10 (Winter 1950): 18–20.

McCloud, Mac. "Otis Clay: 1956–1957." *Ceramic Arts* 1, no. 1 (1983).

MacKenzie, Warren. "Comment: The Vessel." *Ceramics Monthly* 29 (February 1986).

McTwigan, Michael. "Modernism and Ceramics Today: An Overview." *Ceramics and Modernism*. Los Angeles, CA: Garth Clark Gallery, 1982.

Melchert, Jim. "Fred Marer and the Clay People." *Craft Horizons* 34 (June 1974): 38–47.

Natisse, Andy. "The Ceramic Vessel as Metaphor." *New Art Examiner* (January 1976).

Pyron, Bernard. "The Tao and Dada of Recent American Ceramic Art." *Artforum* 2 (March 1964): 41–43.

Rawson, Philip. "Ceramic Echoes." *Ceramic Arts* 1, no. 2 (1984).

_____. "The Vessel as Center," *American Ceramics* 3, no. 4 (1985).

Richardson, Brenda. "California Ceramics." *Art in America* 51 (1 May 1969): 104–105.

Ruff, Dale. "Clay Roots and Routes." *American Ceramics* 1, no. 3 (1982).

Schjedahl, Peter. "The Playful Improvisations of West Coast Ceramic Art." *The New York Times* (9 June 1974): Sec II, 19.

_____. "California Goes to Pot." *The Village Voice* (23 December 1981).

Slivka, Rose. "The New Ceramic Presence." *Craft Horizons* 21 (July/August 1961): 30–37.

Soldner, Paul E. "Raku as I Know It." *Ceramic Review* (April 1973).

_____, and Peter Voulkos. "Ceramic West Coast." *Craft Horizons* 26 (July 1966): 25–28.

Tipton, Barbara. "A Century of Ceramics in the United States." *Ceramic Monthly* 27 (October 1979).

Treacy, Eleanor. "Ceramics: The Art with the Inferiority Complex." *Fortune* 16 (December 1937).

Troy, Jack. "May Pots Survive Their Writers," *American Ceramics* 4, no.2 (1985).

White, Cheryl. "Towards an Alternative History: Otis Clay Revisited." *American Craft*, 5, no.4 (August/September 1993): 120–125.

Woodman, George. "Ceramic Decoration and the Concept of Ceramics as a Decorative Art." *American Ceramics* 1, no.1 (1982).

_____. "Why (Not) Ceramics?" *New Art Examiner* 13 (September 1985).

Zack, David. "California Myth Making." *Art*

and Artists 4, no. 4 (July 1969): 26-31.

_____. "California Myth Makers." *Art and Artists* 4 (March 1970).

ARTISTS

LAURA ANDRESON

Cox, George. "Laura Andreson." *California Arts and Architecture* 58 (January 1941).

Kester, Bernard. "Laura Andreson." *Craft Horizons* 30 (December 1970): 12–17.

Levin, Elaine. "Pioneers of Contemporary American Ceramics: Laura Andreson, Edwin and Mary Scheier." *Ceramics Monthly* 24 (January 1976): 30–36.

Mingei International Museum of World Folk Art. *Laura Andreson: A Retrospective in Clay*. Text by Martha Longenecker. La Jolla, CA: Mingei International Museum of World Folk Art, 1982.

Petterson, Richard B. "Timeless Vessels: The Porcelains of Laura Andreson," *American Craft* 42 (August 1982): 28–31.

Rico, Diana. "Laura Andreson." *American Ceramics* 3, no. 2 (1984).

Scripps College. *Second Bi-Annual Ceramics Exhibition*. Claremont, CA,1947.

University of California, Art Galleries. *Laura Andreson: Ceramics: Form and Technique*. Essay by J. Bernard Kester. Los Angeles, CA: University of California, Art Galleries, 1970.

RUDY AUTIO

Autio, Rudy. "About Drawing." *Studio Potter* 14 (December 1985): 37–38.

_____. "My Development as an Artist: Working in Ceramics from 1950–1985." *Fusion* 10 (Winter 1987).

Clark, Garth, and Sanford Shaman. *The Contemporary American Potter: Recent Vessels*. Cedar Falls, IA: Art Gallery, University of Northern Iowa, 1980.

Depew, Dave. "The Archie Bray Foundation." *Ceramics Monthly* 20 (May 1972): 18–23.

The Evanston Art Center. *The Ceramic Vessel As Metaphor*. Essay by Alice Westphal. Evanston, IL: The Evanston Art Center, 1977.

Everson Museum of Art. *24th Ceramic National Exhibition*. Syracuse, NY: Everson Museum of Art, 1966–68.

Fairbanks, Jonathan, and K.W. Moffett. *Directions in American Ceramics*. Boston, MA: Museum of Fine Arts, 1984.

Harrington, Lamar. "Letter from Seattle— Rudy Autio." *Craft Horizons* 23 (June 1963): 43.

Kalamazoo Institute of Arts. *Contemporary*

Ceramics: The Artist's Viewpoint. Kalamazoo, MI: Kalamazoo Institute of Arts, 1977.

Kangas, Matthew. "Rudy Autio: Massive Narrations." *American Craft* 40 (October/November 1980): 12–17.

_____. *Rudy Autio: A Retrospective*. Missoula, MT: University of Montana, 1983.

_____. "Rudy Autio." *American Ceramics* 3, no. 4 (1985).

Lang, Ron. *Clay Bodies: Autio-Destaebler-Frey*. Baltimore, MD: Maryland Institute, College of Art, 1982.

Lebow, Edward. "The Flesh Pots of Rudy Autio." *American Ceramics* 4, no. 1 (1985).

San Francisco Museum of Art. *A Decade of Ceramic Art: 1962–1972*. Essay by Suzanne Foley. San Francisco, CA: San Franciso Museum of Art, 1972.

Senska, Frances. "Rudy Autio," *Montana Institute of Arts Quarterly* (Spring 1954).

Tvrdik, Valerie. *The Unpainted Portrait: Contemporary Portraiture in Non-Traditional Media*. Sheboygan, WI: John Michael Kohler Arts Center.

Victoria and Albert Museum. *International Ceramics 72*. London: Victoria and Albert Museum, 1972.

BILLY AL BENGSTON

Coplans, John. *Abstract Expressionist Ceramics*. Irvine, CA: University of California, 1966.

Corcoran Gallery of Art. *Billy Al Bengston, Watercolors, 1974–1980*. Washington, D.C.: The Gallery, 1980.

Hughto, Margie. *New Works in Clay by Contemporary Painters and Sculptors*. Syracuse, NY: Everson Museum of Art, 1976.

Monte, James. *Billy Al Bengston*. Los Angeles, CA: Los Angeles County Museum of Art, 1968.

"Museum Clay at Everson." *Craft Horizons* 36 (April 1976): 26-29.

Tsujiroto, Karen. *Billy Al. Bengston*. Oakland, CA: Oakland Museum of Art, and Houston, TX: Contemporary Arts Museum, 1988.

MICHAEL CARDEW

Michael Cardew: A Collection of Essays. Intro. by Bernard Leach and contributions by Michael Cardew....(et al.). London: Crafts Advisory Committee; New York: Watson-Guptill, 1976.

Cardew, Michael A. "Industry and the Studio Potter." *Crafts* (The Red Rose Guild of Craftsmen, 1942).

_____. "Potters and Amateur Potters." *Pottery Quarterly*, no. 38 (1971).

_____. "Life as a Potter." *American Crafts*

Council, Gatlinburg (June 1971).

_____. "What Pots Mean To Me." *Ceramic Review* (March/April 1975).

Garth, Clark. *Michael Cardew: A Portrait.* New York: Kodansha, 1976.

_____. "Michael Cardew and Associates." *Crafts,* London (July/August, 1975).

_____. "The Fire's Path—Michael Cardew." *Studio Potter,* Goffstown (1976).

Counts, Charles. "Michael Cardew." *Crafts Horizons* (February 1972): 22–27.

Crafts Advisory Commitee. *Michael Cardew: A Collection of Essays.* London: Crafts Advisory Commitee, 1976.

Hennel, Thomas. *The Countryman at Work.* London: Architectural Press, 1947.

Marsh, Ernest. "Michael Cardew, A Potter of Winchcombe, Gloucestershire." *Apollo* (March 1943): 129.

O'Brien, Michael (Seamus). "Abuja After Michael Cardew." *Ceramic Review.* 34 (July/August 1975).

Pleydell-Bouverie, Katherine. "Michael Cardew: A Personal Account." *Ceramic Review* 20 (March/April 1973).

HANS COPER

Birks, Tony. *Hans Coper.* London: Salisbury Centre for Visual Arts, 1983.

Boymans Museum. *Lucie Rie and Hans Coper.* Rotterdam: Boymans Museum, 1967.

"Hans Coper" (pamphlet). Düsseldorf: Hetjens Museum, 1980.

Museum fur Kunst und Gewerbe. *Lucie Rie and Hans Coper.* Hamburg: Museum fur Kunst und Gewerbe, 1972.

Lucie Rie, Hans Coper and Their Pupils: A Selection of Contemporary Ceramics Illustrating Their Influence. Norwich: Sainsbury Centre for the Visual Arts, University of East Anglia, 1990.

Rose, Muriel. *Artist Potters in England.* London: Faber, 1955.

Victoria and Albert Museum. *Collingwood/ Coper: A Picture Book 1969.* London: Victoria and Albert Museum, 1969.

_____. *The Craftman's Art.* London: Victoria and Albert Museum, 1972.

_____. *International Ceramics.* London: Victoria and Albert Museum, 1972.

PHILIP CORNELIUS

Ballatore, Sandy. *Viewpoint Ceramics, 1980.* El Cajon, CA: Grossmont College, 1983.

Bettleheim, Judith. "Pacific Connections." *American Crafts* 46 (April 1986): 43–50.

Burnstein, Joanne. "Philip Cornelius: The Container Continuum." *American Ceramics* 1, no. 4 (1982).

Clark, Garth, et al. *Pacific Connections.* Los Angeles, CA: Los Angeles Institute of Contemporary Art, 1985.

Herman, Lloyd E. *American Porcelain: New Expressions in an Ancient Art.* Forest Grove, OR: Timber Press, 1980.

VIOLA FREY

Albright, Thomas. "Mythmaker Art—Humor and Fantasy." *San Francisco Chronicle* (8 August 1981).

Ashton, Dore. "Perceiving the Clay Figure." *American Craft* 41 (April 1981): 24–31.

Ballatore, Sandy. *Viewpoint Ceramics, 1980.* El Cajon, CA: Grossmont College, 1983.

Butterfield, Jan. *Viola Frey: Paintings/ Sculpture/Drawing.* San Francisco, CA: Quay Gallery, 1981.

Chicago, Judy, et al. *Overglaze Imagery.* Fullerton, CA: Art Gallery, California State University, 1977.

Crocker Art Museum. *Viola Frey: Retrospective.* Essay by Garth Clark. Sacramento, CA: Crocker Art Museum, 1981.

Dunham, Judith L. "Ceramic Bricolage: The Protean Art of Viola Frey." *American Craft* 41 (August/September 1981): 29–33.

Glueck, Grace. "Art: The Clay Figure at the Craft Museum." *The New York Times* (20 February 1981).

Jones, Mady. *Figurative Clay Sculpture: Northern California.* San Francisco, CA: Quay Gallery, 1982.

Kelley, Jeff. "Viola Frey." *American Ceramics* 3, no. 1 (1984).

Lang, Ron. *Clay Bodies: Autio-DeStaebler-Frey.* Baltimore, MD: Maryland Institute, College of Art, 1982.

McTwigan, Michael. *In the Eye of the Beholder: A Portrait of Our Time.* New Paltz, NY: College of Art Gallery, University of New York, 1985.

Moore College of Art. *It's All Part of Clay: Viola Frey.* Essay by Patterson Sims. Philadelphia, PA: Moore College of Art, 1984.

Sims, Patterson. "Viola Frey at the Whitney." *Ceramics Monthly* 32 (November 1984): 51–53.

Wenger, Lesley. "Viola Frey," *Currant* 1 (August 1975).

Wilson, Bess M. "Ceramist at University of Southern California Trains Instructors in Haiti." *Los Angeles Times* (25 April 1986).

MICHAEL FRIMKESS

Burnstein, Joanne. "Michael and Magdalena Frimkess," *American Ceramics* 1, no. 4 (1982).

Clark, Garth, and Sanford S. Shaman. *The Contemporary American Potter: Recent Vessels.* Cedar Falls, IA: Art Gallery, University of Northern Iowa, 1980.

Coplans, John. "Sculpture in CA: The Clay Movement." *Artforum* 2 (August 1963).

_____. *Abstract Expressionist Ceramics.* Irvine, CA: University of California, 1966, 3–6.

Frimkess, Michael. "The Importance of Being Classical." *Craft Horizons* 36 (March 1986).

Giambruni, Helen. "Abstract Expressionist Ceramics." *Craft Horizons* 26 (November 1966): 16–26, 61.

Kalamazoo Institute of Arts. *Contemporary Ceramics: The Artist's Viewpoint.* Kalamazoo, MI: Kalamazoo Institute of Arts, 1977.

McChesney, Mary Fuller. "Michael Frimkess and the Cultured Pot." *Craft Horizons* 33 (December 1973): 24–27, 62.

Nordness, Lee. *Objects: USA.* New York: The Viking Press, 1970.

University Art Galleries. *Clay: The Medium and the Method.* Santa Barbara, CA: University of California, 1976.

The Victoria and Albert Museum. *International Ceramics 72.* London: Victoria and Albert Museum, 1972.

SHOJI HAMADA

Birks, Tony. *Bernard Leach, Hamada and their Circle: From the Wingfield Digby Collection.* Oxford: Phaidon, 1990.

Leach, Bernard. *Shoji Hamada.* Tokyo: Kodansha International, 1975.

Lewis, David. "Leach and Hamada," *Studio* 144 (1952).

Monterey Peninsula Museum of Art. *The Quiet Eye: Pottery by Shoji Hamada and Bernard Leach.* Monterey, CA: Monterey Peninsula Museum of Art, 1990.

Peterson, Susan. *Shoji Hamada: A Potter's Way and Work.* New York: Kodansha, 1974.

Yanagi, Muneyoshi. *Shoji Hamada.* Tokyo: Asahi Shimbum Publishing Co., 1966.

VIVIKA AND OTTO HEINO

Bray, Hazel. *The Potter's Art in California: 1855–1955.* Oakland, CA: The Oakland Museum, 1980.

Levin, Elaine. "Otto and Vivika Heino." *Ceramics Monthly* 25 (October 1977).

New Gallery. *Clay Today.* Intro. by James McKinnell. Essay by Abner Jonas. Iowa City, IA: School of Fine Arts, State University of Iowa, 1962.

JUN KANEKO

Cathcart, Linda. "Space in Clay." *Craft Horizons* 35 (August 1975): 29–31.

Everson Museum of Art. *24th Ceramic National.* Syracuse, NY: Everson Museum of Art, 1966–68.

Falk, Lorne. "Jun Kaneko." *American Ceramics* 3, no. 3 (1984).

Griffin, Kit. "Jun Kaneko Workshop." *Ceramics Monthly* 30 (December 1982).

Houston. Contemporary Arts Museum. *Jun Kaneko: Parallel Sounds.* Houston, TX: Contemporary Arts Museum, 1981.

Schonlau, Ree, and Jun Kaneko. "Jun Kaneko: A Ceramics Monthly Portfolio." *Ceramics Monthly* 32 (June/July/August 1984): 49–58.

TOYO KANESHIGE

Baekland, Frederick, and Robert Moes. *Modern Japanese Ceramics in American Collections.* New York: Japan Society, 1993.

KANJIRO KAWAI

Baekland, Frederick, and Robert Moes. *Modern Japanese Ceramics in American Collections.* New York: Japan Society, 1993.

Hinton-Braaten, Kathleen. "Kawai Kanjiro." *Orientations* 14, no. 211 (November 1983): 28–41.

RYOJI KOIE

Kataroniya 1990 (Catalonia 1990) Koie Ryoji Tokiten. Nagoya: Meitetsu Department Store, 1990.

Koie Ryoji Toge. Tokyo: NHK Bunka Bangum, Purodakushyon Bijutsuhan, 1990.

BERNARD LEACH

Birks, Tony, and Cornelia Wingfield Digby. *Bernard Leach, Hamada and Their Circle.* Oxford: Phaidon and Christie's, 1990.

Conant, Ellen P. "Leach, Hamada, Yanagi: Myth & Reality." *Studio Potter* 21 (December 1992): 6–19.

Hogben, Carol, ed. *The Art of Bernard Leach.* New York: Watson Guptil, 1978.

Leach, Bernard. *Beyond East and West: Memoirs, Portraits, and Essays.* New York: Watson Gupil, 1978.

JOHN MASON

Armstrong, Tom, et al. *200 Years of American Sculpture.* New York: Godine in association with the Whitney Museum of American Art, 1976.

Ashton, Dore. *Modern American Sculpture.* New York: Harry N. Abrams, 1967.

Backlin, Hedy. "Collaboration Artist and Architect." *Craft Horizons* 22(May/June 1962).

"Ceramics: Double Issue." *Design Quarterly* 42–43 (1958).

Clark, Garth, et al. *Pacific Connections.* Los Angeles, CA: Los Angeles Institute of Contemporary Art, 1985.

Coplans, John. *Abstract Expressionist Ceramics.* Irvine, CA: Art Gallery, University of California, 1966.

_____. "Out of Clay: West Coast Ceramic Sculpture Emerges as Strong Regional Trend." *Art in America* 51 (December 1963): 40–43.

Dickson, Joanne A. "John Mason at the Hudson River Museum." *Art in America* 67 (January 1979): 145-146.

Foley, Suzanne, and Richard Marshall. *Ceramic Sculpture: Six Artists.* New York: Whitney Museum of American Art, 1981.

Giambruni, Helen. "Exhibitions: John Mason." *Craft Horizons* 27 (January/February, 1967): 29–41.

Hudson River Museum. *John Mason: Installations From the Hudson River Series.* Yonkers, NY: Hudson River Museum, 1978.

Hughes, Robert. "Molding the Human Clay." *Time* (18 January 1982).

Kelley, Jeff. "In Search of a Transparent Art: John Mason." *American Ceramics* 2 (Winter 1983).

_____. "John Mason." *Arts Magazine* 55 (September 1980): 14.

_____. "Re Clay." *Arts Magazine* 56 (March 1982): 77–79.

Kramer, Hilton. "Ceramic Sculpture and the Taste of California." *The New York Times* (20 December 1983).

Krauss, Rosalind. "John Mason and Post-Modernist Sculpture: New Experiences, New Words." *Art in America* 67 (May/June 1979): 120-127.

Larson, Kay. "California Clay Rush." *New York* (11 January 1982).

Los Angeles County Museum of Art. *John Mason: Sculpture.* Intro. by John Coplans. Los Angeles, CA: Los Angeles County Museum of Art, 1966.

McClain, Mac. "John Mason." *Ceramics Monthly* 36 (January 1988).

Norland, Gerald. "John Mason," *Craft Horizons* 20 (May/June 1960).

Olson, J. Bennett. "Exhibitions: Soldner, Mason, Rothman." *Craft Horizons* 17 (September 1957): 41.

Pasadena Museum of Art. *John Mason: Ceramic Sculpture.* Essay by Barbara Haskell. Pasadena, CA: Pasadena Museum of Art, 1974.

Plagens, Peter. *Sunshine Muse.* New York: Praeger, 1974.

San Francisco Museum of Art. *A Decade of Ceramic Art: 1962-1972.* Essay by Suzanne Foley. San Francisco, CA: San Francisco Museum of Art, 1972.

Slivka, Rose. "The New Ceramic Presence." *Craft Horizons* 21 (July/August 1961): 30–37.

MAC MCCLAIN

"Ceramics: Double Issue," *Design Quarterly* 42–43 (1958).

Coplans, John. *Abstract Expressionist Ceramics.* Irvine, CA: Art Gallery, University of California, 1966.

McClain, Mac. "Otis Clay: 1956–1957." *Ceramic Arts* 1, no. 1 (1983).

_____, and Fred Marer. *Earth and Fire: The Marer Collection of Contemporary Ceramics.* Claremont, CA: Galleries of the Claremont Colleges, 1984.

JAMES MELCHERT

Hinton, Sue E. "Remembering Vicarious Voyage." *Artweek* 20 (September 1989): 7.

Hunt, William. "Jim Melchert." *Ceramics Monthly* 33 (January 1985): 44–47.

Joselit, David. "Projected Identities." *Art in America* 79 (November 1991): 116–123.

Melchert, James. Interview conducted by Mady Jones, April 1991. Archives of American Art, Smithsonian Institution.

Princenthal, Nancy. "Holley Soloman Exhibit, New York." *Art in America* 79 (December 1991): 115-116.

Reveaux, Tony. "Fleeting Phantom." *Artweek* 22 (March 1991): 1.

University of Iowa Museum of Art. Iowa City, IA: University of Iowa Museum of Art, 1981.

MINEO MIZUNO

Clark, Garth. *American Ceramics: 1876 to the Present.* New York: Abbeville Press, 1987.

WILLIAM STAITE MURRAY

Collis, Louise. "A Potful of Devils." *Art and Artists* 232 (January 1986): 12–14.

Dalziel, Melissa. "The Dean's Taste." *Crafts* 73 (March/April 1985): 40–41.

Ismay, W. A. Rev. of *William Staite Murray,* by Malcolm Haslman. *Ceramic Review* 94 (July/August 1985).

"Studio Pottery of the 1920's and 1930's by William Staite Murray." *Art and Artists* 223 (April 1985): 33–34.

RON NAGLE

Brown, Sylvia. "The Tough and Tender Look of Ron Nagle's New Wares." In *Ron Nagle: 1978 Adeline Kent Award Exhibition.* San Francisco, CA: San Francisco Art Institute, 1978.

Cohen, Ronny. "Ron Nagle." *Artforum* 27 (January 1984): 76–77.

Felton, David. "Nagle Among the Termites." *Rolling Stone* (14 August 1978).

Halverstadt, Hal, Ed Ward, and Joseph Pugliese. "Ron Nagle in Rock and Clay: The Songwriter, The Potter." *Craft*

Horizons 31 (June 1971): 34.

Hays, Jo Anne Burstein. "Beyond Ceramic Traditions." *Artweek* (27 October 1984): 3.

McDonald, Robert. "New Work by Ron Nagle." *Artweek* (November 1975).

McTwigan, Michael. "Ron Nagle." *American Ceramics* 2, no.4 (1984).

Pugliese, Joseph. "Ron Nagle the Potter." *Craft Horizons* 31 (June 1971): 35–37.

ANNE SCOTT PLUMMER

Bartman, William. *Anne Scott Plummer.* Interview by Viola Frey. Essay by Martha Drexler Lynn. Beverly Hills, CA: A.R.T. Press, 1989.

Gallery at the Plaza. *Imaginative Sculpture: Slater Barron, Bruce Hutton, Fritz Hudnut, Karen Kitchel, Gary Lloyd, Anne Scott Plummer, Roland Reiss, Rick Ripley, Richard Roehl, Robert Schiffmacher, Jeffrey Valance.* Essay by David Rubin. Los Angeles, CA: Gallery at the Plaza, 1982.

Lazzari, Margaret. "Between Fine Art and Kitsch." *Artweek* 20 (September 1989): 5.

KENNETH PRICE

Collins, Tom. "Kenneth Price." *American Ceramics* 9 (Spring 1991): 50.

_____. "Views: With a Room." *American Ceramics* 9 (Summer 1991): 26–33.

Colpitt, Frances. "Earthly Objects." *Art in America* 81 (February 1993): 98–101.

"Contemporary American Crafts." *Bulletin of the Philadelphia Museum of Art* 87 (Fall 1991): 1–56.

Coplans, John. "The Sculpture of Kenneth Price." *Art International* 8 (20 March 1964).

Derfner, Phyllis. "Kenneth Price at Willard." *Art in America* 63 (May/June 1975): 87–88.

Figurine Cups. Los Angeles, CA: Gemini G.E.L., 1970.

Hopkins, Henry T. "Kenneth Price: Untitled Ceramic." *Artforum* 2 (August 1963): 41.

Ken Price. Essay by Jeff Perone. St. Louis, MO: Greenberg Gallery, 1989.

Kenneth Price: Happy's Curios. Intro. by Maurice Tuchman. Los Angeles, CA: Los Angeles County Museum of Art, 1978.

King, Mary. "Ceramics Exhibit by Kenneth Price." *St. Louis Post-Dispatch* (3 October 1976).

Layton, Peter. "Kenneth Price Cups at Kasmin." *Studio International* 179 (February 1970).

Lebow, Edward. "Ken Price." *American Ceramics* 7, no. 2 (1989): 16–25.

Parks, Addison. Exhibition Review. *Arts* (January 1980).

Porges, Maria. "A Meeting of Rough and Refined." *Artweek* 20 (29 April 1989): 3.

Radcliff, Carter. "Notes on Small Sculpture." *Artforum* 14 (April 1976): 35–42.

Robert Irwin/Kenneth Price. Essay by Lucy Lippard. Los Angeles, CA: Los Angeles County Museum of Art, 1966.

Russell, John. "Kenneth Price." *The New York Times* (7 December 1979).

Silberman, Robert. "Ken Price in Retrospect." *American Craft* 52 (August/September 1992): 44–49.

Silverthorne, Jeanne. "Ken Price at the Willard Gallery, New York." *Artforum* 24 (January 1986): 91.

Simon, Joan. "An Interview with Kenneth Price." *Art in America* 68 (January 1980): 98–104.

Teplow, Joshua. "Ken Price at the Willard Gallery, New York." *Arts Magazine* 60 (January 1986): 130.

ANTONIO PRIETO

Brunson, Jamie. "Visions of the Surreal." *Artweek* 20 (8 April 1989): 6–7.

Schomer, Karine. "Goddesses, Courtesans, Peasants." *Artweek* 16 (12 October 1985): 3.

LUCIE RIE

Houston, John. *Lucie Rie: A Survey of Her Life and Work.* London: Crafts Council, 1981.

Lucie Rie. Directed by Issey Miyake. Tokyo: Miyake Design Studio, 1989.

Lucie Rie: A Retrospective of Earthenware, Stoneware and Porcelain, 1926–1967. London: The Arts Council Gallery, 1967.

Lucie Rie, Hans Coper, and Their Pupils: A Selection of Contemporary Ceramics Illustrating Their Influence. Norwich: Sainsbury Centre for the Visual Arts, University of East Anglia, 1990.

JERRY ROTHMAN

Beard, Geoffrey W. *Modern Ceramics.* London: Studio Vista, 1969.

Clark, Garth. *Jerry Rothman: Bauhaus Baroque.* Claremont, CA: Ceramic Arts Library, 1978.

Entous, Karen Alpert. "Visiting Jerry Rothman." *Ceramics Monthly* 33 (February 1985): 53.

Folf, T.C. "The Otis Revolution." *Ceramics Monthly* 38 (December 1990): 26–29.

Glasgow, Lukeman. "Jerry Rothman." *Ceramics Monthly* 29 (September 1981).

"Jerry Rothman." *Ceramics Monthly* 24 (November 1976): 38–39.

Levin, Elaine. "Jerry Rothman: A Ceramics Monthly Portfolio." *Ceramics Monthly* 40 (November 1992): 55–60.

Muchnic, Suzanne. Exhibition Review. *American Craft* 52 (December/January 1992-1993): 64–65.

Soup Tureens: 1976. Essay by Helen Drutt. Camden, N.J: Campbell Museum, 1976.

Tunis, Roslyn. *20 American Studio Potters.* London: Victoria and Albert Museum, 1966.

EDWIN AND MARY SCHEIER

Lebow, Edward. "A Sense of Line." *American Craft* 48 (February/March 1988): 24–31.

Levin, Elaine. "Pioneers of Contemporary American Ceramics: Laura Andreson, Edwin and Mary Scheier." *Ceramics Monthly* 24 (May 1976): 30–36.

PAUL SOLDNER

Bates, Malcolm S. "Anderson Ranch." *Ceramics Monthly* 35 (April 1987): 50–56.

Burstein, Joanne. "Paul Soldner." *American Ceramics* 1 (Spring 1982).

Conrad, Becca, and Marvin Bartel. "Paul Soldner Workshop." *Ceramics Monthly* 37 (May 1989): 67–68.

Davis MacNaughton, Mary, Elaine Levin, and Mac McClain. *Paul Soldner: A Retrospective,* Claremont, CA: Scripps College in association with University of Washington Press, 1990.

Dunhan, Judith. "Paul Soldner: A Ceramics Monthly Portfolio." *Ceramics Monthly* 27 (June 1979).

Fudge, Jane. "Under the Influence." *Artweek* 20 (1 April 1989): 4.

Harrod, Tanya. "Paul Soldner: Ceramic Forms." *Crafts* 92 (May/June 1988): 50.

Levin, Elaine. "Paul Soldner: A Ceramics Monthly Portfolio." *Ceramics Monthly* 27 (June 1979).

McTwigan, Michael. "A Conversation with Val Cushing and Paul Soldner." *American Ceramics* 7, no.4 (1989): 36–39.

Roberts, David. "Magic Potter." *Ceramic Review* 109 (January/February 1988): 34–38.

Rubin, Michael G. "Paul Soldner." *American Ceramics* 1 (Fall 1982).

Soldner, Paul E. "Raku as I Know It." *Ceramic Review* (April 1973).

_____. "Creative Limbo." *Studio Potter* 12 (June 1984).

_____. "The Personal Mark." *Studio Potter* 14 (December 1985).

_____. "The American Way of Raku." *Ceramics Review* 124 (July/August 1990).

_____. "Without Laws." *Ceramics Monthly* 40 (May 1992).

White, Cheryl. "Paul Soldner." *Artweek* 17 (8 February 1986).

HENRY TAKEMOTO

Clark, Garth. *American Ceramics: 1876 To The Present.* New York: Abbeville Press, 1987.

Perry, Barbara. *American Ceramics: The Collection of Everson Museum of Art.* New York: Rizzoli, 1989.

PETER VOULKOS

Albright, Thomas. "Peter Voulkos, What Do You Call Yourself." *Artnews* 77 October 1978): 118–124.

Ashton, Dore. *Modern American Sculpture.* New York: Harry Abrams, 1967.

Brown, Conrad. "Peter Voulkos." *Craft Horizons* 16 (October 1956): 12–19.

Burstein, Joanne. "Peter Voulkos." *American Ceramics* 1 (Summer 1982).

The Dome Studio Group: An Exhibition of Works by the Artist from Peter Voulkos' "Dome" Complex. Las Vegas, NV: University of Las Vegas Art Gallery, 1979.

Coplans, John. "Voulkos: Redemption through Ceramics." *Artnews* 64 (Summer 1965): 39–40, 64.

Fisher, Hal. "Art of Peter Voulkos." *Artforum* 17 (November 1978): 41–47.

Folk, T.C. "The Otis Revolution." *Ceramics Monthly* 38 (December 1990): 26–29.

Gallucci, Timothy. "Peter Voulkos: Faithful Iconoclast." *Ceramics Monthly* 37 (November 1990): 18–22.

Halper, Vicki. "Clay Revisions: Plate, Cup, Vase." *American Ceramics* 6, no.3 (1988): 16–29.

Hillex, Virginia. Exhibition Review. *New Art Examiner* 13 (May 1986).

Iwabuchi, Junko. "Peter Voulkos in Japan." *Ceramics Monthly* 31 (September 1983).

Levin, Elaine. "Peter Voulkos: A Ceramics Monthly Portfolio." *Ceramics Monthly* 24 (November 1978).

"The Marer Collection." *Ceramics Monthly* 32 (October 1984): 21–23.

Melchert, James. "Peter Voulkos: A Return to Pottery." *Craft Horizons* 28 (September/October 1968): 20–21.

Peter Voulkos. San Francisco, CA: Braunstein/Quay Gallery, 1991.

Peter Voulkos: Bronze Sculpture. San Francisco, CA: San Francisco Museum of Art, 1972.

Peter Voulkos: Sculpture. Los Angeles, CA: Los Angeles County Museum, 1965.

Sculpture and Painting by Peter Voulkos: A New Talent in the Penthouse. New York: The Museum of Modern Art, 1960.

Sewell, Darrel, Ivy Barsky, and Kelly Leigh Mitchell. "Contemporary American Crafts." *The Philadelphia Museum of Art Bulletin* 87 (Fall 1991): 1–56.

"A Short Survey of the San Francisco Bay Area Potters and Artists." *Studio Potter* 13 (December 1984): 21–47.

Slivka Rose. "The New Clay Drawings of Peter Voulkos." *Craft Horizons* 34 (October 1974).

———. *Peter Voulkos: A Dialogue with Clay.* Boston, MA: New York Graphic Society, 1978.

Taragin, Davira S. "From Vienna to the Studio Craft Movement." *Apollo* 124 (December 1986): 542.

PATTY WARASHINA

Clark, Garth. *American Ceramics: 1876 to the Present.* New York: Abbeville Press, 1987.

Perry, Barbara. *American Ceramics: The Collection of Everson Museum of Art.* New York: Rizzoli, 1989.

MARGUERITE WILDENHAIN

Colvin, Lynn M. *Marguerite: A Retrospective Exhibition of the Work of Master Potter Marguerite Wildenhain.* Ithaca, N.Y.: Herbert F. Johnson Museum, 1980.

Counts, Charles. Obituary. *American Craft* 45 (June/July 1985): 96.

Marcks, Gerhard. *The Letters of Gerhard Marcks and Marguerite Wildenhain, 1970–1981: A Mingling of Souls.* Ames: Iowa State University Press; Luther College Press, 1991.

Morphis, Thomas. "The Legacy of Marguerite Wildenhain." *Ceramics Monthly* 38 (March 1990): 67–68.

Pottery of Marguerite Wildenhain. Raleigh, N.C: North Carolina Museum of Art, 1968.

Prothro, Hunt. "Sustained Presence: Marguerite Wildenhain." *American Craft* 40 (August/September 1980): 28–31, 76.

Talley, Charles. "School for Life." *American Craft* 51 (April/May 1991): 36–39.

Wildenhain, Marguerite. "Pottery as a Creative Craft." *Craft Horizons* 10 (Summer 1950).

———. "An Open Letter to Bernard Leach from Marguerite Wildenhain." *Craft Horizons* 13 (May/June 1953).

———. *Pottery: Form and Expression.* New York: American Crafts Council, 1962.

———. *The Invisible Core: A Potter's Life and Thoughts.* Palo Alto, CA: Pacific Books, 1973.

———. *That We Can Look and See: An Admirer Looks at the Indians .* Seguin, TX: South Bear Press, 1979.

BEATRICE WOOD

Beatrice Wood: A Retrospective. Foreword by Robert L. Frankel. Phoenix, AZ: Phoenix Art Museum, 1973.

Beatrice Wood Retrospective. Essays by Dextra Frankel, Garth Clark, and Francis Naumann. Fullerton, CA: California State University Fullerton, 1982.

Bryan, Robert. "The Ceramics of Beatrice Wood." *Craft Horizons* 30 (April 1970): 28–33.

The Ceramics of Beatrice Wood. San Francisco, CA: San Francisco Museum of Art, 1958.

Ceramics by Beatrice Wood. New Delhi: All India Handicrafts Board, 1961.

Clark, Garth, and Francis Naumann. "Beatrice Wood." *American Craft* 43 (August/September 1983): 24–27.

Deats, Suzanne. "Beatrice Wood." *American Ceramics* 8, no. 3 (1990): 30–35.

"Guest Speaker: Beatrice Wood—Marcel's Mischief and Other Matters." *Architectural Digest* 41 (May 1984): 38.

Handley, Richard, and Jim Danisch. "Beatrice Wood." *Ceramics Monthly* 31 (April 1983).

Hapgood, Elizabeth R. "All the Cataclysms: A Brief Survey of the Life of Beatrice Wood." *Arts Magazine* 52 (June 1977).

——— ."All the Cataclysms: A Brief Survey of the Life of Beatrice Wood." *Arts Magazine* 52 (March 1978).

Hare, Denise. "The Lustrous Life of Beatrice Wood." *Arts Magazine* 52 (June 1977): 134–139.

"Honoring Excellence: The American Craft Council Awards." *American Craft* 52 (August/September 1992): 6.

Intimate Appeal: The Figurative Art of Beatrice Wood. Oakland, CA: The Oakland Museum, 1989.

Levin, Elaine. "Women in Clay." *Ceramic Review* 91 (January-February 1985): 30–33.

Lovoos, Janice. "An Extraordinary Craftsman." *Southwest Art* 5 (April 1979).

Naumann, Francis. "Beatrice Wood." *American Craft* 43 (August/September 1983): 24–27, 80.

Reiss, Robert. Rev. of *I Shock Myself*, by Beatrice Wood. *Archives of American Art Journal* 26, no. 2/3 (1986).

Richardson, Elizabeth. "Conflicting Stories." *Artweek* 18 (11 July 1987): 5.

Seigel, Judy. "Beatrice Wood." *Women Artists News* 12 (Fall-Winter 1987): 9–10.

Stanley, Don. "Beatrice Would." *Connoisseur* 218 (November 1988): 58.

Talley, Charles S. Exhibition Review. *Artweek* 21 (11 January 1990): 17.

Wood, Beatrice. *Beatrice Wood*. Cologne: Amerika Haus, 1990.

_____. *Beatrice Wood and Friends, From Dada to Deco*. New York: The Gallery, 1978.

_____. *The Door That Did Not Close*. Wheaton, IL: The Theosophical Press, n.d.

_____. "I Shock Myself." *Arts Magazine* 51 (May 1977).

_____. *I Shock Myself: The Autobiography of Beatrice Wood*. ed. Lindsay Smith. Ojai, CA: Dillingham Press, 1985.

_____. *33rd Wife of a Maharajah*. New Delhi: Allied Publishers, 1992.

Woodard, Josef. Exhibition Review. *Artweek* 22 (10 January 1991): 18.

BETTY WOODMAN

The Ceramics of Betty Woodman. Reading, PA: Freedman Gallery, Albright College, 1985.

Clark, Garth. "Betty Woodman: The Storm in a Teacup." *Betty Woodman*. Rochester, MN: Rochester Art Center, 1980.

"Colorado Faculty Biennial." *Ceramics Monthly* 32 (November 1984): 75.

"Contemporary American Crafts." *The Philadelphia Museum of Art Bulletin* 87 (Fall 1991): 1–56.

Cyphers, Peggy. Exhibition Review. *Arts Magazine* 66 (February 1992): 81–82.

Devore, Richard. "Ceramics of Betty Woodman." *Craft Horizons* 38 (February 1978): 28–31, 66–67.

Eight Independent Production Potters. Kansas City, MO: Kansas City Art Institute, 1976.

Goreski, Jeannine. Exhibition Review. *New Art Examiner* 16 (September 1988): 58.

Halper, Vicki. "Clay Revisions: Plate, Cup, Vase." *American Ceramics* 6, no.3 (1988): 16–29.

Heartney, Elenor. "Betty Woodman." *New Art Examiner* 13 (November 1985).

Koplos, Janet. "From Function to Form." *Art in America* 78 (November 1990): 166–171.

"Opera Selecta: The Work of Betty Woodman 1975-1990." *Kunst & Museumjournaal* 2 (1990).

Rubin, Michael. "Betty Woodman." *Ceramics Monthly* 35 (June/August 1987): 89.

Russel, Ina. "Reversing the Object's Role." *Artweek* 19 (19 March 1988): 6.

Schmidt, Linda. "Beyond the Boundaries of History and Form." *American Ceramics* 7, no.3 (1989): 18–25.

Wechler, Susan. "Betty Woodman." *American Ceramics* 1 (Winter 1982).

White, Cheryl. "Vessels: The Human Connection." *Artweek* 17 (19 April 1986): 3.

Woodman, Betty. "About Pots." *Decade* (February 1979).

_____. "The Italian Experience." *Studio Potter* 11 (June 1983).

Woodman, Elizabeth, and George Woodman. "Ceramist's Odyssey of Clay: Italy." *Craft Horizons* 30 (May/June 1970).

Index

Page numbers of illustrated works are in boldface type.

Photography Credits

Photograph numbers refer to check list. Those in italics refer to pages on which figure illustrations are found

Jack Case: *21*

Imogene Cunningham: *16*

Gene Ogami: 1, 2, 3, 4, 5, 8, 10, 11, 12, 13, 14, 15, 16, 19, 22, 27, 28, 29, 30, 31, 32, 35, 36, 37, 38, 39, 40, 41, 42, 43, 44, 45, 47, 49, 52, 53, 54, 55, 56, 57, 58, 59, 60, 61, 62, 63, 64, 65, 67, 68, 69, 70, 71

Susan Einstein: 6, 7, 9, 17, 18, 20, 21, 23, 24, 25, 26, 33, 34, 46, 48, 50, 51, 66, 68

Paul Soldner: 65

Schenck and Schenck: 51, *109*

Don Tuttle: 60

George Woodman: *106*

REVOLUTION IN CLAY
THE MARER COLLECTION OF CONTEMPORARY CERAMICS
was produced by Perpetua Press, Los Angeles
for the Ruth Chandler Williamson Gallery,
Scripps College
Edited by Letitia Burns O'Connor
and Brenda Johnson-Grau
Designed and composed on a Macintosh II Computer
by Dana Levy
Display and text type is Berkeley Book
Printed in Hong Kong by South China Printing Co., Ltd